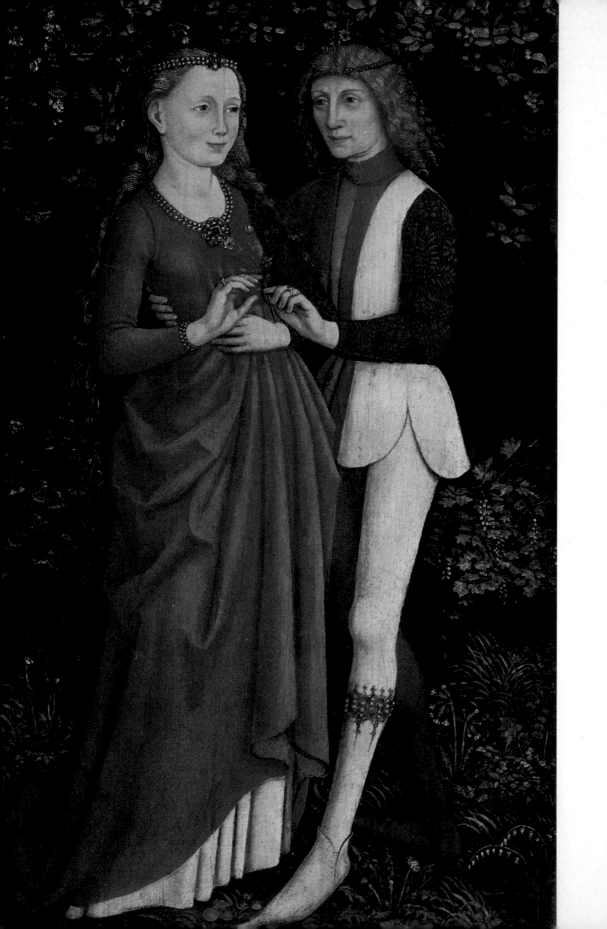

D.D.R. Owen

Noble Lovers

New York: New York University Press 1975

New York University Press
Washington Square, New York NY 10003

First published 1975
© 1975 by Phaidon Press Limited
All rights reserved

ISBN 0-8]47-7365-6
Library of Congress Catalog Card Number: 75-4303

12·2·75

Printed in Great Britain by Jolly & Barber Limited, Rugby.

Contents

Chapter I

Passions
and
Prejudices

The Middle Ages do not stand alone in their preoccupation with love, war and religion. But it was the achievement of medieval man to formalise these basic human activities and envelop them in ritual to a degree achieved in few other societies. For the practice of all three he evolved new techniques and principles, with his attitude to love between the sexes showing the most truly radical development of all, creating a social revolution that began, but did not end, with the noble classes and involved a transformation of the view of woman, and of woman as the beloved.

Though society could not go on without her, she had to weather many storms of contempt, suspicion and disapproval blowing largely from the direction of the Christian Church, the new guardian of morality. Had not Tertullian, one of its early Fathers, proclaimed her early in the third century to be the gateway for the Devil? The belief took root, and two hundred years later St Augustine's struggles against her fatal fascination were reported in his *Confessions* and taken much to heart. Eve it was who had first tasted the apple and brought the burden of sin upon mankind. So the black list of temptresses began with her and was extended with relish by the preacher, while Venus, love's incarnation from a former age, quickly took her place among the demons of the infernal pantheon. In the eyes of the Church, the only pure love to be indulged on this earth was the mystical pursuit of God. Friendship could be admirable, but sexual desire was seen as an unfortunate fact of life, never to be applauded, merely condoned within the married state for the sake of man's survival, but even then very much second best to the blessed state of chastity. By clinging to so stern a doctrine, the pious prelates doomed themselves to a hopeless and unending battle against human frailty, not least within their own institutions.

Men who took major orders within the Church committed themselves to a life of celibacy. If they were already married, they had to renounce all con-jugal relations with their wives, who could not themselves re-marry after the husband's death. If they had had two wives, or had married a widow, they were debarred from taking orders. Solemn edicts and the protestations of the righteous tell from early times how widely practice diverged from principle. In the sixth century the good Gregory of Tours spoke sourly of backsliding clerics like the drink-sodden adulterer who pitched to his death from the walls of Angers, or the reprobate who made off with a married woman in man's disguise. By the ninth century, things had reached a sorry pass, with some monasteries sheltering not only the monks, but their wives and children too. The social anarchy of the age was reflected by the conditions prevailing with-in the Church throughout much of Europe; and the custom of investing powerful laymen with ecclesiastical office meant that bad examples were

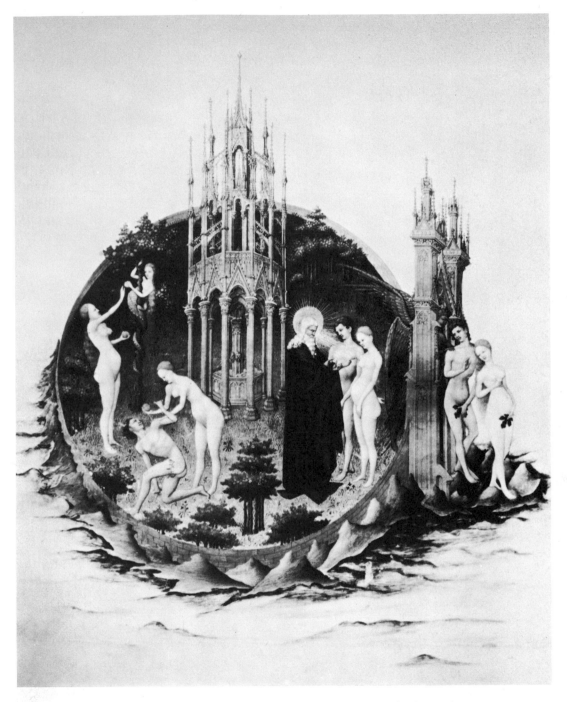

1 The Temptation, Fall and Expulsion from the Garden of Eden, a miniature by the Limburg brothers, 1415–16.

frequently handed down from above: many bishops were married, clerics took either wives or mistresses and maintained them on money that should have been put to God's works. Married priests were heard invoking St Paul himself in their defence and citing such texts as: 'To avoid fornication, let every man have his own wife, and let every woman have her own husband' (1 Corinthians 7, 2). As for those women who, from choice or compulsion, took the veil, they did not always thereby elude fleshly temptation; and not every convent was a sure stronghold against the assaults of passion.

2 Unchaste clerics in Hell, a French 15th-century miniature.

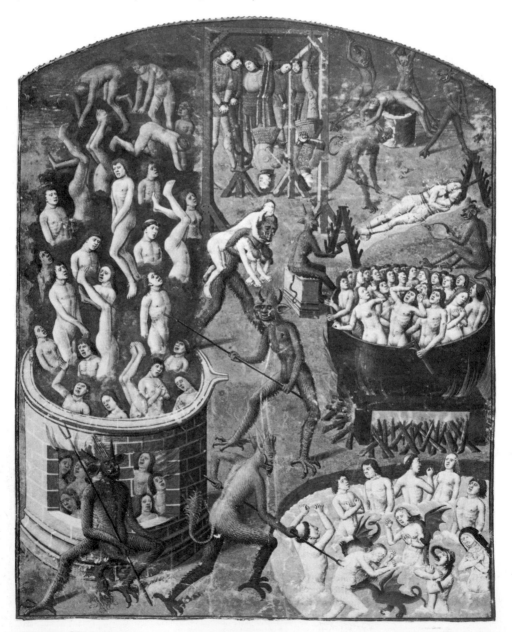

The powerful reforming movement that gathered momentum under the banner of the great abbey of Cluny did much during the eleventh and twelfth centuries to purge the religious community of its more blatant displays of licence; but many were the tales that continued to be told and written, in Latin as well as the developing vernaculars, of lecherous monks and priests with wives or concubines, or of nuns whose minds pursued thoughts less chaste than were to be found in their breviaries. Those among the clerics who were outwardly less unbridled might indulge in the vicarious solace to be found in reading; and it is no accident that of all the books of the Bible one of the most popular was the *Song of Songs*, that masterpiece of spiritualised eroticism. Moreover, Ovid was far from being a stranger to monastic libraries and school curricula; and it was as a master in the art and remedies of love as well as a mythographer and accidental generator of Christian allegories that he was known and acclaimed, and so widely that the twelfth and thirteenth centuries have been styled 'the age of Ovid'. But always there were some pious souls who achieved the Church's ideal of total renunciation and asceticism and who, attaining some degree of mystical experience, saw in their visions their unchaste brothers and sisters burning in the fires of Hell. Then they told of what they saw as a warning to all who might fall prey to lust, one of the Seven Deadly Sins.

It would be wrong to suppose there were no shining examples of feminine virtue and even saintliness. There were; and when they appeared, they earned the praise of prelate and poet alike, if largely for their renunciation of

3 (*left*) St. Jerome tempted by the thought of maidens.

4 (*right*) The fate of an errant wife.

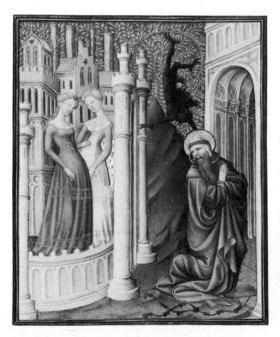
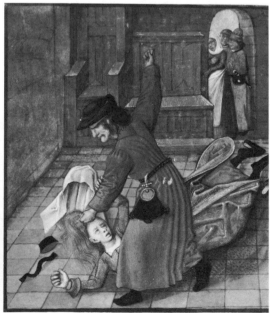

the earthly passions. Christian women, unlike their Moslem counterparts, were credited by their co-religionists with immortal souls capable of salvation; and the supreme Woman, the Virgin Mary, was venerated as the divine intercessor and mediator between them and God. Yet in the main, the existence of the fair sex was a source of unease to the men of God, who would have been less embarrassed had virgin birth not been so unique a phenomenon.

In secular society the position of woman, though eyed with less suspicion, seems also grossly undervalued by modern standards. The Church's scornful attitude fortified the layman in his belief that she was his inferior, provider of his children and domestic needs, but at his command and disposal. In the thirteenth century St Thomas Aquinas, echoing St Paul's words in Ephesians 5, 22, still insisted that she was subject to man as man is to God. Her betrothal and marriage were commonly arranged to serve dynastic or similarly practical ends, and she was frequently taken to wife while still little more than a child. Love had no necessary place in these unions, the propagation of many, preferably male, heirs being their chief function. A wife who failed to meet her husband's expectations was easily disposed of, despite the Church's hardening attitude to divorce from late Carolingian times. Charlemagne himself had been thrice wedded; and though he restrained his daughters from matrimony, he did allow them offspring by some of his leading nobles. For affairs outside wedlock were the natural corollary to the practice of marriage by expediency. Moreover, that the habit of taking mistresses was condoned by society as freely as it was condemned by the Church is shown by the number of bastards who move, not always without honour, through the pages of medieval chronicle.

5 (*below*) A cleric tries to tempt a girl with a ring, a 14th-century miniature.

6 (*facing*) Marriage as a feudal transaction involving for the parents the bestowal of property as well as their daughter's hand.

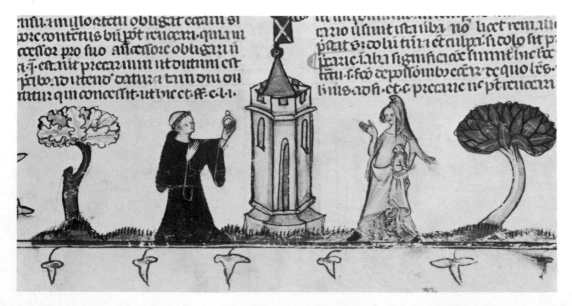

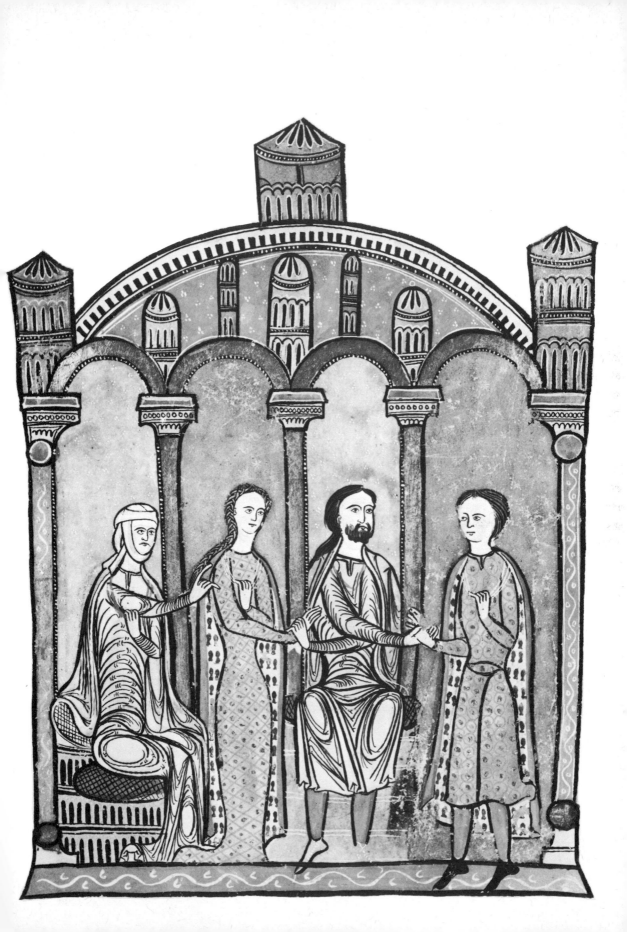

To say that in the early Middle Ages women were little more than men's chattels is, of course, to generalise, but without too much risk of distortion, if one considers the available evidence. Legislation reflects their status as property: an ancient Germanic law stipulated the fine for killing a mature woman as three times that for the slaying of a young girl (three hundred as against one hundred cattle); a wife persisting in adultery could properly be despatched by the husband along with her lover; a father was entitled to make an end of his daughter's seducer. To shade the crude picture of female subservience and deprivation, however, it must be said that, though for a long time they could not normally hold fiefs or otherwise assume the man's role in society, even the earlier centuries provide outstanding instances of women who, by force of character or intelligence, left their mark on history. In more modest terms, they had an important part to play in domestic affairs, particularly during the absence of their husbands. And to modify our general-

7 A triple wedding ceremony: a French early 14th-century miniature.

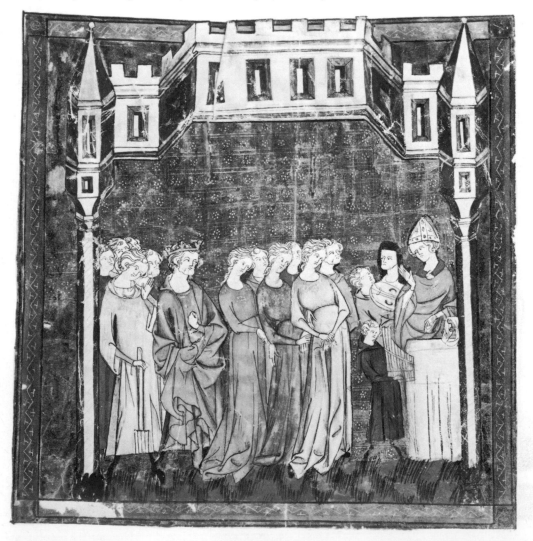

isation even further, their influence and degree of freedom varied from place to place. Thus it is significant, as we shall see, that in the south of France a more egalitarian spirit was quite early in evidence.

In conditions such as I have outlined there would seem to be little place for love as a romantic passion, either among the upper classes, of whom we know a certain amount from a variety of mainly Latin texts, or among the hard-pressed commoners, of whom we know all too little. For evidence to the contrary one may search almost in vain the literature composed before 1100. Most of that is pious or panegyric, or both, while scattered fragments survive from an age-old epic tradition. One finds, it is true, some Latin lyrics dressed with rhetoric in the Classical fashion, in which worthy poets address their devotion to women of high and perhaps holy station. Such longing as they express is, if not imagined, at least chastely modulated. And there are a number of other Latin songs, less elevated, more wanton, but anonymous and hard to date. The problem, though, is not to find whether romantic love existed, for of course it did and always has. The question is rather how it was viewed in the early Middle Ages, and whether the social consciousness took stock of it at all. Was there, in fact, a place for the lover in society?

Europe passed through bitter times after the crumbling of Charlemagne's empire, and the feudal system painfully evolved to rescue it from total

8 A knight leaves for the campaign. Sir Geoffrey Luttrell bidding farewell to his wife and daughter-in-law.

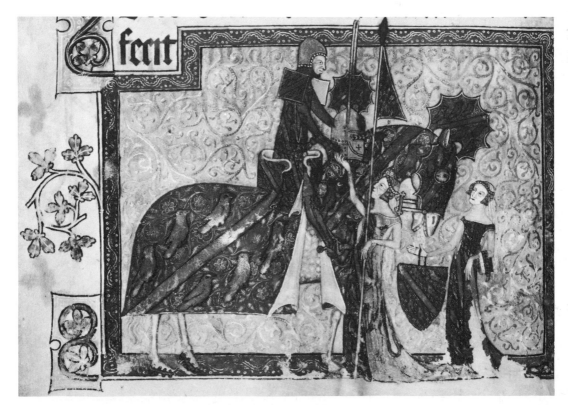

anarchy. Manners were as rough as the age; and among the warrior classes, bent on survival, the gentle lover and the romantic courtship were irrelevant. We are simplifying the picture again, but only as it was simplified by the old epic poets: brides seized and wedded in a trice, then left to mind the castle while the knights were off campaigning; sons raised and soon taken from their mothers' care to receive their martial apprenticeship from the men, so that they could renew the cycle of feuding and fighting. The love of the epic warrior was the fierce love of sons, nephews and comrades, horses and sharp steel, at best mingled with a tender remembrance of the wife and daughters nursing their anxieties at home. Relapsing from the violently extrovert

9A, B (*below and facing*) Scenes of Paris student life in the early 13th century.

spirit of his class, spurned by the Church for reasons we have seen, the noble lover was an anomaly in early medieval society, little understood and vulnerable in his predicament. The change in his fortune, when it came, was to be dramatic.

The calamitous story of Peter Abelard, though unique, may illustrate something of the tensions induced when religious and social prejudice came in the way of the pursuit of love. Born into the lesser Breton nobility, Abelard chose the sword of the intellect in preference to that of the knight; and in the first year of the twelfth century, the handsome, precocious young student left the schools of the provinces for Paris, attracted there by the teaching of William of Champeaulx. Almost at once he was outstripping his master in

debate; and admiration turned to rivalry when he set up his own schools of philosophy and divinity, first outside Paris, then on the Montagne Sainte-Geneviève; and after a spell away from the city, he took the master's chair, until recently held by William, at Notre-Dame itself.

A canon of the cathedral, Fulbert, had taken into his house his niece Heloïse, a girl who was fired with a zeal for learning remarkable at the time in any woman outside the convent wall. Abelard, already by his mid-thirties a celebrated and controversial scholar but still a complete novice in amorous affairs, resolved to further his education in the latter sphere. With a lack of scruple already evident in the way he had advanced his career, he determined to make the conquest of this paragon of maidens, whose beauty (she was still in her teens) matched her intelligence. Fulbert agreed to give him lodgings in his own house, unwittingly, as Abelard himself confessed, putting the tender lamb at the mercy of the ravening wolf. Initially, then, there was no love on the part of Abelard, merely the cynical will to possess. But from the moment of their first meeting, Heloïse, innocent of such calculations, surrendered her heart to him, eager and entire. She was to be his pupil, but the curriculum was other than Fulbert supposed. In his later confessions to a friend Abelard wrote:

> With study as our pretext, we made ourselves wholly free for love, and our lessons provided the furtive privacy love desired; and so, though our books lay open, more words of love prevailed than of instruction, more kisses than precepts. Hands moved more frequently to breasts than to the books. Love turned our gaze more often into each other's eyes than reading kept it on the text. And sometimes, the better to avoid suspicion, I gave her blows, but of love not anger, of affection not wrath, and sweeter they were than any balm. What more can I say? In our passion we omitted none of the steps lovers take, and if there was anything less usual our love might devise, that too we accomplished. And the less versed we had been in those delights, the more ardently we pursued them, and the less sated we became.

The victor was now in turn love's victim, engrossed in his relationship at the expense of his studies, devoting his energies to the composition of love-songs (now lost, alas) rather than of learned glosses and treatises. Fulbert was slow to realise the nature of a situation all too transparent to others; but in the end disclosure came, and Abelard was summarily expelled from his house and the company of his niece. The parting, he tells us, kindled their passion even more fiercely. But then came a letter from Heloïse joyfully announcing that she was to have a child. Seizing the opportunity offered by Fulbert's absence from home, Abelard carried his mistress off in nun's disguise and saw

II The betrothal of two noble lovers—perhaps the Duke of Berry's granddaughter Bonne and Charles d'Orléans.

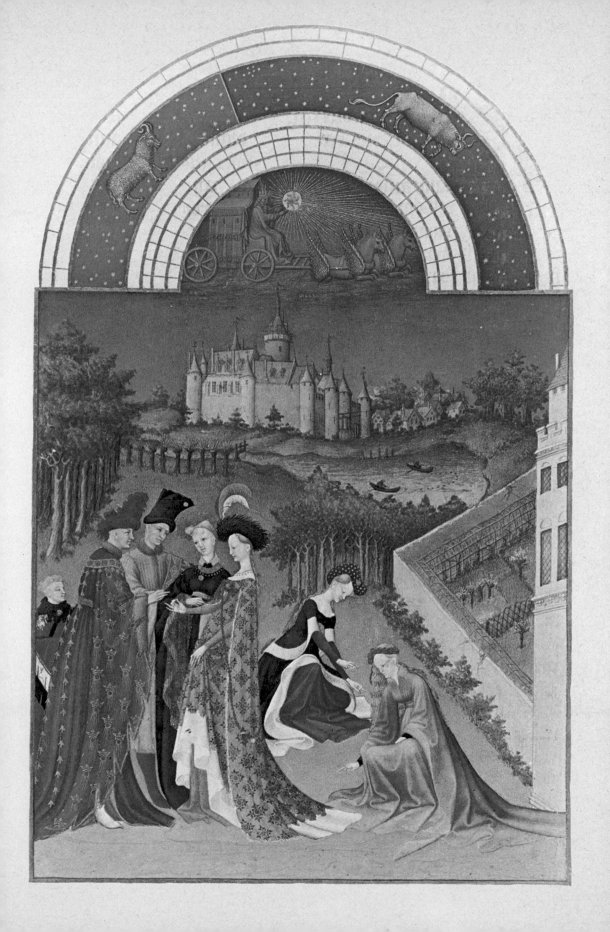

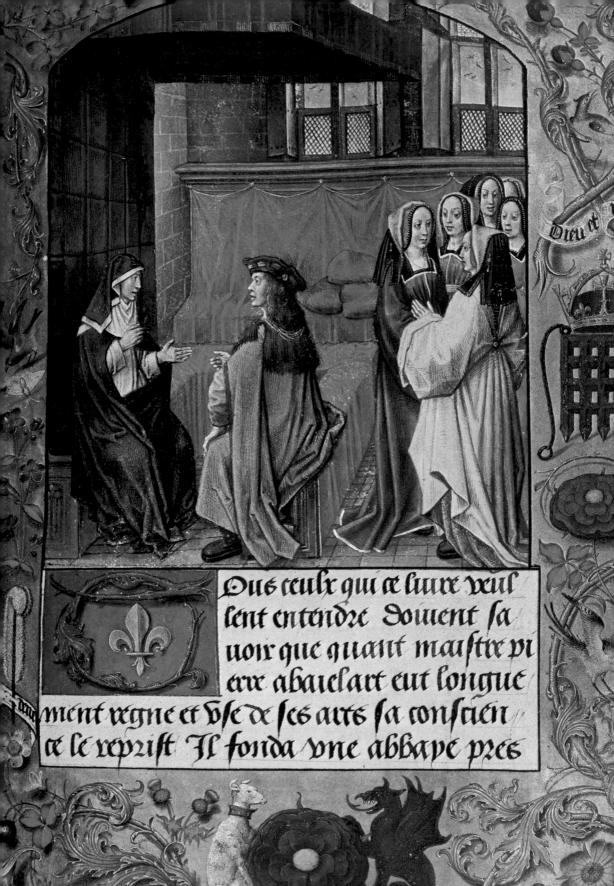

Ous ceulx qui ce liure veul
lent entendre Doiuent sa
uoir que quant maistre pi
erre abaielart eut longue
ment regne et vse de ses arts sa conscien
ce le reprist Il fonda vne abbaye pres

her safely to his own family estate in Brittany. There Peter Astrolabe was born.

The coiled spring of tragedy had begun to unwind, though slowly at first. After a while, Abelard thought fit to visit Fulbert with apologies and offers to make amends. He would, he told him, marry his niece, provided it was done in secret for the safety of his reputation (his clerical status seems to have been no impediment). To this he secured Fulbert's consent; but that of Heloïse was less easily obtained, and then only after many anguished objections and her fearful premonition that, should they marry, 'one certain fate awaits us: we shall both be destroyed, and our grief will be no less than our love was before.'

So the marriage was secretly celebrated before Fulbert and some witnesses. Very soon, however, the matter became public, divulged, according to Abelard, by the canon himself and members of his household. Whatever the truth, Fulbert's treatment of Heloïse grew so harsh that her lover sent her to a convent at Argenteuil, where she presently took the veil. This further incensed Fulbert who, with some of his kinsmen, exacted a last grim punishment on Abelard:

> One night as I lay sound asleep in a private room of my lodgings, having bribed a servant of mine, they took a most cruel and shameful vengeance on me, of which the world learned with the greatest stupefaction, namely they cut off those parts of my body with which I had performed the deed they complained of.

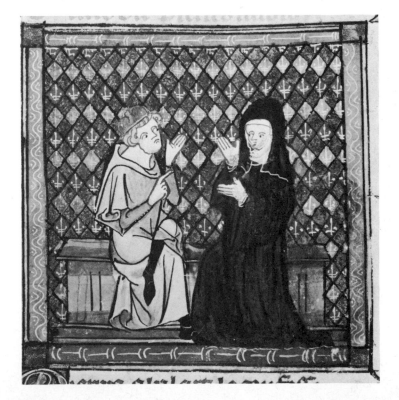

10 Abelard conversing with Heloïse.

III Abelard and Heloïse in the oratory of the Paraclete.

The story of the ill-starred couple does not end there. Abelard returned to his studies and to the renown, controversies and persecutions that had always attended them. He founded and sought refuge in an oratory in the Champagne countryside dedicated to the Holy Spirit, or Paraclete 'the Comforter'. His comfort and refuge were only temporary; but in due course he was to instal there his beloved Heloïse at the head of a small band of nuns, returning to live for a while in their company before slanderous gossip uprooted him once more. This new parting was the signal for a moving correspondence between the lovers in which Abelard plays the role of spiritual director, while Heloïse's letters still glow with a passion refined, perhaps, but not subdued. Hear in these extracts how she opened the exchange:

> The letter you sent to a friend for his consolation, my beloved, has recently been passed to me. Recognising at once from the very first line of the heading that it was from you, I began to read it with an eagerness matching the affection in which I hold the writer, so that, now I have lost his person, my spirits might as it were be restored by at least some reflection of him in his words. Almost everything in that letter was, I remember, full of wormwood and gall, telling as it did the wretched story of our conversion and your own ceaseless sufferings, my incomparable one. . . . What excellence of mind and body did not adorn your youth? What woman who envied me in those days is not now driven to pity by my misfortune, seeing me deprived of such delights? What man or woman is there who, even if originally my enemy, is not touched by a just compassion for me? Though I have committed much wrong, I am, as you know, very innocent; for the crime lies not in the act but in the intention behind it, and the test of justice is not in what is done, but in the spirit in which it is done. But you alone are capable of assessing what were my constant feelings towards you. I leave everything to your verdict and rely in all matters on your judgment.
>
> Tell me one thing, if you can: why, after our conversion, which you alone decreed, I have been so neglected and forgotten by you that I am not cheered by having you to speak with here, or comforted by letters in your absence. Tell me, I say, if you can; or I will say what I for my part feel and what the general suspicion is. It was carnal longing that bound you to me more than affection, and the heat of lust more than love, so that once your desires ceased, along with them disappeared the outward show they inspired. This, my beloved, is not my assumption but that of everybody, not my particular belief but the common one, not so much a private opinion as that of people in general.

Abelard's visits to the Paraclete became infrequent; and his later years were

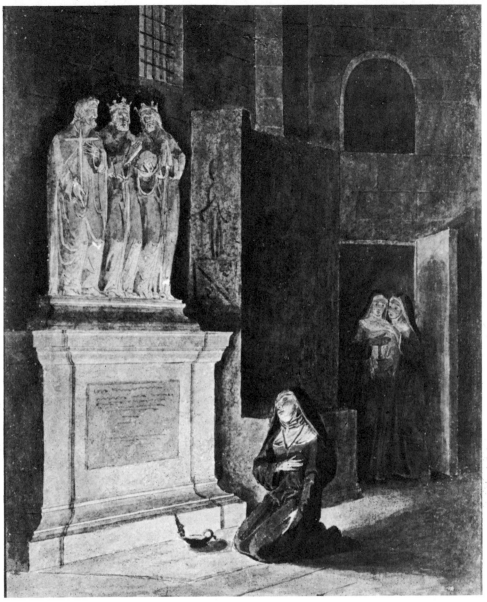

11 The tomb of Heloïse and Abelard in the Paraclete, drawn shortly before its destruction in the French Revolution.

still plagued by doctrinal controversy, even papal condemnation. But he ended his life in peace in a small Burgundian priory. That was in 1142. His body was soon brought to the Paraclete for reburial; and there too Heloïse, having survived him for over twenty years, was laid to rest, beside him. In 1800 their remains were brought to Paris, and today they lie together in a single tomb in the cemetery of Père-Lachaise.

Ahead of his time Peter Abelard may have been in some aspects of his thought; but as a lover he had his back to the new age at whose dawning he stood. For he still represents the possessive, predatory male of those earlier centuries. He did not bring his heart as an offering to Heloïse as she had surrendered hers to him. Painfully he had had to discover his own love, through her and through adversity, after his first callous conquest. The lover in the new mould would behave very differently.

Chapter II

The Singers
of Courtly
Love

In the early Middle Ages love had not always shown its face freely and openly. But the year 1100, which had been a turning point in the life of Peter Abelard, can also serve as a convenient, if approximate, pivotal date in our story of its public display. Whereas before that time affairs of the heart must have been the fevered concern of countless individuals, society as a whole had looked askance at the pursuit of love for its own sweet sake. We have seen how for the Church it had been deeply tainted with sin, while for the warrior knight it had been a frivolous distraction from his feudal duties— and however the ladies felt about it, their views were of small account.

Quite suddenly a profound change came about among the upper classes. Perhaps because times were more settled, and greater leisure bred reflection, people seem to have devoted more attention than before to the quality of their home life. Pleasure was found in a well-groomed social existence; and the gradual refinement of manners brought with it an appreciation of the contribution made by women, an appreciation in fact of women themselves. And from there it was a short step to the realisation that the love of women can be a precious and life-enhancing experience, something to be appreciated and savoured like good wine, not gulped down to slake a moment's thirst or laid aside under the seal of marriage for everyday domestic use. Thus the commerce of the sexes came to be taken seriously as a vital ingredient in courtly life and in 'courtliness', the art of living that life elegantly and with consideration for others. It was quickly to discover its own code of behaviour and eventually, in the more sophisticated circles, achieved the status of a kind of lay religion. This is the phenomenon to which scholars have applied the extremely flexible name of 'courtly love'. Its first exponents were the Provençal troubadours.

It has long been assumed that this new cult was not created from the void; but the academic argument over its origins has swayed now this way, now that. Sociological explanations have been hazarded: the preponderance in the courts of lusty young knights over marriageable women, which encouraged them to look for satisfaction above their station (the courtly suitor was very often of lower rank than the lady); the accessibility of noble wives during their husbands' absence on crusades or other business; the sublimation, through an amorous posture towards the lady of a castle, of the poorer knights' social rather than sexual ambitions; the relatively free, 'permissive' conditions and advanced culture among the nobility of Provence, where courtly love seems first to have blossomed; the insidious influence of certain heretical movements. Or does Latin literature hold the key? The influence of Ovid, already mentioned, or of Plato through his medieval commentators and influence on Christian mysticism and the concept

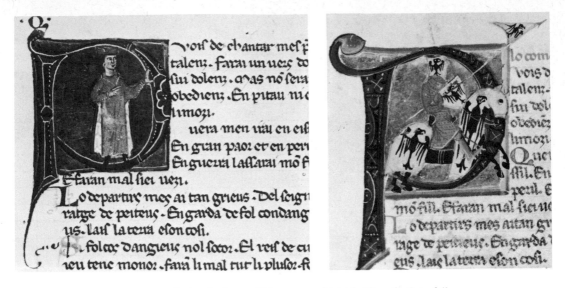

12, 13 Guillaume de Poitiers at the head of one of his songs and (*right*) riding forth in full array.

of divine love (as in St Bernard's commentary on the *Song of Songs*)? Reminiscences of later Latin court poetry, or of the anonymous 'wandering scholars', who were indulging their fancies in erotic verse as well as in drinking songs long before 1100? A formal and thematic influence on the new love-lyrics of Gregorian chant and Latin hymns, especially those increasingly composed in praise of the Virgin? Could there even be some Celtic influence lurking in the background, or a tradition of popular folk song, now past recapture? And what of the theory of Arabic origins?

Already by the ninth century there had been elaborated in far-off Baghdad a refined concept of love as an ennobling passion, in whose service a man might exhaust a lifetime's aspirations and, if need be, find death without dishonour. This ardent, yet largely chaste, eroticism soon found expression in Arabic texts composed in the south of Spain and sometimes carrying possible undertones of pre-Moorish influence. As well as some formal elements, certain motifs appear that will recur in the poetry of the troubadours: love at first sight or even induced by a mere description of the lady; the secrecy that fears the intervention of guardians, jealous rivals or public gossips; the merit of a humbly submissive attitude in the lover. Such notions and the songs that carried them could well have found their way north across the Pyrenees into the courts of Provence. For southern nobles had campaigned in Spain long before they answered the call to crusade against the infidel in the Holy Land; and from Spain they are known to have brought back captive Moslem girls and a taste for the lute, whose very name is Arabic. The case is as appealing as it may seem exotic. But to seek a single point of origin for courtly love is surely wrong: it came into existence to

satisfy a profound need which, like a vacuum, drew in matter from all directions.

Significantly, though, the first known troubadour was a man of the south with Spanish connections. Guillaume, seventh Count of Poitiers and ninth Duke of Aquitaine, led an eventful and, judging from his few extant poems, gay life, warring against his neighbours, taking part in a disastrous expedition to the Holy Land in the wake of the Crusaders, more than once suffering excommunication and, despite a wife acquired in Spain (not herself a native of the Peninsula), voraciously womanising while bearing on his shield the portrait of one of his many mistresses. He died in 1127 but, if we are to believe his medieval biographer, only after long practice in deceiving the weaker sex.

Guillaume's feet were planted firmly in the age of the predatory male, although his eyes sometimes looked ahead. In one of his songs (and troubadour poems were sung, with words and music often by the same hand) he asks his companions' advice in choosing between two mounts, which in the end turn out to be two fair ladies. Another begins idyllically enough with an evocation of the sweet freshness of spring that turns his thoughts to his lady. Then:

> I still remember one morning when we called a truce to our war, and she gave me so great a gift: her love and her ring. God grant I live long enough to get my hands under her cloak!

Guillaume may not here be at his most explicit, but his intentions are unmistakeable. Yet in other poems he is already trying on the mantle and the meek, melancholy expression of the courtly lover:

> I must say naught but good of love. Why, though, do I not have the smallest part of it? Perhaps it is not right for me to get more; and yet it freely grants great joy to those who keep its rules.

And elsewhere:

> I shall compose a new ditty before the onset of wind, frost or rain. My lady is trying me out and putting me to the test to discover the nature and quality of my love for her. However she may take me to task, I shall never seek release from her bondage. Instead I yield and make myself over to her, so she may inscribe me in her charter.

Here, then, is the first of our noble lovers, caught for once with the leer off his face. If, as some have thought, he invented the new courtly mode almost single-handed, his heart seems not fully in it. But a beginning had been made; and for centuries to come his successors in northern France as well as Provence gave allegiance to those rules of love of which he spoke. The fashion soon spread to other lands; and notably in Germany the poets took to celebrating their ladies in the courtly style.

Let us then look at some of the more important 'rules' as they acquire form and authority in the verse of these singing poets, whose ranks contain high nobles as well as more lowly entertainers. The whole process is as remarkable as it is complex, with emotion, art, social proprieties, ideals and realities all having their claims to stake. What has emerged is a splendid but delicate compromise, in which the fewest concessions have been made by art. And once in being, this new vision of courtly love became itself an active force that was to bear upon life as well as fiction.

The first requirement of the new lover suddenly smitten is that he leave behind his male arrogance and place himself humbly in his lady's service. No longer is she the passive prey to his desires, but an ideal to which he must aspire from below, the focus of his every thought and energy. Hear how Bernard de Ventadour, one of the greatest and most admired of the troubadours, expresses his own situation. (Bernard's life is obscure, but he does appear to have been received at the court of Eleanor of Aquitaine, granddaughter of the first troubadour and Queen of England from 1154.)

> When I see the lark fluttering its wings for joy in the sun's beam then falling back, entranced by the sweetness that enters its heart, ah, I am so sorely envious of all I see rejoicing that I wonder my heart does not straightway melt with desire.
>
> Alas, so much I thought I knew of love, yet know so little! For I cannot help loving her from whom no benefit will ever come to me. She has plucked from me my heart and my being, herself and the whole world; and taking herself from me, she left me nothing but deep longing and desire.
>
> Control and possession of myself I lost the instant she let me look into her eyes, a mirror full of delight for me. Mirror, since I reflected myself in you, sighs rising from the depths have slain me, and I have lost myself like fair Narcissus in the fountain.

14 Bernard de Ventadour, as he is shown in a French song-book.

The highest in the land are not immune to woman's beauty, itself the reflection of her moral and spiritual perfection, as we see from the reaction of the northern *trouvère* Thibaut, Count of Champagne and King of Navarre, when he sings of his lady's qualities:

> Thoughts fail me when, in my astonishment, I wonder where God came upon such uncommon beauty. His was a great and gracious act towards us to set her here below among mankind. He has through her illumined the whole world, for in her worth every excellence is contained: this much you would learn from all who have seen her.

The ideal love should not, however, be one-sided, as Bernard de Ventadour declares;

> The love of two noble lovers lies in pleasures and wishes shared. No profit can it hold unless the will is mutual.

Its elevating quality is suggested by Marcabrun, one of the earliest troubadours:

> Moderation is in fair speech, and courtliness in loving. Let him who wishes to avoid contempt beware of all baseness, mockery and folly; if he pays heed to this, he will be wise. For thus may a man hold to wisdom and a worthy lady increase in merit.

The highest aspiration of the courtly lover is to attain the state expressed by the poets in the word 'joy', usually denoting a blissful exaltation of the spirit rather than the fruit of physical satisfaction:

> When the young grass and the leaf appear, and the blossom buds on the bough, and the nightingale raises its voice high and clear to begin its song, then I take joy in him and joy in the flower, joy in myself, and in my lady most of all. On every side I am girdled and enclosed by joy, but by that joy that triumphs over every other joy.

<div align="right">(Bernard de Ventadour)</div>

But though this joy beckons, it is elusive; and a lady's haughty or fickle conduct sets a melancholy key for many lyrics, if not most. Here is the German poet, Heinrich von Morungen, in one of the more sombre of his moods:

> She is my heart's one joy, crown of all ladies I have ever seen; fair, fairer still, fair above all the fairest is she, my lady, as I must avow. The whole world, by her beauty, should lay this plea before her: 'Now it is high time, lady, that you grant him his reward, or else it would be folly for him to praise you.'

15 The 13th-century poet Konrad von Altstetten, falcon on wrist, enjoys the love of his mistress beneath a flowering rose bush.

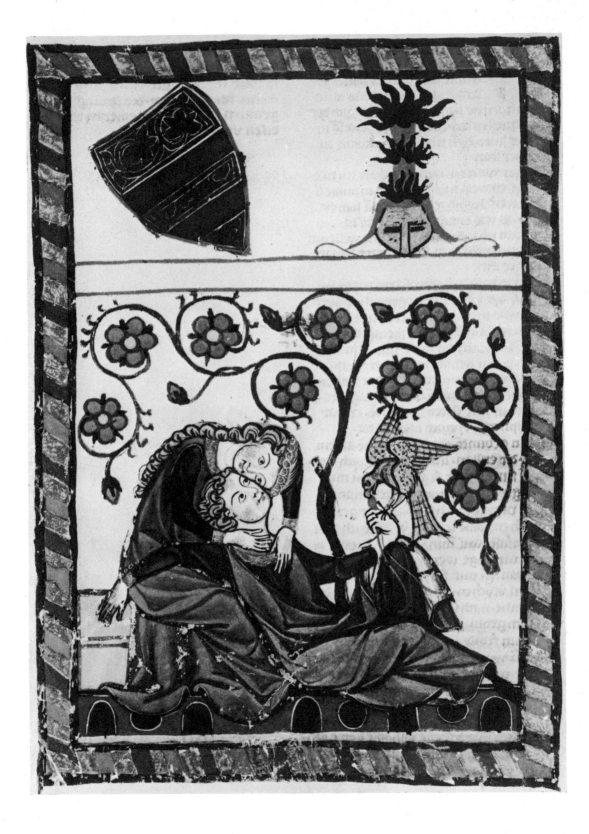

When I stand before her and gaze upon the miracle God has worked in the beauty of her person, so overwhelmed am I to be there alone with her that I would gladly stand there for ever. But then, alas, I must go away in deep dejection; and so dark a cloud comes between us that her radiance is quite shut off from me.

A poet's luck, though, may always turn; and here is one of those happier moments caught by Blondel de Nesle, the *trouvère* from the north who, according to legend, secured the release of King Richard Lion-Heart from his capitivity:

I cannot but sing, for I have found again the joy that has been fleeing and escaping me. Many are the days that have cost me grief and anguish; but now is the time to leave all that behind, since the fair one I have long loved, but who has been challenging my love for her, has newly come to terms with me. Now she will be prepared to grant and bestow on me her noble love, for which I have yearned so long, brooding by day on its account and lying awake by night.

Ah, God of Love, how great is your dominion! You have the power to slay lovers or to save them, giving death to one and life to others, making one man languish, another laugh and sport. Me you have slain and now brought back to life, and I must worship you above everything; for you have made her my friend who was my enemy, and for

16 A lady offers her heart to her suitor—and a lover tempts a lady with the offer of a purse.

this I owe you great love. Now I shall sing your praises all my life, your willing servant, glad to honour you.

There is much talk of love-service in these poems, and one Provençal text mentions specific stages through which the toiling lover must pass in his quest for his lady. First he is the aspirant to her favours, silently adoring from afar. After a while, emboldened by his passion, he will become a suppliant, somehow acquainting her with his ambitions. If fortune and the lady favour him, he may then become her recognised suitor. The ultimate success will be his when he is taken as an accepted lover; but this is a triumph rarely treated in song, on the principle perhaps that passion fulfilled makes dull poetry.

Our courtly lover, then, enlists in his lady's service, binding himself in all honour to carry out her least command, and pledging his unswerving loyalty, even to the death. In return he is entitled to expect his beloved not to let her eyes wander elsewhere. It was an expectation all too liable to be deceived, as many poems testify. Their authors, admittedly, were mostly men (one or two women did compose), so the lady's point of view is seldom heard. As petitioner, though, the man was always open to disappointment, subject to the lady's indifference or, if not that, at least to the stern tests she might impose, tests that he was in no position himself to set. The astonishing reversal of roles brought about by courtly love (and that quite early in the

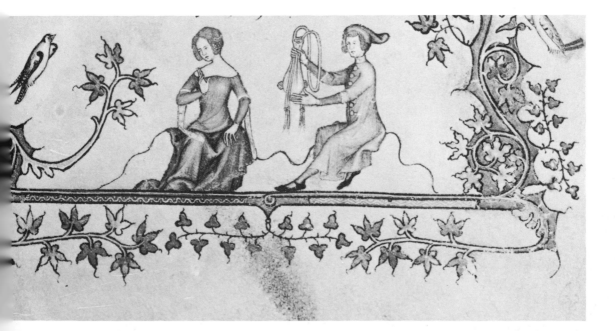

twelfth century) is now apparent. The amorous relationship has taken on the outward form of the feudal pact between lord and vassal; but now the lady has become the lord, a fact strikingly illustrated by the troubadour practice of transferring to her the masculine form of address (*midons*, 'my lord'). The love-service is an amorous vassalage that can be solemnly entered into by the lover ritually placing his hands between the lady's and giving the pledge of

17 Lovers embroidered on a 13th-century French purse; the woodpecker symbolises the devil.

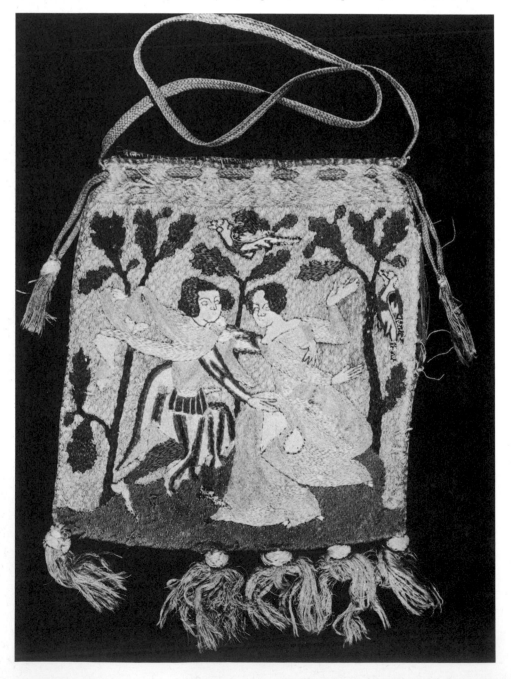

fealty. A legalistic air often touches the verse, in which the terminology of the feudal compact abounds:

> Worthy lady, I ask you only to take me as your servant, for I will serve you as my good lord, whatever wages may come to me. Behold me at your command, O noble, courtly one, modest and gay! You are no bear or lion to kill me if I give myself into your charge.

<div align="right">(Bernard de Ventadour)</div>

18 The noble 13th-century poet Schenke von Limburg pays homage to his lady who gives him his helmet before he leaves on campaign. The 'A' on his tunic stands for 'Amor'.

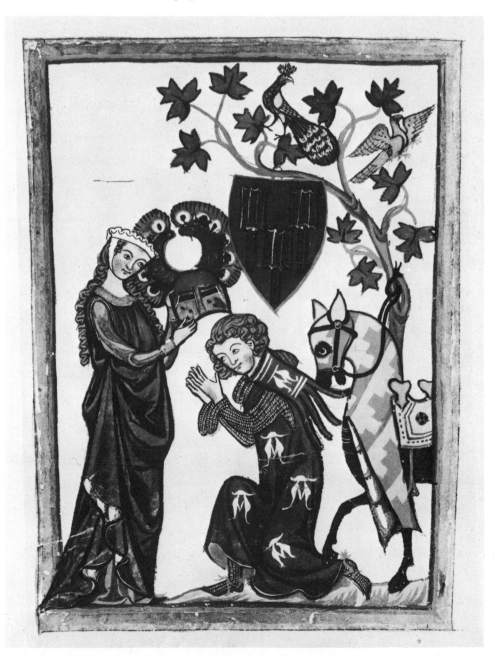

The lady's identity is often masked by a pseudonym, in accordance with another of the conventions (and a strict one): the rule of secrecy. It was held that love disclosed was true love no longer; moreover to make it public was to expose it to the sinister interpretations or designs of others. Even Guillaume de Poitiers affected caution:

> If my lady is willing to grant me her love, I am ready to receive it with gratitude, to keep it secret and cosset it, to say and do what pleases her, cherish her great worth and advance her praise.

At most each lover might have a single confidant, like the companion in a song by Guiraut de Bornelh who, having kept watch all night beneath the window of the room where his friend lies in his beloved's arms, calls ever more urgently to him as daylight approaches. In the last stanza comes the friend's response:

> 'Fair, gentle companion, so richly am I lodged that I wish dawn or day might never appear; for I hold in my embrace the noblest lady ever born of mother; therefore I rate both the jealous fool and the dawn of small account.'

Why so furtive an attitude to relationships whose noble character is continually proclaimed? Is there here some influence from the Arabic literature I mentioned? Did the poets wish to steer clear of trouble in the close-knit society of the courts? Or were they trying to hide the fact that their verses were just general variations on a popular theme, their passions fictitious and their ladies pure abstractions? Or, and this is the usual assumption, was secrecy the dark cloak of adultery? There is no need to see all the poetry of courtly love as necessarily addressed to married women, though some of it undoubtedly was; and the frequent allusions to gossips, slanderers, jealous folk and sometimes husbands do give an illicit tang to many of the poems. Here, for instance, is the conclusion of a dawn song, perhaps by Gace Brulé, a knight of Champagne; and this time it is put into the mouth of the lady herself:

> 'Now I beg all true lovers to go singing this song just to spite slanderers and wicked, jealous husbands. Now I hate nothing so much as day that parts me, my love, from you.'

Yet despite the repeated hints of scandal, the poets are not given to betraying any feelings of guilt. On the contrary, they are often heard devoutly appealing to God for aid and protection in the furtherance of their love, evidently cherishing the belief that God is the friend of lovers. Sometimes whole poems are suffused with pious vocabulary and sentiment to the point where one wonders whether it is an earthly love they sing, or whether their subject is the mystical pursuit of God or praise of the Virgin Mary.

IV The German poet Heinrich von Morungen dreams his lady is standing beside him. His left hand holds a scroll representing his poem that tells of the dream's fleeting joy.

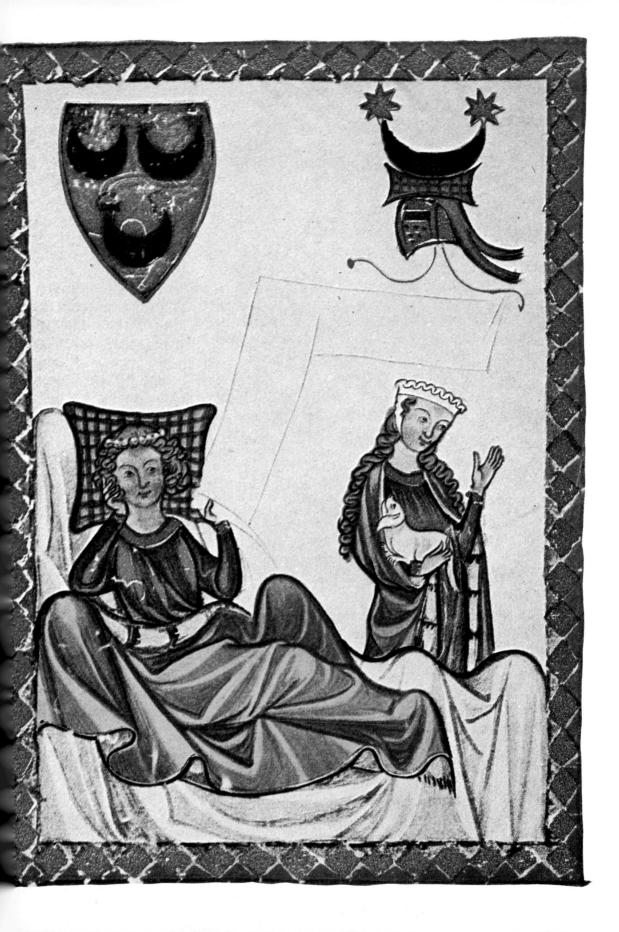

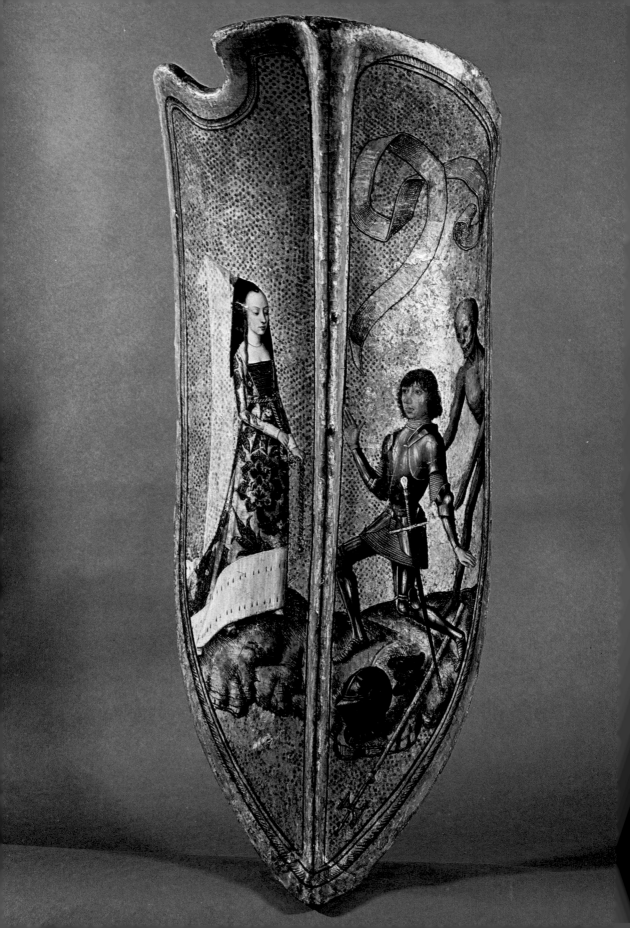

One of the most elusive, and influential, of all troubadour songs was composed by Jaufré Rudel towards the middle of the twelfth century. In it he celebrates *un amor de lonh*, a distant passion, love in absence:

> When the days are long in May, I take pleasure in hearing sweet bird-song from afar; and having turned from that, I call to mind a distant love. I go about so pining and cast down that neither song nor hawthorn blossom mean more to me than winter's frost.
>
> The true lord in my eyes is he through whom I shall see that distant love; but for every benefit I reap from it I have two ills, so far away am I. Ah! would that I were a pilgrim there, so that her lovely eyes might light upon my staff and cloak.
>
> I shall know true joy when I ask her, for the love of God, for that distant lodging; and if it pleases her, I shall dwell close to her, though I come from afar. What noble discourse there is then, when the lover from far away is now so near that he may enjoy his courtly solace.
>
> I shall depart in grief and sorrow, if I do not see that distant love. But I shall see her, though I know not when, for our lands are so far apart. The roads and ways are many, so I am not kept away from her. But may it all be as God pleases.
>
> Never shall I find joy in love unless I enjoy that distant love, for none better or more noble than she do I know in any place, near or far. Of such supremely precious worth is she that for her I would fain be called a captive in the Saracens' kingdom.

19 Jaufré Rudel rides to seek his distant love, the subject of the accompanying song.

V A lover dedicates himself to his lady. The scroll says 'You or Death': Death stands behind him.

> May God, who created all that comes and goes and fashioned that distant love, grant me the power, for I am in good heart, truly to see that love where it is fitting; and then the chamber and the garden would always seem a palace in my sight.
>
> He speaks the truth who says I go craving and longing for a distant love; for I take pleasure in no other joy so much as in this rejoicing for a distant love. But I am so frustrated in my desire since my godfather wished this fate on me: that I should love and be not loved.
>
> But I am so frustrated in my desire that I call down a curse on this godfather who fated me to be unloved.

What was this mysterious love, of which Jaufré sings so hauntingly? A real lady, or a phantom of his dreams? Could it be a vision of the Virgin herself or of Jerusalem, or a glimpse of the divine essence, netted in words? All this has been proposed at one time or another. But the Middle Ages, always anxious to reduce the unknown to the known, produced another solution in the form of a fictitious biography of the troubadour, which has fixed his name in legend as one of the great tragic lovers:

> Jaufré Rudel of Blaye was a most noble man and prince of Blaye. And he fell in love with the countess of Tripoli, without having seen her, for the good report he had of her from the pilgrims returned from Antioch; and for her he composed many a song with a fine melody and simple words. And desirous of seeing her, he took the cross and embarked on the sea. And on the ship he fell ill and, seeming dead, was borne to a hostelry in Tripoli. And this was made known to the countess, who came to the bed where he lay and took him in her arms. And he knew that she was the countess and, recovering his hearing and his sense of smell, praised God for having sustained his life long enough for him to see her. And thus he died in her arms. And she had him buried with great honour in the Templars' house and then, that very day, became a nun because of the grief she felt for his death.

This simple tale and the poem that inspired it illustrate much that is best in courtly love: the delicacy and idealism of its sentiments, its ultimate nobility.

Having looked now at some of its main features, we may develop our reflections a little. I have suggested that to gain public respectability, the cult of love had two potentially hostile forces to contend with: the attitude of the Church, and the warrior mentality. We have seen how subtly it overcame the latter threat, namely by modelling the amorous on the feudal relationship and by enlisting in the service of love all the knight's instinctive virtues: the loyal and unquestioning service of his superior, whose interests and

20 Jaufré Rudel dies in
the arms of the Countess
of Tripoli.

honour he protects at all times, courage in adversity, and the unswerving
pursuit of merit and personal integrity. As for the other obstacle, although
men trained for an ecclesiastical career and even monks are found in the ranks
of the troubadours, it was never likely that the Church would soften in its
attitude towards love between the sexes, and indeed it never did. Yet for all
the amorality and even the adulterous associations of courtly love, one may
detect some shadow of a compromise: love purged of its more crudely
sensual aspects, the chaste melancholy of so many of its devotees, the almost
mystical language of adoration and the frequent invocation by the lovers of
divine support. There was of course no narrowing of the gap between
sacred and profane love, but across it there had been thrown a flimsy bridge
that enabled churchmen to couch some of their own verse in courtly
phraseology.

If courtly love is, as I have suggested, a magnificent compromise, it is also
to some extent a compromise with reality. I would not deny that individual
poets on certain occasions would turn their hearts' true yearnings into

polished verse, or that passion may be created through the act of expressing it. But it is hard not to suspect these artful singers of having gone far in the reduction of love to a gallant fiction, with all its conventional situations, mistresses of matchless yet matching perfection, and its lack of explicitness under the plea of secrecy. By concealing their lady's identity the poets have generalised their love so that any woman may have a share in its flattery. To this extent it may be seen as something of a courtly game played in the abstract, less a declaration of passion experienced than the artificial evocation of emotions, and only on this level to be taken seriously.

By the thirteenth century some of the troubadours' poetic fictions came home to roost when aspiring biographers extracted them from their songs, added what scraps of fact they could come by and, as we have seen in the case of Jaufré Rudel, presented them in brief, naïve terms as the life-history of the poet in question. More serious (yet how serious?) were certain attempts to codify the rules of love. Of these the first, and by far the most interesting, is a curious Latin treatise on the *Art of Loving* by the otherwise unknown Andreas Capellanus (Andrew the Chaplain).

Andreas probably composed his work at the court of Champagne, where culture and sophistication went hand in hand, some time in the 1180s and perhaps under the influence of the countess Marie, daughter of Eleanor of Aquitaine and hence great-granddaughter of the first troubadour. In the course of his treatise Andreas describes the nature and conventions of love, and of courtly love in particular, considers certain problems and reports judgments on them rendered by various noble ladies, including Eleanor and Marie. He further lays down a number of precepts and rules of love before, in his third and final section, standing his whole edifice on its head and roundly condemning profane in favour of Christian love, with marriage as its proper end. Was the whole exercise performed tongue-in-cheek? Did he wish his readers to carry away the lesson that courtly love is after all no more than an elegant, delightful social diversion, and to be treated as such? Here, anyway, are his thirty-one Rules of Love, and we may take them how we choose:

1. The pretext of marriage is no proper excuse against love.
2. No one who is not jealous can love.
3. No one can have two loves at once.
4. Love is always growing or diminishing.
5. There is no savour in anything obtained by the lover against the beloved's will.
6. It is not customary for a man to love before puberty.
7. It is right that the lover should remain unmarried for two years after the death of the beloved.

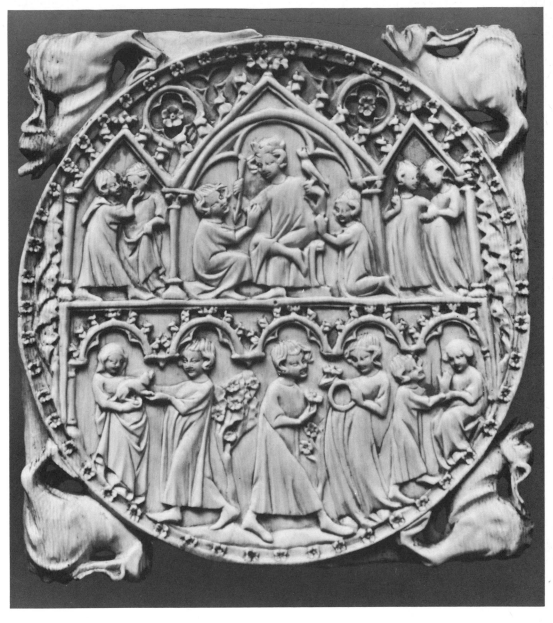

21 Scenes of gallantry on a 13th-century French ivory mirror case.

8. No one should be deprived of his love without very good reason.
9. No one can love unless driven on by the prospect of love.
10. Love is always banished from the home of avarice.
11. It is not right to love women whom one would be ashamed to take to wife.
12. The true lover desires no embraces from any other than the beloved.
13. A love divulged rarely lasts.
14. An easy conquest makes love worthless, a difficult one gives it value.
15. Every lover grows pale at the sight of the beloved.
16. At the sudden sight of the beloved the lover's heart quakes.
17. A new love drives out the old.
18. Honesty alone makes a person worthy of love.
19. If love grows less, its decline is swift, and it seldom recovers.
20. A man in love is always fearful.
21. True jealousy always increases love's ardour.
22. A suspicion concerning the beloved increases jealousy and love's ardour.
23. A man perturbed by thoughts of love sleeps and eats the less.
24. The beloved's every act ends in the thoughts of the lover.
25. The true lover esteems nothing good except what he thinks will please the beloved.
26. Love can deny nothing to love.
27. The lover cannot be sated with the solace of the beloved.
28. A slight presumption forces the lover to suspect the worst of the beloved.
29. He who is fired by too much lust is not likely to love.
30. The true lover is at all times continually absorbed in imagining the beloved.
31. Nothing prevents a woman from being loved by two men or a man by two women.

We may wonder how much these rules were taken to heart and how far courtly love was truly practised. But there is no doubt that, whatever its fictional trappings, it came to be a real force in society and had a refining influence on the attitude of man to woman. And whether a cause or a product of the move towards female emancipation in the twelfth-century courts, or more likely a little of each, it brought a bright polish to both literature and life.

Chapter III

Lancelot:
Courtly
Lover

There is abundant evidence that courtly love provided themes for debate as well as song. Andreas Capellanus reports a number of such debates; and it has been claimed that there even existed so-called 'courts of love', held, as occasion demanded, by noble lords and, more especially, ladies for the settling of disputes arising out of points in the amorous code. Andreas tells us at one point how Marie de Champagne was asked for a ruling on two matters: whether true love can exist within marriage, and whether jealousy between lovers is to be approved. Her reply was unequivocal: true love between man and wife is impossible, not least because it is stipulated in one of love's rules that he who is not jealous cannot love, and the requisite jealousy is not to be found within marriage. She further maintained that a wife could only obtain the God of Love's reward by serving him outside the bonds of wedlock. Marie, it seems, was for adultery.

Chrétien de Troyes, the greatest French writer of romance, was, to judge from his works as a whole, against adultery and for marriage, which he appears to have regarded as the natural and proper objective of two noble lovers. One presumes that his was an attitude more in tune with the orthodox conscience of the time. Still, even allowing for an excess of professional zeal among the contemporary moralists, we must take some notice of the gaudy picture they paint of the slide of aristocratic society into permissive ways, with extravagance in dress matching that in sexual pursuits, and with the young bloods attending church, if at all, only to ogle the girls. But to assume that adultery was universally approved by the upper classes, let alone recommended, would be absurd; and maybe Marie herself was only making a theoretical debating point.

The subject did, however, interest her; and at about the same time as she delivered her judgement (1174) she asked Chrétien, who may well have frequented her court at Troyes, to compose a romance about Lancelot's pursuit of Queen Guenevere. This Chrétien agreed to do; but it seems to have gone rather against the grain, if we can assume this from the fact that he left the work for a colleague to complete. He informs us in his prologue that Marie furnished him with the matter of the story. In what form? He does not say; but it was probably some rough and ready account, derived from Celtic legend, of the abduction of King Arthur's wife by a mysterious Otherworld figure (an early Welsh saint's life mentions such an event). Now Chrétien took pride in clothing shabby, out-of-date tales in new finery of contemporary cut; so he had the idea, very possibly on Marie's prompting, of turning this old myth into a demonstration of courtly love in action.

All was consternation in King Arthur's court at Camelot. An armed knight

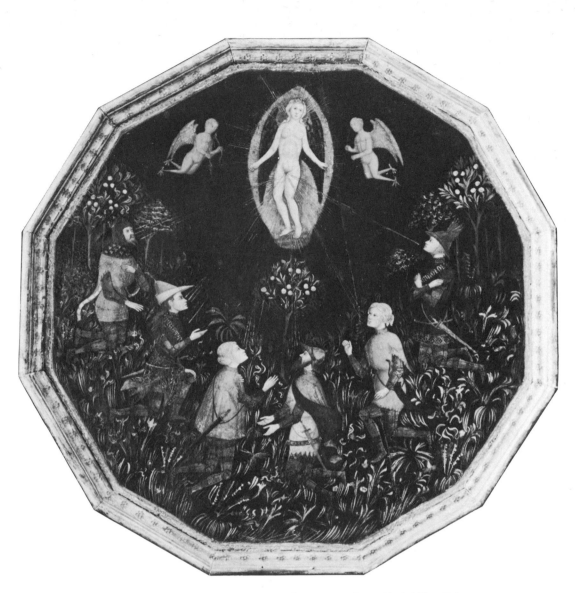

22 Lancelot (third from the left) appears as a devotee of Venus together with Achilles, Tristan, Samson, Paris and Troilus on a North Italian tray (*c.* 1400).

had just burst in without ceremony and proclaimed that he held many of the King's subjects captive and without any hope of rescue — unless, he added as an afterthought, there was anyone at court prepared to follow him into the forest with the Queen and there defend her in combat, the victor to have both Queen and captives. Arthur permitted the adventure to be claimed by Kay his seneschal, for whom he seemed to show more concern than for his wife. So Guenevere was led away without more ado, whispering a regret that a certain person she did not name was not present to prevent it.

She was not alone in her anxiety; for Sir Gawain, Arthur's nephew and the very paragon of chivalry, had his own doubts about Kay's ability to undertake the task and decided to ride off in pursuit. But too late: in the forest he came upon the signs of a violent struggle and Kay's horse running loose. Then a little further on he overtook an unknown knight whose own steed was almost dead from exhaustion. Fortunately Gawain had a spare one; and he gladly gave it to the stranger, who galloped frantically away. Following at a more leisurely pace, Gawain soon found this second mount lying dead among more traces of furious combat; and there ahead was the stranger, now walking beside a cart of the kind normally reserved for criminals. In those days people would cross themselves at the sight of such tumbrils and call on God for protection; but not this knight. He at once hailed the dwarf who was driving it and asked if he had any news of his lady, the Queen; for this, as we learn only much later, was Lancelot, the lover for whom Guenevere had heaved her sighs as she was led from the court. The dwarf promised him news on the morrow, provided he would mount the cart. Torn between love and his better judgement, Lancelot hesitated for just two paces, then climbed aboard, while Gawain rode behind.

Evening brought them to a castle where, despite the inhabitants' derision of Lancelot perched on his cart of shame, the charming mistress of the place gave both knights lodging. In the small hours a blazing lance flew down at the hero, grazing his side and setting fire to the bed where he lay. An alarming experience; but with surprising calm, Lancelot doused the flames, lay down again, and slept soundly until morning. After hearing Mass, he was sitting pensively by a window, when he caught sight of a distant procession: a tall figure leading a lady on horseback, and a wounded knight on a bier with three weeping damsels in attendance. As it disappeared from sight, Lancelot, knowing the lady to be the Queen, would have dashed himself from the window but for Gawain's restraining hand.

Given a fresh steed, Lancelot left with his companion; but ride as they might, they could not catch up with the procession. Instead, at a crossroads, they encountered a maiden with some useful information: Guenevere's abductor was Meleagant, son of Bademagus King of Gorre, a land from which no stranger returns. There were, she said, two roads leading to that country: one by way of an underwater bridge, the other by a sword bridge, even more perilous. Offered the choice, Gawain (unexpectedly in view of his reputation) opted for the first route; so Lancelot was left to follow the other one on his own.

(I need hardly point out that this is a very strange romance, packed with preposterous adventures reported by Chrétien without his usual care for

coherence and psychological plausibility. More curious still, Lancelot is beginning to take on the stature of a hero pursuing a single-minded quest into some Otherworld. We think, perhaps, of Orpheus, Hercules, St Paul, or even . . . But no, not quite yet. On the other hand, there are at the same time touches of real humour, some of which may glimmer through a summary even as bald as mine. Already, then, we are beginning to ask ourselves just what Chrétien is up to.)

On his way to the sword bridge, Lancelot was deep in his thoughts of the Queen when he failed to hear the challenge of the guardian of a ford. Only when he was knocked into its chilly waters did he come to and set about his assailant. His next adventure was in the nature of a fidelity test; for he was offered hospitality by another beautiful chatelaine on the sole condition that he sleep with her that night. He agreed, but oh how reluctantly. Before the testing moment arrived he rescued, as he thought, his hostess from imminent rape, only to find her coolly dismissing the aggressors. Then, when it was time to retire, he undressed with desperate embarrassment and lay like a monk, thinking solely of the Queen. His fair bedmate at length tactfully retired, recognising that he must have some weighty mission on hand. In the morning she went with him on his way until they came to a fountain, beside which lay an ivory comb with some strands of golden hair. When the damsel identified it as Guenevere's property, Lancelot almost swooned with emotion before tenderly removing the hairs and placing them beneath his shirt, against his heart. Next, in the course of a protracted encounter with a young knight who wished to abduct the damsel, he gave sure proof of his quality and, for us, more food for thought. For in a cemetery he raised the slab of a tomb, on which an inscription stated that whoever could perform the feat was destined to release all the captives from that land whence none may freely return. The damsel, having failed to elicit this champion's name, went her own way.

It appears that by now Lancelot had crossed the boundaries of the realm of Gorre, since he met some of the prisoners (who moved freely enough about the land) and with them fought a skirmish against their captors. After more hospitality and the slaying of a knight, for which a further damsel promised him future reward, he found himself at the sword bridge, flung across a raging torrent. The bridge itself was forbidding enough, but even the added sight of two lions on the far bank could not deter Lancelot. Putting his trust in God, he bared his feet and hands, then painfully edged across, led on by love. When he arrived at the opposite shore, he found that the threatening lions had been an illusion; but his testing had been grim enough, for he bore great wounds in his hands and feet.

In front of him now rose a tower, from which King Bademagus and the abductor Meleagant had watched his exploit. Surprisingly, the amiable King wished Guenevere to be surrendered to the intruder; but his cruel son had no thought of letting her go without a fight. That night Bademagus had Lancelot's wounds well tended; and on the morrow he was pitted in combat with Meleagant before a throng of captives from Arthur's kingdom, all the maidens among them having fasted for three days to enlist God's aid for their champion. Bademagus went up into the tower to watch the duel; and with him he took Queen Guenevere. It was from her lips that the hero's name was first heard, at a moment when things were going badly with him: Lancelot of the Lake. She told it to a damsel, who called at once: 'Lancelot! Turn and see who has her eye on you!' From that instant he could not look away from his lady in the tower, which proved a singular disadvantage when he was forced to try and counter Meleagant's attacks behind his back. Happily, on the King's order and with Guenevere's agreement a truce was called for a year, during which time the Queen was to be surrendered to her lover's care. Now

23 Lancelot crosses the sword bridge, watched by King Bademagus in his tower.

there was a custom in that land by which, once one captive was delivered, all were free to leave. It was therefore amid scenes of great jubilation that the pact was made.

Lancelot, beside himself with joy, was led by Bademagus before the Queen. But what were these stern looks of hers? She had no word for her rescuer, towards whom, she told the King, she felt no sense of gratitude. 'Lady,' said Lancelot like the noble lover he was, 'this grieves me indeed; but I dare not ask why.' At that Guenevere left them, pursued, says Chrétien, by Lancelot's heart though his eyes were left weeping with his body. Speaking words of comfort, Bademagus led him away for a reunion with the sorely wounded Kay.

If we have by now forgotten Sir Gawain, Lancelot had not, but set forth in search of him, while Guenevere waited in Gorre for news, or so she said. A mishap to Lancelot was to bring her true feelings to light. He was seized, through a misunderstanding, by some of Bademagus' subjects, and a rumour of his death reached the court. The Queen was overwhelmed with remorse: her treatment of her lover had been a joke, she said; but now her only wish was for death. She did indeed fall into a rapid decline, with the result that it was Lancelot's turn to hear premature talk of his beloved's decease. He was

24 Inspired by Guenevere, Lancelot has Meleagant at his mercy when King Bademagus intervenes.

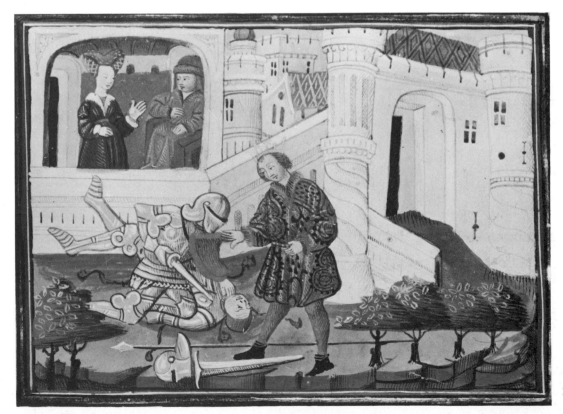

no less distraught than she. Since he was being led captive on horseback at the time, he took his belt, made a noose of one end for his neck and, tying the other to the saddle-bow, slid quietly from his mount. His suicidal plan, however, was thwarted by his guards, who cut him loose, so that he kept his life and had a sore throat into the bargain.

Then came a rapid change of fortune. Both rumours were found false, both lovers overjoyed. Lancelot was freed and brought once again into Guenevere's presence, to find this time a more cordial reception awaiting him. What, though, was the cause of her earlier displeasure? It was, she said, that before mounting the cart he had hesitated for two paces, out of shame. Such are the rigours of the courtly mistress! But now all was forgiven; and with a stealthy glance she indicated to him a window where he would be welcome to come that night for more intimate conversation and a kiss or two through its bars. As she had to share a room with Kay, no closer contact would be possible. But she had reckoned without Lancelot's valour. When the time came, he wrenched the bars with a great effort from their sockets and joined her in bed under the nose of the sleeping Kay. Only the dawn came to part them. The elated Lancelot replaced the bars when he left, then prostrated himself before the room as before a shrine.

At last the path of true love seemed to have run straight. But not quite. In removing the bars, Lancelot had cut the last joint of his little finger. A small enough penance, one might think; but a greater was in store. For the blood had spotted the Queen's sheets, a circumstance that did not escape the jealous eyes of Meleagant. However, because the unfortunate Kay's wounds had opened during the night, so that his sheets were also soiled, Meleagant jumped to the conclusion that the seneschal was guilty of the act performed in reality by Lancelot. In vain Guenevere pleaded a nosebleed: a challenge was issued by Meleagant, which Lancelot immediately took up on behalf of Kay.

The romance still has two-fifths of its length to run, but we can be briefer now. This second duel between Lancelot and Meleagant was stopped on the understanding that it would be resumed, as previously arranged, at Arthur's court. So again Lancelot set out to look for Gawain, but only to be kidnapped by Meleagant's men a league short of the underwater bridge. That is where we are now taken in time to see Gawain losing his footing and bobbing in the river, to be rescued with branches, poles and hooks and, after drying out, be taken to the welcoming Bademagus' court. There, false news arrived that Lancelot was already back with King Arthur; so the Queen and her company left for home to join him, as they supposed. They were cruelly deceived, when he was nowhere to be found. Nevertheless, the Queen agreed to

attend a forthcoming tournament that had been arranged by those damsels of the court who were in search of husbands.

Lancelot, now held prisoner by Meleagant's seneschal, learnt of the proposed event, and in the seneschal's absence persuaded his wife to let him attend it, on the promise of a prompt return. On the first day he entered the lists incognito, bearing vermilion arms and carrying all before him until the Queen, suspecting with feminine intuition that this was her lover, sent him word to do his worst. For the rest of the day Lancelot played the coward, and Guenevere's last doubts were dispelled. On the morrow he appeared again, prepared to do his worst or his best, as the Queen commanded. By the end of the tournament all the glory was his; but when it disbanded, he slipped furtively away, back to his captivity. As ill luck would have it, however, the seneschal had discovered his absence; so to make sure the bird did not fly again, he had him walled up in an impregnable tower.

This is the point where Chrétien laid down his pen and left the romance for a colleague, Godefroi de Leigni, to finish. Godefroi contrived Lancelot's escape with the aid of that damsel who had earlier promised him a reward (she turned out to be Bademagus' daughter); and then he had him fight and destroy Meleagant, to the delight, we are told, of King Arthur and all who were there. The King might have been less enthusiastic had he known what had been going on behind his back.

So Lancelot has been launched on his memorable career; and in Chrétien's romance the code of courtly love, as developed by the troubadours and their imitators, has been given its first full narrative development. In the previous chapter we detected a large element of fiction in the code itself; so it was only natural that this should be extended into a well nourished story chronicling the whole progress of a love affair, of which lyric poems could only capture isolated moments of ecstasy or despair. It is not an easy operation. In particular, it is hard to convert the passive, near Platonic troubadour passion into a relationship that develops and matures convincingly. Where would one find a satisfactory ending? A clandestine affair is all very well to contemplate, but not easily worked out on a courtly level. Was it because he saw the problem more clearly than the solution that Chrétien in the end abandoned his task? For an acceptable conclusion he would have had to explore beyond the courtly rule-book, and this he was not prepared to do. So we have been left with Lancelot and Guenevere facing a problematic future as they nurse their guilty thoughts, of which Arthur is still blissfully unaware.

Although the troubadours had endowed love with social respectability, that is a far cry from commanding general agreement on how it should be

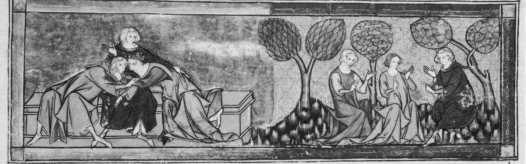

25 Galehaut arranges the first meeting of Lancelot and Guenevere.

VI Lancelot rides in the cart of shame, accompanied by the mounted Gawain.

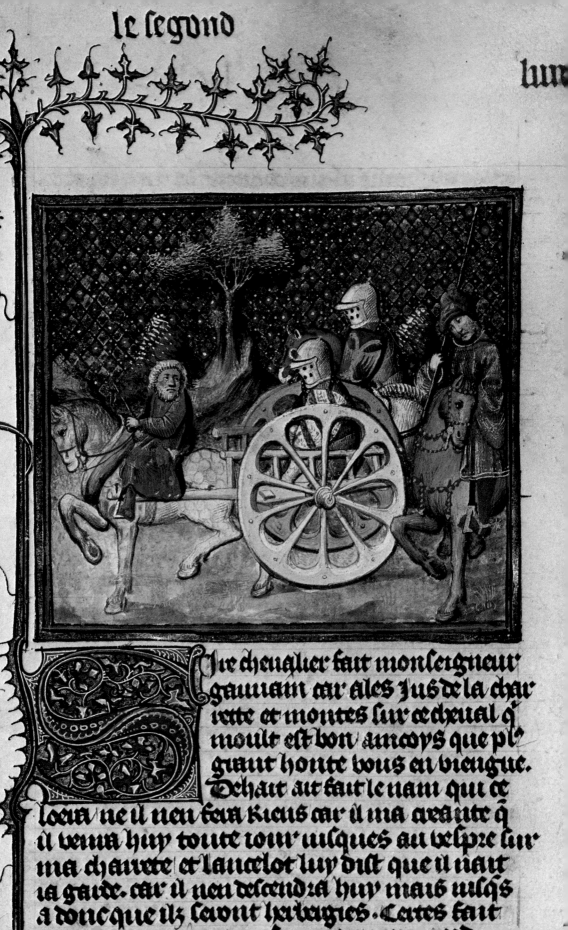

ire cheualier fait monseigneur
gauuain car ales ius de la char
rette et montes sur ce cheual q̃
moult est bon amcoys que pl'
grant honte bous en biengue.
Dehait ait fait le nam qui ce
loera ne il nen fera riens car il ma creaute q̃
il beura huy toute iour uisques au bespre sur
ma charrete et lancelot luy dist que il nait
la garde. car il nen descendra huy mais uisq̃s
a donecque ilz seront herbagies. Cates fait

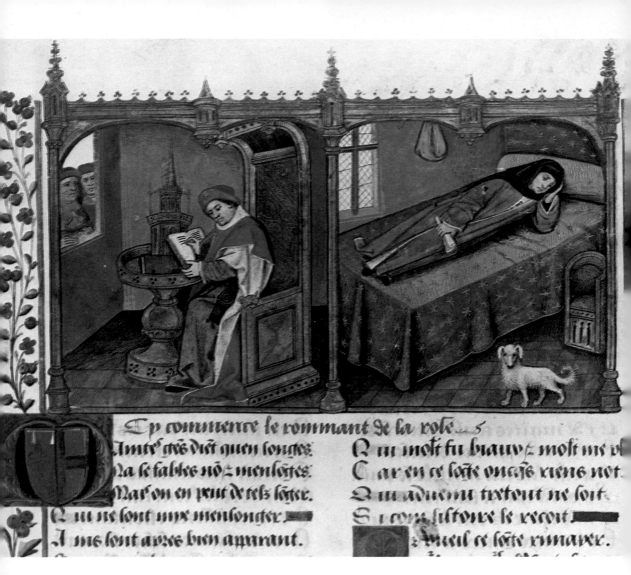

Cy commence le rommant de la role

Amtes gés dit quen songes
Na se fables noz mensonges.
Mas on en peut de tels songes.
Qui ne sont mye mensonger.
I mes sont apres bien apparant.

Qui mollt fu biaux et mollt me pl
Car en ce songe oncas riens not.
Qui aduienu tretout ne soit.
Si com listoire le recoit.
e ueil ce songe rimaier.

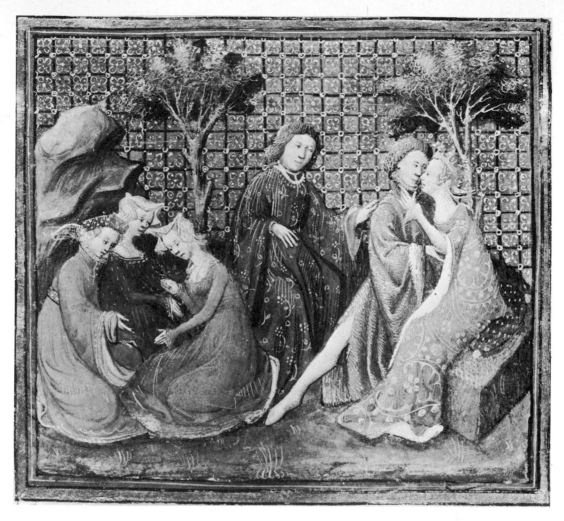

26 The first kiss of Lancelot and Guenevere with Galehaut looking on.

practised. Even among their own ranks there were those who lapsed some-
times from the tone of earnest amorous dedication. Not all of their public
were as sympathetic towards their doctrines as Marie de Champagne ap-
pears to have been; not all found the matrimonial bond as slack or paid such
high respect to the eternal feminine. In broad terms one might say that those
with views on courtly love fell into two categories: let us call them the
romantics and the realists.

Chrétien, I believe, was in this sense a realist. He knew well the songs of
poets like Bernard de Ventadour and even composed some himself. But al-
though he was not averse to playing the courtly game and realised that this
was what part of his public expected, he was deeply sceptical of its applica-
tion to real life. So while he saw through the fond antics of Lancelot and

VII Guillaume de Lorris has his dream, which he records (see p. 54).

Guenevere, he wished to give no offence to any of the gentle folk who read his romance (for by this time literacy was becoming more widespread), or more likely heard it read aloud in the court. He therefore presented the story in quite ambiguous terms: the more romantic and sentimental could pine and swoon with Lancelot, if they felt so disposed; but others would not fail to share Chrétien's chuckles at the expense of his besotted hero. The humour is very gentle, very muted. At times indeed the romance carries some of the religious overtones we have found in the lyric; and the reader may have taken my hint and noticed how Lancelot's deliverance of the captives in Gorre is startlingly modelled not on those stories of Otherworld adventure I mentioned, but on Christ's harrowing of Hell. In this way Chrétien has crowned with an aureole the image of the noble lover — or, if one prefers, ridiculously over-inflated it. Already, during the lifetime of some of the greatest troubadours, I feel, he was probing the weak spots of courtly love, quietly smiling at some of its absurdities.

It was, however, to be the romantic view of Lancelot that prevailed. After Chrétien, the prose romancers gave him a full biography, later to be used by Malory. They told how as an infant he had been snatched from his cradle and raised to manhood by the mysterious Lady of the Lake, then brought by her to Arthur's court for knighting. They recounted his friendship with Galehaut who, learning of his infatuation with the Queen, arranged their first meeting. Thereafter, Lancelot's passion was fated to grow, more often in Guenevere's absence than her presence, and increasingly clouded with anguish and presentiments of doom as time went by. Along with the other knights of the Round Table, he took part in the quest of the Holy Grail, but without ever, because of his impure love, learning of its ultimate secrets. Still prone to finding himself in beds he had not sought, he lay one night with the Grail King's radiant daughter, bearer of the precious vessel, having been misled by a magic potion into thinking it was Guenevere's embraces he enjoyed. From that union was to come Galahad, the virgin knight destined to accomplish the great quest and achieve the knowledge denied to his father. At one point Lancelot was brought to repent of his earlier behaviour, but only to relapse into his old desires; and, having abducted Guenevere to his castle of Joyous Gard, he had to face the might of King Arthur, on whom the truth had at last dawned. But when Arthur had received his own death-wound at the hand of the traitor Mordred, the Queen took the veil of penitence and, dying soon after, was buried in Glastonbury beside her too trusting husband. Lancelot also spent his remaining days in pious contrition before surrendering his soul to the angels, while his body found rest beside that of Galehaut in Joyous Gard.

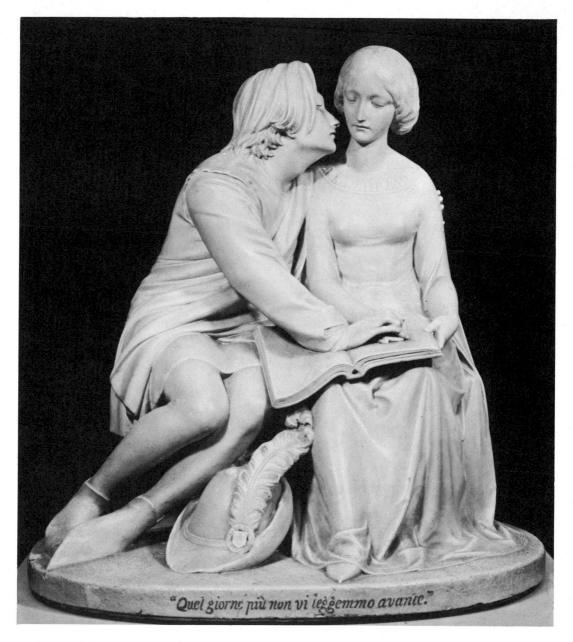

"*Quel giorne più non vi leggemmo avante.*"

27 Paolo and Francesca reading the tale of Lancelot.

Despite the ambiguity of Chrétien's treatment of the story, the Middle Ages fell beneath its spell. Its lesson was very different from those found in the books used as a pretext by Abelard and Heloïse. But our thoughts return to them as we read Dante's account of his meeting with the unhappy shades of Paolo and Francesca da Rimini who, for their own love, had surrendered

their lives to the hand of Francesca's jealous husband. It is she who, telling of the birth of their fatal passion, pays this poignant tribute to our legend's power to move:

> 'One day,
> For our delight we read of Lancelot,
> How him love thrall'd. Alone we were, and no
> Suspicion near us. Oft-times by that reading
> Our eyes were drawn together, and the hue
> Fled from our alter'd cheek. But at one point
> Alone we fell. When of that smile we read,
> The wished smile so rapturously kiss'd
> By one so deep in love, then he, who ne'er
> From me shall separate, at once my lips
> All trembling kiss'd. The book and writer both
> Were love's purveyors. In its leaves that day
> We read no more.'
>
> (*Inferno* v, 127–138, H. F. Cary's translation)

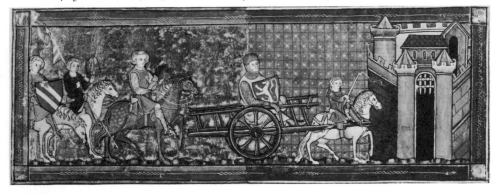

28, 29 (*above*) Lancelot riding in the dwarf's cart, followed by the mounted Gawain. *Below*, he crosses the sword bridge, watched by Bademagus.

Chapter IV

Love's Allegory

The troubadours had invented and given lyrical expression to courtly love; writers like Andreas Capellanus had legislated for it; Chrétien de Troyes, by showing it in action, had given it dimensions in space and time. Now came an attempt to explore its whole inner, psychological landscape. The *Romance of the Rose*, one of the most influential and popular poems of the Middle Ages (over three hundred manuscripts of the original French text have survived), was still appreciated even during the Renaissance and those centuries which preferred to turn to Classical Antiquity for their inspiration. One of its remarkable features, and perhaps attractions, is that it presents the two distinct views of courtly love that I have called 'romantic' and 'realist'. For this we have to thank not a single schizophrenic poet but the fact that the first author, Guillaume de Lorris, died with his work still incomplete. That was probably in the 1230s; and some forty years later Jean de Meung, a man of a very different cast of mind, carried it to a total length of over twenty thousand lines, of which he wrote more than four fifths.

Guillaume de Lorris, known to us only through his work, was a poet of skill, charm and deep sensibility. He tells us that it was five or six years ago, when he was just twenty, that he had one night a wonderful dream, which he will recount; for it contains not only hidden truths, but the whole Art of Love. So he reveals his vision, in which he found his way into a splendid garden where the God of Love was holding court; and there he discovered a rose-bud that he would dearly have wished to pluck had not obstacles and opposition left him to languish without hope of success. Guillaume, then, is presenting the history of a love-affair transposed into allegorical terms; and because allegory tickles few modern palates, it is as well, before looking at his poem, to consider the audacity of his achievement.

From the first we are transported out of the everyday world into a dream-state, where we are shown the wavering fortunes of the love-affair. This is not presented in real terms, but through a depiction of the interplay of the varied emotions and impulses of its two participants. Of these, we are aware of the dreamer as a person; but his beloved is never given human shape. The rose-bud represents her innermost self, her heart, her love, which the dreamer wishes to possess; otherwise we perceive her as a shifting complex of emotional and mental states, themselves reacting in harmony or conflict, with a life of their own. How is it possible to describe in words something so abstract, so far removed from physical reality, so infinitely subtle yet, as Guillaume shows, so true to human experience? It is hard indeed to see how it could be done without the use of allegory. Yet so adept is Guillaume and so penetrating his psychology that one can, if one wishes, re-clothe his abstract drama in flesh and blood to create a typical but still individual courtly

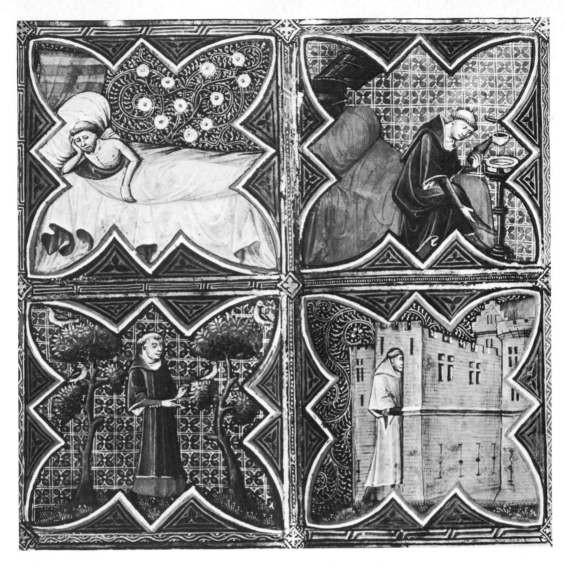

30 The poet dreams that he approaches the garden of the God of Love.

situation. This banal transposition I shall briefly attempt in my italicised commentary.

I dreamt, says Guillaume, that one morning in the fresh month of May, when every living thing is roused by love, I was wandering among the riverside meadows, when I came to a great garden, all enclosed. On its walls were paintings of unlovely figures: Hatred, Wickedness, Baseness, Covetousness, Avarice and Envy, Sadness, Age, Hypocrisy and Poverty. Yet from the garden came such sweet birdsong that I longed to enter. At length I found a small door, which was opened to my knocking by a damsel of radiant beauty, whose fair tresses were crowned with a gold-embroidered circlet and a

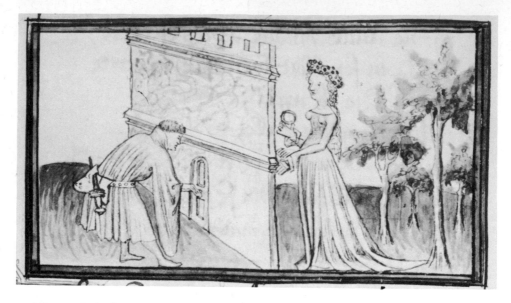

31 Idleness admits the Dreamer to the garden.

garland of roses. She carried a mirror, and her elegant appearance told me that she would spend the entire day in combing her hair and grooming herself. Her name, she said, was Idleness, and she was the intimate friend of Pleasure, the owner of the garden. When she admitted me, I thought I was in the Earthly Paradise, with the birds like angels, singing their courtly lays and songs of love.

A narrow path led me to where Pleasure was holding his revels amid a dancing company led by Gladness, Pleasure's own mistress. Her love had been his since she was barely seven years old; and he wore a chaplet of roses she had given him. Courtesy called me to join the dance, and I was happy to do so. Not far away was the God of Love, arrayed in a flowery robe and wearing a garland of roses on his head, round which fluttered nightingales and other birds. He was as handsome as an angel straight from Heaven; and beside him stood a youth called Fair Glance. The lad carried two bows, one fine, one ugly, along with his master's ten arrows. Five of the arrows were golden and were named Beauty, Simplicity, Nobility (feathered with Merit and Courtesy), Company and Fair Appearance; the other five were black and called Pride, Baseness poisoned with Wickedness, Shame, Despair and New Thought.

The God of Love had well chosen the company dancing before him. Beauty was there, and Richness (who was held in great honour and awe), Largesse too, holding one of King Arthur's knights by the hand, Nobility, and Youth, a smiling twelve-year-old kissing a lad no older than herself. Each of the dancers had a gay partner and, when it pleased them, they left the round for love-talk in a shady place.

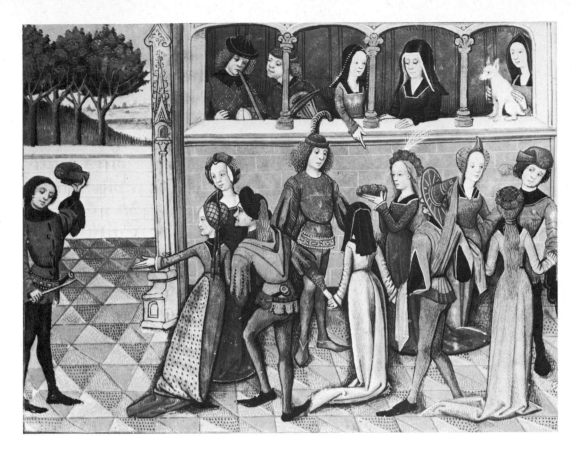

32 Courtesy calls the Dreamer to join the dance.

33 The Dreamer walks in the garden, followed by the God of Love.

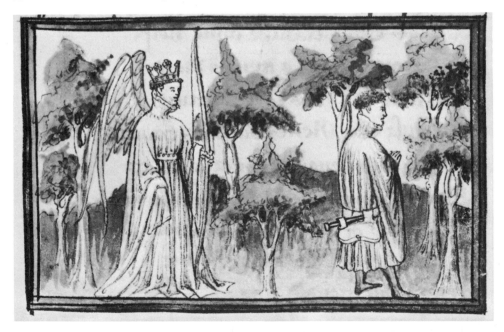

God! How fine a life they led! Only a fool would not wish to live like that; and the man who could have such fortune would wish for nothing better, as one cannot be in greater paradise than with the sweetheart of one's choice.

Wishing to see more of the garden, I left the company; but as I strolled this way and that, the God of Love took from Fair Glance his golden bow and five arrows, and followed like a huntsman in my tracks. I wandered among the splendid trees and the flowers with which the earth was painted until my steps brought me to a grove with a fountain shaded by a stately pine tree. The water flowed into a marble basin, on whose brim stood the inscription: 'Here died the fair Narcissus.' For this is where the prayer of the nymph Echo, whose love Narcissus had spurned, was answered. Before dying of her grief, she had called on God to teach the young man the pain of an unrequited love. Her appeal was heard; and one day Narcissus, gazing into this very fountain, fell so ardently in love with his own reflection that he died of despair at finding his passion not returned. Recalling his fate, fear for a moment held me back; but then I too looked down into the water. In its depths I saw two crystal stones of marvellous beauty, in which was mirrored every detail of the garden. How I have since regretted the deception practised on me by this mirror! Its rightful name is the Fountain of Love; for here Cupid, the son of Venus, had sown his seed and set his snares to trap young men and maids. Among the thousand things I saw reflected there was a rose bush, covered with blossoms, and set within a hedge in a secluded corner. From that moment, my one desire was to go to this bush.

The fateful moment has arrived. We have been introduced to a young gallant who

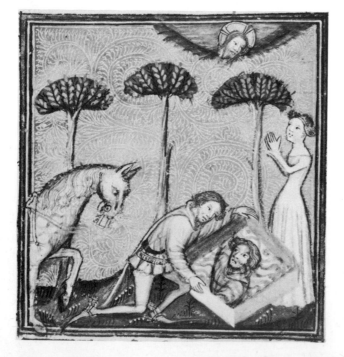

34 Echo's prayer is answered and Narcissus falls in love with his own reflection.

35 (*facing, above*) The Dreamer gazes into the fountain of Love, then sees the rose bush.

36 (*facing, below*) The God of Love shoots the arrow tipped with Beauty into the eye of the Dreamer who thus becomes the Lover.

has been leading a life of bachelor idleness and pleasure such as might be enjoyed in some of the more civilised French courts. Among his companions, love affairs blossomed like mayflower, but as yet his own heart was entire. Life was lived very much on the surface, with more account taken of grace and the courtly ethic than of present misfortunes and future problems. Then one day our carefree youth looked into two bright eyes and saw there great beauty and the prospect of love.

I made my way to the rose bush, and the sweet scent of its flowers penetrated my whole being like a balm. I would have plucked at least one of the roses for its fragrance, but for my fear of offending the lord of the garden. There was, however, a bud as yet unopened whose loveliness attracted me more than all the rest; and to this one I would have reached out had I dared

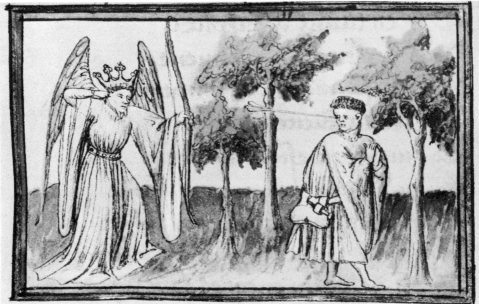

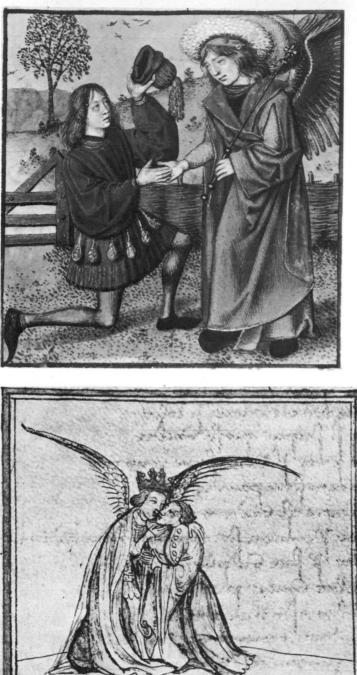

37 The Lover kneels before the God of Love.

38 The God of Love exchanges the kiss of homage with the Lover.

and had not a tangle of briars and thistles kept me at a distance. Seeing I had made my choice, the God of Love, who had not let me from his sight, put an arrow to his bow and with unerring aim shot it straight through my eye into my heart. I fell to the ground in a swoon. When I had regained a little strength, I tried to pull the arrow from my body; but the point, whose name

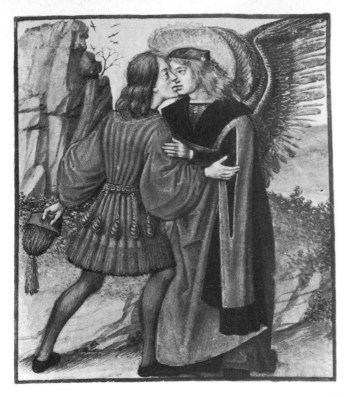

39 The kiss of homage.

was Beauty, stayed embedded in my heart. I tried again to reach the rose-
bud, only to be struck by a second arrow; and its point too, Simplicity,
could not be withdrawn from my heart. Thrice more the God of Love drew
his bow on me, and the tips of the arrows Courtesy, Company and Fair
Appearance were lodged with the other two. But the point of Fair Appear-
ance had been rubbed with a soothing ointment; and weak and pale as I was,
I felt its restoring powers.

Now the God of Love came up to me, calling for my surrender; and this I
could not refuse, but asked only that one day he would have mercy on me. I
wished to kiss his feet, but he took me by the hand, saying:

'From this you gain greatly, for I wish you here and now to do me
homage to your own advantage. You will kiss me on the mouth, a
favour I would grant to no base or uncouth fellow: only courtly and
noble men do I take in this way as my vassals. Those who serve me have
certainly to endure great toil and tribulation; but I do you great honour,
and you should rejoice to have so good a master, so renowned a lord,
who bears Love's standard and the banner of Courtesy: so gentle, up-
right and noble is he that whoever serves and honours him with zeal
rejects baseness, wrongful deeds and all bad influence.' Then I became
his man, hands joined in his; and you can imagine how my heart leapt
when his mouth kissed mine.

The God then demanded some gage of my fidelity. 'Sire,' I said, 'you have

taken possession of my heart. Put a lock on it, then, and take away the key.'
To this he consented, and with a tiny golden key locked my heart so gently
that I scarcely felt his touch. He told me that if I was loyal, patient and
prepared to suffer, he would advance me far. Then he made his command-
ments.

I must avoid baseness and telling what should be concealed, be discreet and
fair of speech, honour and serve all women and guard against pride. I must
cultivate cleanliness and elegance in dress, be gay and ready to show off my
particular skills, and gain a reputation for generosity.

'Now I order you as a penance to fix your every thought on love, night
and day, without remission; think of it always, ceaselessly, bearing in

40 The God of Love turns the lock on the Lover's heart.

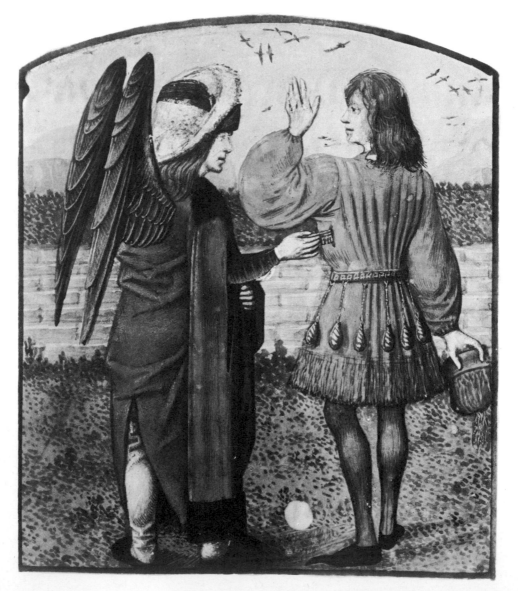

mind that sweet moment whose joy is so long delayed. And so that you may be a noble lover, I wish and command you to have your whole heart in a single place, so that it is not divided but quite entire, without deceit, since I have no liking for duplicity. . . . Take care not to lend it out, a wretched act in my eyes; but surrender it as an outright gift, and the greater merit will be yours. . . .

When you have given your heart as I have told you, there will be hard and cruel trials for you to undergo. Often, when your love comes to your mind, you will be forced to leave people's company so they may not see the trouble that racks you. You will keep yourself to yourself, sighing, lamenting, trembling and more besides, suffering in many ways: now hot, now cold, flushed one moment, pale another; no steady or recurring fever is so distressing. Before you escape you will have sampled all the pains of love. Frequently your thoughts will make you oblivious to all else, and for a long time you will be like a mute statue, still and motionless, not stirring a foot or a finger, hands or eyes, quite without speech. At length you will come to your senses again and, startled to do so, will tremble like a man afraid. Then you will heave deep sighs; for this, to be sure, is what those people do who have known the ills that so afflict you now.'

He told me I would go in search of my beloved; and, if I found her, her beauty would kindle my passion all the more, though courage to address her would fail me, for only false lovers chatter freely. At night I would toss and turn, think she was in my arms, then, finding myself deceived, lament aloud and pray for the dawn to come and end my misery. How, I asked, can lovers endure all these ills? The God answered that Hope would be my chief protector, while Fair Thought, Fair Speech and Fair Glance would also stand me in good stead. With that, he suddenly disappeared.

The young man is attracted to the girl (married or unmarried, we cannot tell) by her unaffected, gracious manners as well as her beauty; and suddenly he finds himself in love for the first time. His own timidity and the girl's natural reserve as well as social obstacles make it difficult for him to approach her; but he vows to conduct himself in such a manner as to attract both her attention and her affection, though without making any public show of his love. Realising there will be no easy conquest, he is prepared to wait with what patience he can muster, never giving up hope, whatever frustrations and disappointments lie ahead.

As I was wondering how to pass through the hedge to the rose bush without incurring any blame, a young man called Fair Welcome came up to offer me his help. This I was glad to accept; and together we went so close to the roses that I could have touched them with my finger. But a rascally fellow

called Reluctance, who was their guardian, lay hidden close by; and with him were Slander, Shame and Fear. Fair Welcome invited me to go closer still and touch the bush; and he picked me a leaf from a branch close to the bud. I did not realise he thought I only wanted to smell the roses; but when I told him of my love and said I would be cured if he would pluck the bud for me, he was shocked and refused. At this, Reluctance dashed up, red-eyed and hideous, cursing Fair Welcome for bringing me here and shouting at me to be off. Terrified, I jumped back over the hedge, while Fair Welcome fled in another direction, leaving me in anguish at having to abandon the rose.

The girl has noticed the young man and given him a welcoming smile, not yet realising his intentions. Once he has made his love clear, she is alarmed and put on the defensive, partly from natural modesty (this is her first experience too of real love) and partly through fear of people talking and soiling her reputation. A sudden chill comes over her manner; and the youth goes away feeling miserable and rejected, and a little ashamed at having been too abrupt in his approach.

There was a tall tower in the garden, and from its top a lady had seen my grief. Her name was Reason; and she was of middle age and height, neither too fat nor too thin, her noble appearance enhanced by the crown she wore. God had created her in His own image to keep men from folly. She came down from her tower and at once took me to task. I had behaved foolishly, she said, in allowing Idleness to lead me into the garden. But for Idleness I

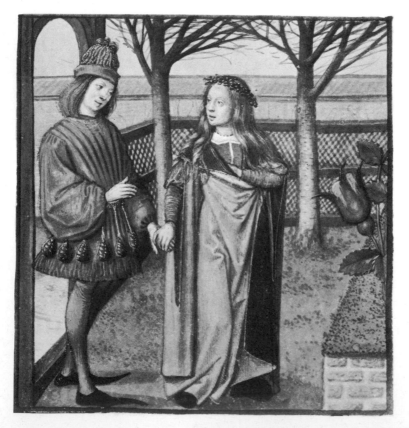

41 Fair Welcome (here shown as a lady) leads the Lover to the rose.

VIII
The Dreamer enters the garden.

Ssez y fery et
sourtay·
Et maintesfois
se escoutay
Se ie oiroie seaue nulle ame
Le ruisset qui estoit de charme
Ille ouurit une pucellette
Qui asses estoit coincte et nette
Cheueulx eut blons come ung bassi'
La char plus tendre que ung poussin

Front reluisant souter voulsis
Lentreueil si nestoit pas vng
Ame fut asses trans y mesme
Le nes eut bien fait a droiture
Les yeulx eut uers come faucone
Pour faire enuie a toute sionie
Douice alaine eut et sauouree
La face blanche et coulouree
La bouche petite et grossette
Et au menton une fossette

Esse gent dont
le vne duuse
Sestoient vne
a la carose
Et vne dame seur chantoit
Qui liesse appellee estoit
Bien sceut chanter et plaisamment
Plus que nulle et mignotement
Son bel refrain mlt bien lui fist
Car de chanter merueilles fist

Elle auoit la voix clere et saine
Laquelle nestoit pas villaine
Et tresbien se sauoit debriser
feur du pie et remoiser
Les gens la tenoient intichier
pource quelle estoit la premi
De belle face et plaisier
Courtoise estoit et non prestir
De loyauste fut marrie
Et aussi de solas fournie

would never have fallen under the power of Love, from whom I must now flee. The joy I seek is elusive and seldom attained, so well guarded is the rose bush by Reluctance, Slander, and above all by Reason's own daughter Shame. To this I retorted that I would rather die than betray my lord Love; so Reason stopped her preaching and left me alone once more.

Then I recalled that Love had recommended me to find someone in whom I could safely confide and so obtain some consolation. I had such a companion, called Friend; and I went to see him at once, telling him how, with Fair Welcome, I had been rebuffed by Reluctance. Friend said he knew that fellow well and how he could be wheedled with a humble request for forgiveness and a promise that nothing more would be done to offend him. So I went back to Reluctance, and putting on a contrite look I said:

'Sire, I have come to beg your mercy. I am deeply sorry if I have done anything to anger you; but I am ready now to make amends in whatever way you require. Truly it was Love that made me do it, for he will not yield up my heart to me. But never again will I hanker after anything that may grieve you: I will rather suffer great hardship than incur your displeasure. So I beg you to have pity on me and forget your anger, which fills me with alarm; and then I pledge my word always to keep from wronging you in any way, so long as you grant me what you ought not to deny. Just let me love: I ask for nothing more. Agree to this, and I will do whatever else you wish. Indeed, to be frank, you cannot prevent me; for I have a mind to love and will, whomever it may please or vex. But I would not wish to do it at your displeasure.'

42 The Lover and Fair Welcome are confronted by Reluctance.

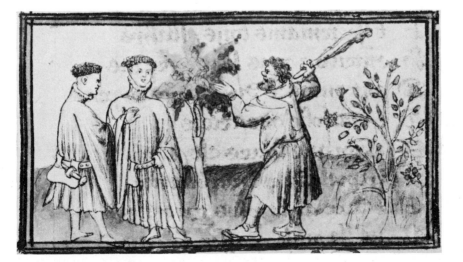

IX Gladness leads the dance in the garden.

To this Reluctance gave his grudging consent. Friend was delighted at my success and assured me that the fellow, having once shown his arrogance towards lovers, usually went on to treat them favourably.

I took leave of Friend and went back to the hedge, longing to see my dear rose-bud once more. With Reluctance keeping a strict eye on me, I dared not pass through the hedge again. Then God sent Nobility and Pity to my aid; and as a result of their pleas, Reluctance agreed that I might resume my association with Fair Welcome.

It occurred briefly to the distraught lover that he was acting against all reason and would do better to forget his passion. But this he was unable to do. Instead he found a trusted friend, to whom he poured out his heart. Taking the friend's advice, he went straight to his beloved, apologised for his rashness, and promised that, though he could not go against the dictates of his heart, he would henceforth give no offence, but only try to please her. After a show of resistance, the girl relented and put on a welcoming face once more; for she had a good heart and was truly sorry to have hurt the young man's feelings.

Now I could go anywhere I wished with Fair Welcome. My rose-bud had grown and opened a little, its crimson hue was deeper, and it was even more beautiful than before. Fair Welcome was as helpful and compliant as I could wish; so I ventured to ask him a further favour: that I might be allowed to kiss my fragrant rose. This Fair Welcome dared not grant, since Chastity had forbidden it. I was prepared to resign myself to a long wait when Venus, the

43 The Lover speaks with Reason.

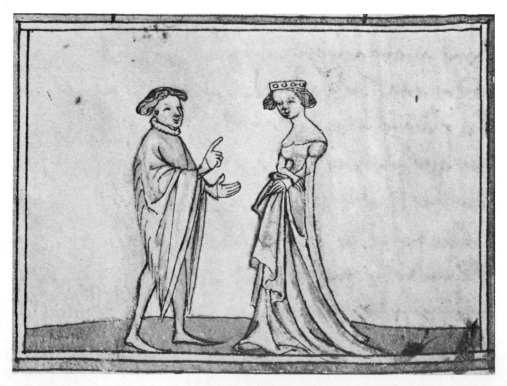

mother of Love and sworn enemy of Chastity, came to my assistance. She was graceful and dressed like a goddess or a fairy (it was plain she was not in religious orders), and in her hand was a blazing torch. Turning to Fair Welcome, she scolded him for refusing me the kiss, declaring that I was well bred, elegant in dress and behaviour, with all the advantages of youth. She would despise any fine lady or chatelaine who refused to kiss my red lips, she said. Fair Welcome, feeling the heat of Venus' torch, relented at this and gave me the permission I sought. Quickly I took from the rose a kiss so sweet that its savour and fragrance penetrated my body and drove out all my pain. Never had I known such joy, joy I shall always recall at the memory of that kiss, despite all the suffering and sleepless nights I have had since.

This had not escaped the notice of Slander, who at once made such an outcry, accusing me and Fair Welcome of a guilty relationship, that it came to the ears of Jealousy. She rushed like a fury upon Fair Welcome, deploring his association with strangers and threatening to wall him up in a tower. Shame had not kept a close enough eye on him and had paid too little attention to Chastity to let such a thing happen. I took to my heels; and Fair Welcome would have fled too had he not been seized there and then.

The young man took full advantage of the new favour shown to him, winning the girl's confidence more and more. Eventually, he summoned up the courage to ask for a kiss. The girl hesitated, knowing that a kiss can lead so easily to other things. Her lover did not insist, fearing she might ban him from her company again, and prepared to bide his time in patience. But now the girl herself was feeling the first stirrings of passion; and on a sudden impulse she gave him the kiss he longed for. His joy was to be short-lived; for their embrace had been seen, and soon scandal was being talked about this mere stripling and the designs he had on the girl. It came to the ears of her guardian, who turned furiously on her, accusing her of loose relationships and forbidding her to let herself be seen in public. The young man fled from the scene in alarm.

Shame, veiled like a nun, came to plead with Jealousy, excusing Fair Welcome on the grounds that his only fault is to make friends too easily, and not always with the most desirable people.

'Shame,' said Jealousy, 'I am very much afraid of being betrayed; for Lechery has reached such a position that I could easily be fooled. It's no wonder if I am wary, because Lust reigns everywhere, and with increasing power: Chastity is no longer safe, even in abbeys and cloisters. So I shall put a new wall round the rose bush and its roses, and not leave them unprotected like this; for I don't trust you to guard them. . . . I shall certainly bar the way to those who come round spying out my roses to dishonour me. I'll not rest until I've built a fortress round the

rose bushes; and in the middle will be a tower to serve as a prison for Fair Welcome, for I fear treason. I shall keep him so well guarded that he'll not be able to get out and keep company with those louts who bring him shame with their cajoling talk.'

Now Fear had come forward but, finding Jealousy in a rage, withdrew again until he had gone. Then she went complaining to Shame that they were being blamed for what was really the fault of Reluctance. So they turned to him, accusing him of being too soft towards Fair Welcome and so bringing trouble on them all. Reluctance readily admitted his fault and became even fiercer than at first, going round his hedge on the lookout for the tiniest hole that he could block. I meanwhile was left to curse the hour I took the kiss, and Slander who made it public knowledge.

True to his word, Jealousy had a great moat dug and a massive wall thrown up round the rose bushes. In the centre of the fortress was built a tower of immense strength, and round that the bushes were planted. The gates and fortifications were guarded by Reluctance, Shame, Fear and Slander with armament of all kinds and bands of troops. In the tower Jealousy imprisoned Fair Welcome, with an old woman to watch over him, someone who had had her share of love in her young days and knew all its tricks and ruses. Now Jealousy could rest without fear of intruders coming to steal her roses.

I am left outside the walls in great despair, fearing that my patience and hope have been in vain. Through Love's good offices, I had begun to put all my faith in Fair Welcome; but so fickle is Love that I now find Fair Welcome a captive, and unless he leaves his prison, my ill will never find a cure. Ah, Fair Welcome, keep your heart for me in your captivity! Do not surrender it to Jealousy, or blame me for your imprisonment. I am guiltless of that, for never did I disclose anything that should have been kept secret, and I suffer more than you for what has happened. I fear the gossips and those full of treachery and envy who try to set you against me. Perhaps they already have. If I lose your goodwill, I shall never be comforted; for all my trust is placed in you.

The girl was ashamed at being reproached for wanton behaviour. She claimed innocence of any fault except, perhaps, being too kindly disposed to those young men she met. But her guardian was not to be appeased. Morals, he said, were in such a decline that it was no longer safe for women to have any kind of freedom. His attitude increased the girl's fear and confusion: perhaps she was wrong to have entertained any of the youth's advances. She must be more careful in future. In any case, it seemed she would have little opportunity to further the relationship, as her freedom was now restricted, and she went nowhere without a chaperone. Her lover, mean-

44 The Lover (*top left*) gazes disconsolately at Jealousy's fortress, guarded by Reluctance ('Dangier').

while, was again in the depths of despair, unable to see her or know whether she still had any warm feelings towards him. Perhaps she blamed him for her present situation, or had already been turned against him by people who wished him ill. What would be left for him, if this was so?

This is where Guillaume de Lorris takes leave of his lover — at the moment of his greatest crisis. I have not wished to imply by my commentary that he was making a study of any particular relationship, still less of a love affair of his own, as some have supposed. My purpose was simply to show that the allegorical figures, however hollow and even tiresome they may seem at first sight, really do carry much penetrating psychological insight. What Jean de Meung undertook to complete, no easy task, was an unfinished masterpiece. How would he set about it?

The odd thing is that he tried at all, so different was his temperament from his predecessor's: perhaps a spirit of contradiction had something to do with it. Whereas Guillaume's first appeal would have been to the aristocratic society of the courts, the outlook Jean expressed was that of the newly emerged bourgeoisie. Guillaume's art was dedicated to the exquisite pursuit of intangibles; Jean looked reality straight in the eyes. If Guillaume composed lyrically, from the heart, Jean had a sharp, satirical tongue. Indeed, people have spoken of him as a medieval Voltaire, on account of both his witty cynicism and his encyclopedic learning, which he showed off with evident relish in his continuation of the poem, using and citing authorities ranging from Plato to his near-contemporaries. We know of a number of his own translations from the Latin, including the letters of Abelard and Heloïse. Hardly the man, one would think, to finish off the *Romance of the Rose*, especially as one can add to his qualities a misogynistic attitude. Yet finish it he did, and in a way to make poor Guillaume de Lorris turn in his grave.

The lover, with nothing to look forward to but death, is visited again by Reason, who paints for him a picture of love as more or less unbridled lust. Refusing to abandon the rose, he turns back to Friend for advice. This is on a very practical level: the art more of seduction than of love. Harsh things are said of marriage and of women, in whom virtue is hardly ever to be found. Heloïse was exceptional in that her learning and devotion to letters helped her to overcome her feminine nature, and she, moreover, had not wished to marry. Armed with Friend's advice, the lover sets out for the fortress, but finds small prospect of success until Love consents to assemble his barons and lead an attack on it. The defences are breached by a ruse: False Appearance and Abstinence, disguised in religious habits, go to Slander as he guards one of the gates; when he accepts confession from them, they strangle him, cut out his tongue, and fling his corpse into the moat. With the connivance of the

old woman, the lover is able to visit Fair Welcome in his tower; but the final assault on the castle has yet to come. It is in the end achieved when Venus shoots her fiery brand, and the flames quickly take hold. Fair Welcome is released; and without more ado the lover plucks the rose in unambiguously erotic terms. With that, the dreamer awakes.

It can be seen that here allegory has been robbed of its rich psychological content and has just become a rather lame excuse for a rough-and-tumble story of amorous conquest. Its characters are now simply people with quaint names performing antics void of any inner significance. The fact is that Jean was not interested in the psychology of passion, nor in love as a courtly game, nor even in the course and outcome of the lover's trials. His mind was set on satirising many of the social evils of his day and, fortified by his uncommonly wide reading, proclaiming something of his own philosophy of life. In this, love certainly held a central position, despite his unflattering views on the nature of the weaker sex (he is very close here to the clerical standpoint). For love has been established by Nature as the principle by which the human species survives, and should therefore be indulged in as she requires. Despite what the priests say, man is not born to be celibate, and youth is the time for loving. Jean's message on the ostensible subject of the

45 Slander is strangled by False Appearance.

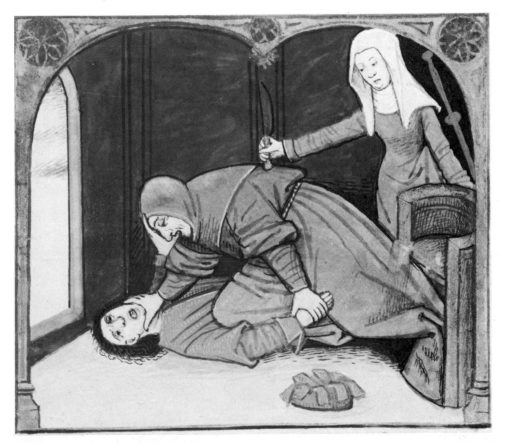

46 The Lover attains the rose.

47 (*below*) In this miniature of the Lover winning the rose, we are shown the reality behind the allegory.

48 (*facing*) The assault on the Castle of Love. Both sides use roses as ammunition, while the God of Love aims his arrow at the attackers. Beneath the balcony two knights joust for their ladies' favour.

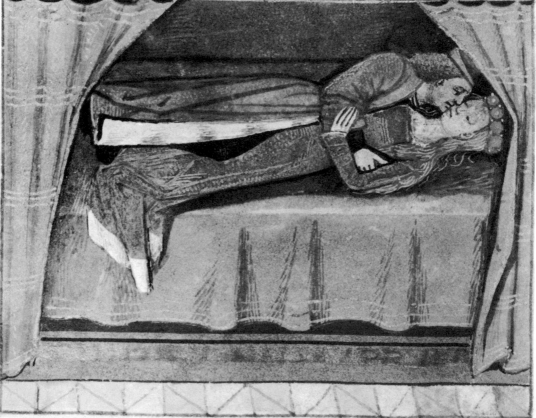

romance beats about no courtly rose-bushes and can be summoned up in the age-old erotic principle: 'Gather ye rosebuds while ye may!'

As an artist, Jean was quite lacking in Guillaume de Lorris' reticent good taste. He had all the gusto of a Rabelais, and poured out his thoughts in vast digressions, some of them well over half the length of Guillaume's entire contribution. He just did not know the meaning of moderation, one of the first courtly principles, and was little inclined to pay respect to anything, least of all to a romantic, self-denying passion for an idealised lady. Parisian as he was, he showed all the irreverent wit and cynicism of the bourgeois poets of his time: courtly love was none of his business.

The two sections of the *Romance of the Rose*, then, face in quite opposite directions. This had two consequences: on the one hand it appealed, at least in part, to a wide band of the social spectrum; and on the other it provoked a literary quarrel, spanning the fourteenth and fifteenth centuries, between the defenders and the denigrators of womankind. It was translated, re-worked, turned into prose and even, by one Italian poet, condensed into a long sonnet-sequence. Chaucer had a hand in its English translation; and while some think Dante may have been responsible for an Italian version, others claim that it prompted him to compose his *Divine Comedy*. It was widely acclaimed in France during the Renaissance, both for its lyrical exploitation of the love theme and for the humanistic qualities of Jean de Meung's disquisitions. And with its well-framed scenes and vividly depicted encounters, it was, along with some derivative texts, a splendid source of inspiration for

49 Heralds sound the assault on the Castle of Love as the ladies hurl down their roses. No direct literary source is known for this popular motif.

artists in paint, ivory, wood, metal-work, tapestry. In their products we see the rose-garlanded subjects of the God of Love endlessly repeating their graceful dances, while the Castle of Love suffers assault after assault and the Rose waits trembling on its branch. So the reverberations of the romance were loud and slow to die away: perhaps its distant echoes can still be caught from time to time by the attuned ear.

Chapter V

Love and Fate: Tristan and Ysolt

Tristan — the very name has a melancholy ring; and indeed the medieval tradition told that he was so called from the French word *triste*, 'sad', in token of the grief attending his birth and in anticipation of the life of care that lay before him. However, scholarship has come along, and not for the first time, to spoil a good story. For if we peer back far enough towards the legend's beginning, we find that its hero is unlikely to be a pure fiction, but once breathed the Scottish air under the name of Drust, a Pictish king who died in about the year 780. We know scarcely anything about the man behind the name and certainly nothing of his love-life; but that is just as well, since it would be wrong to introduce too much history into a legend that has always been touched by a wistful, haunting magic. It is a magic that has its source in the Celtic lands; so let us linger there for a moment before we turn to the poets of England, France and Germany, who recorded the story in the form we know today.

There was a very ancient Irish tale of Diarmaid and Grainne, of which only scraps and a version surviving in modern Irish remain. It spoke of the mighty Finn mac Cumaill and how he sought as his wife Grainne, daughter of the High King of Ireland. But it was not to Grainne's taste to have as a husband a man older than her father; so when he and the King and their companies were feasting together, she called to her maid to fetch a golden cup. This she filled and passed round to those in the hall. All who drank from it fell asleep. Then she asked the handsome young Diarmaid, Finn's nephew and reputedly the best lover in all Ireland, if he would take her to his heart. Knowing she was already promised to Finn, Diarmaid refused, whereupon she put him under a *geis* or compulsion that he would be destroyed should he not make off with her that night before the company awoke from their sleep. He asked advice from three companions, one of them Finn's own son, and they said he should do as Grainne asked.

So he took the princess and travelled far across Ireland until they came to a forest. There he built a house with seven doors where they might dwell. But Finn set out to find the eloped couple, and with him went Diarmaid's companions, who contrived to send Finn's dog Bran to them as a warning. Their danger was revealed to Diarmaid's divine foster-father, and he came to take them to safety. Diarmaid allowed Grainne to go, but himself refused to leave. Soon Finn and his men came to the doors of the house, promising him safe exit if he would come out. Diarmaid, however, found the door where Finn was waiting and, with a great leap, cleared the heads of him and his followers and escaped into the forest, soon to rejoin Grainne.

At first, Diarmaid would not grant Grainne his love, since it had been only on her insistance that he had eloped with her: at night they would sleep

apart, and he would place a cold stone between them. One day as they were travelling, some muddy water splashed up onto her leg. She turned to him with a reproach: 'Brave as you are in battle, this splashing water is more daring than you.' The words cut to the young man's heart, and he thereupon took Grainne as his wife. After many adventures, peace was made between them and Finn, and Grainne bore Diarmaid four sons. For long years they lived happily until the day when, hunting a wild boar, Diarmaid was cruelly wounded by the beast. Finn, who was there, could have saved his life by bringing him water in his hands to drink; but remembering Grainne, Finn opened his fingers, and the water flowed away.

A far cry, this, from courtly love as played out by Lancelot and Guenevere or the Dreamer in the *Romance of the Rose*: the girl forcing her passion on the young man by a kind of spell, quite against his will; the thwarted bridegroom (in an early version Finn is already married to Grainne) pursuing them furiously, then accepting the *fait accompli* before having the last word in the hero's destiny. One has too the impression that the chief actors in the drama are even less in control of their fate than are the conventional courtly lovers. Diarmaid's death, we are told, followed his infringement of a taboo; his

50 Aerial photograph of the ruined fortress of Tintagel in Cornwall.

elopement was compelled by a *geis* laid on him by Grainne; we see the inter-
vention of mysterious personages still charged with the power of their
ancient divinity. Love, when it comes, may be true and passionate, but it
does not rule the stage alone: there are other, even more uncanny, forces
with which it has to contend. On the other hand, those who see some Celtic
influence behind courtly love would point to the dominant position of the
lady who, in other Irish and Welsh tales, appears as a fairy mistress with
absolute control over her lover, issuing commands he disobeys at his peril.
The fact is that these ancient myths did contain features which could, with
skill, be harmonised with the vision of courtly love: after all, Queen Guene-
vere's abductor seems to have once been a figure from the Celtic Otherworld,
of which evident traces remain in his land of Gorre. But what of Tristan in all
this?

We left him, as King Drust, among the Scottish Picts. Now legends grew
about his name and spread to the Welsh, avid storytellers who also knew of
Diarmaid's adventures and something of another legendary king, Mark of
Cornwall. Tales fused and developed and, it seems, passed to Brittany, where
further ingredients were stirred in, such as the slaying of a dragon to whom a
princess was to be sacrificed. The brew was still not ready for courtly appe-
tites until it had been spiced by elements from yet more exotic parts: Indian
and Arabic sources are among those that have been proposed. Only then did
it find its way into French and to ultimate recognition as one of the great love
stories of all time.

The next stage in its career is, however, the subject of continuing dispute.
Chrétien de Troyes, in his *Cligés*, mentions that in an earlier work, now lost,
he had dealt with King Mark and the fair Ysolt. Strangely, he does not speak
at this point of Tristan; but he was certainly familiar with him, for in the
same romance he makes disparaging remarks about the nature of his love for
Ysolt. Why disparaging? Because, we may surmise, he was pricked by a
sense of rivalry with an Englishman called Thomas, whose own version of
the story was already circulating and winning public acclaim. Thomas, who
wrote in French, is likely to have worked under the patronage of the cultured
Queen Eleanor, whose acquaintance we have already made.

About a generation later, in the last decade of the twelfth century, a
Norman, Béroul, composed a *Tristan*, which has a great deal in common with
a rather earlier German poem by a man called Eilhart. The story was already
casting its spell over wide areas of northern Europe and would continue to do
so through the Middle Ages and beyond. Another German poet, the highly
talented Gottfried von Strassburg, translated Thomas' romance from French
in the first decades of the thirteenth century, and it was also soon rendered

into Norse and, much condensed, into English. A few accounts of individual episodes plucked from the legend exist in French and German; but the reverse process early set in with the composition of long, rambling French prose versions, which provided a mine of material for writers in Italy and Spain as well as for Malory, when he came to compose his own *Book of Sir Tristram*. The dispute I mentioned is not concerned with this later period, but with the possible existence of a single French, or Anglo-French, ancestor of all the surviving texts and the form it might have taken. This, however, is too complex and thorny a problem to be discussed here.

One further word before we turn to the story itself. The course of its transmission has suffered almost as many vagaries of fate as did the progress of the love it describes. Béroul's version is incomplete, Eilhart's preserved largely in a late redaction: together they present a relatively unpolished form of the legend. Thomas and Gottfried, on the other hand, combine to offer us a much more courtly version — literally combine, because neither of their romances has come down to us in its entirety; and by a curious chance, the surviving fragments of the Englishman's begin where the German's poem breaks off. My summary will be of the chief episodes in this courtly version.

Gottfried dedicates his work to all those of noble heart. In it they will find love exalted and virtue, honour and constancy encouraged: so blessed a thing is love that without it no man can aspire to these high qualities. Yet he must be prepared to find suffering too; for pain is inseparable from love, and whoever has not discovered this for himself has never truly loved.

Tristan was born in grief, since his mother the lovely Blancheflor, learning of the death in battle of her husband Rivalin, died from sorrow at the very moment of his birth. The lad was brought up by his father's marshal and trained in all the courtly and chivalric arts: reading, the study of languages, singing and playing all manner of instruments, riding, running, jumping and excelling at the martial sports, while no one ever learnt to hunt and track as well as he. Some merchants from Norway arrived in Brittany, Tristan's land, and were so impressed by his gifts that they kidnapped him and carried him off in their ship; but thinking a great gale that overtook them was God's punishment, they abandoned him on a rocky shore.

This is how Tristan left his native country and found himself in Cornwall, the realm of King Mark who, unbeknown to him, was his own uncle, his mother's brother. Before long his many accomplishments won him great favour in the royal court at Tintagel; and it was there that his foster-father the marshal came one day in search of him and disclosed his true identity, there too that Tristan, having reached an age for knighthood, was dubbed by

Mark with high pomp. At once he sailed for his own land, took vengeance on his dead father's enemies, and rewarded those who were now his own vassals. Then he returned to his uncle's court at Tintagel.

His welcome there was clouded by the distress into which the men of Cornwall had been plunged by the sudden appearance of Morholt, the giant champion of the King of Ireland. He had come to demand for his lord a tribute to which he had long laid claim: thirty boys chosen from among the finest youth of Cornwall. The only alternative was to find a man who could defeat the giant in single combat. Tristan asked that the Cornish cause be placed in his hands; and on a nearby island the duel took place. Although he

51 Tristan harping before King Mark, on a 13th-century English floor tile.

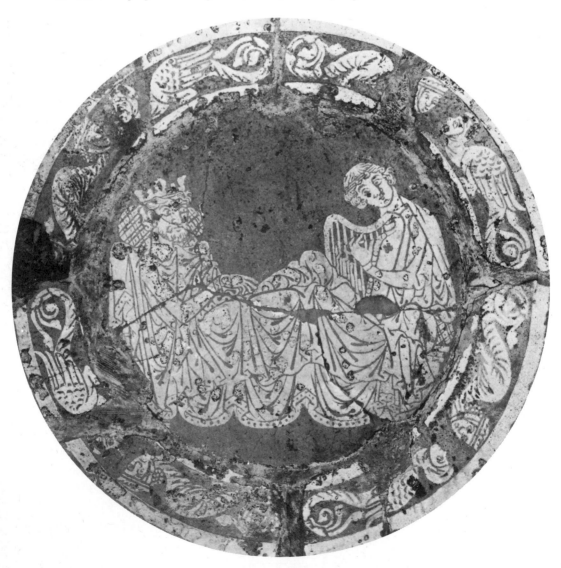

X Venus hurls her fiery brand at Jealousy's fortress (see p. 71).

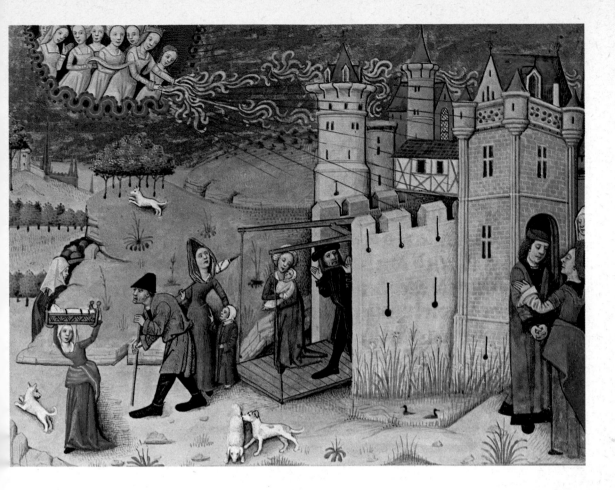

Pvce ce que ie boue
ay par maintes
fois cote histoire
du saint grial.
moult me mueil
que aucun ne vient qui translate
le latin en francoys. Car ce seroit
vne chose que volentiers orroient
poures et riches. Et pour conter
belles adventures qui advindrent en
la grant bretaigne au temps du
bon roy artus. le sire cheualier se
du chastel de gaut voisin prochain
de salesbieres emprainst a translater

du latin en francoys vne partie de
ceste hystoire. Non mie pour ce que ie
soye francoys ainz suy anglois Et
se mensbe que ie pourray ie transla
teray ce que se latin en deuise de hi
stoire de tristam. qui fut le plus
sonnerain cheualier qui onques
fust en la grant bretaigne deuant
le roy artus et apres freres galaas
et lancelot du lac. Et ce deuise bien
le saint grial. Car ilz ne furent
au monde que trois cheualiers qui
feussent aprisiez. fors galaas lance
lot et tristam. Et pource que ie freis

suffered terrible wounds, Tristan finally sank his sword into Morholt's skull, where a piece of its blade remained imbedded. The Irish who had come with Morholt carried back with them no tribute but the corpse of their champion, who was brother to their own Queen. Overcome with grief, she went with her daughter to take the fragment of Tristan's blade and lay it away in a casket. And there was none who mourned more deeply than the girl, the fair princess Ysolt.

In Tintagel the joy was short-lived. Tristan grew ever weaker from his wound, made by a sword whose tip, as Morholt had confessed, was smeared with a poison for which only his sister the Queen knew the cure. Tristan

52 King Mark embraces his nephew Tristan.

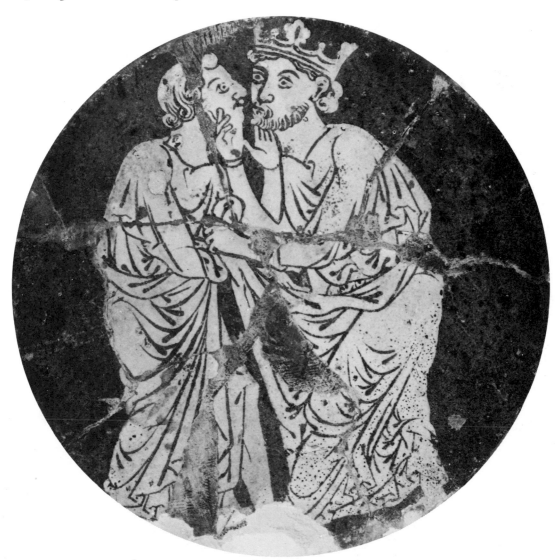

XI Episodes from the Tristan legend.

begged to be secretly taken into a boat and left to drift towards the Irish shore with only his harp for company; and this was done. Some passing sailors, hearing his singing and the sweet strains of the harp, took him from the boat and brought him with them to Ireland, where the news of this dying man who sang and played with such art came quickly to the ears of the Queen. Announcing himself as Tantris, a court minstrel, the harpist performed so exquisitely when he was carried before her and her daughter Ysolt that she not only devoted her care to his cure but also put the princess under his tutorship. At last he was quite healed; and, on the false plea that he had a wife awaiting him at home, he took his leave of them both and returned to Cornwall.

At his uncle's court, his lavish praise of the perfections of the lovely Ysolt

53 The Irish king Languis appoints Morholt to lead his army to Cornwall. Morholt holds the glove and mace, symbols of his ambassadorial office.

was soon used against his interests by Mark's barons, who had grown jealous of the favour in which he now stood. Though the King wished no heir other than Tristan, they advised him to seek Ysolt's hand in marriage and to send his nephew to do the wooing for him in Ireland, where there was still no man more hated than the slayer of Morholt. Ironically, it was Tristan himself who finally won Mark's agreement. (At this point Gottfried pours scorn on an old story of a swallow that had carried one of Ysolt's golden hairs from Ireland and how Mark swore to marry none other than the lady from whose head it had come.)

The mission was as perilous as Mark's barons had hoped. To begin with, the Irish King had resolved to give his daughter over to no man except the one who could slay a dragon that ravaged his lands. This the unrecognised

Tristan accomplished; but he was so overcome by the venom issuing from his victim that when, after the combat, he was found by Ysolt and her mother, he was near to death. Fortunately, it was not long before the princess recognised him as Tantris the minstrel and nursed him lovingly back to health. However, looking one day at his sword as he sat in his bath, she

54 'How Morholt came to Cornwall with forty galleys.' The figure on the poop directs the rowers with a whistle. Morholt has disembarked and is challenged by Tristan who offers his glove as a battle-gage.

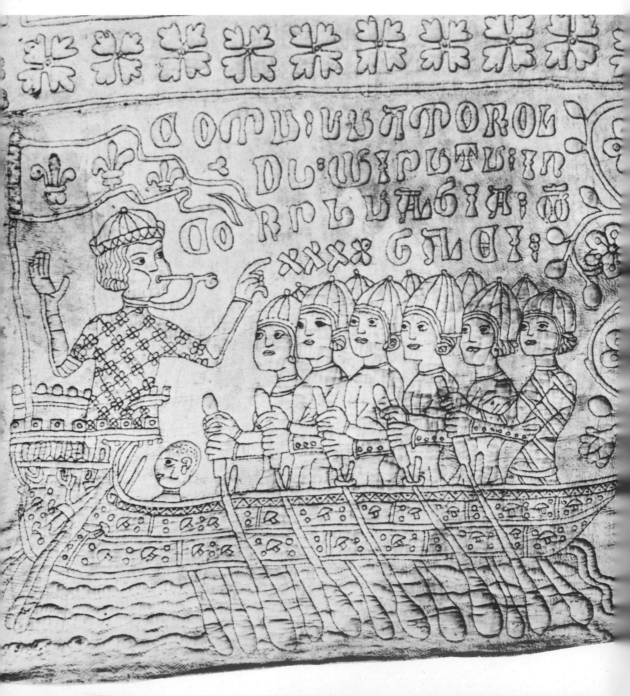

noticed the notch in its blade. With her suspicions aroused, she fetched the fragment found in Morholt's skull. It fitted the notch perfectly. Only then did she identify the name Tan-tris with Tris-tan. In her distress she would have put an end to him there and then, had she not been restrained by her mother, who had earlier pledged his safety, by the pleadings of her attendant Brangain, and by her own womanly pity. Eventually, Tristan was reconciled not merely with them, but with the Irish King as well, and to such good

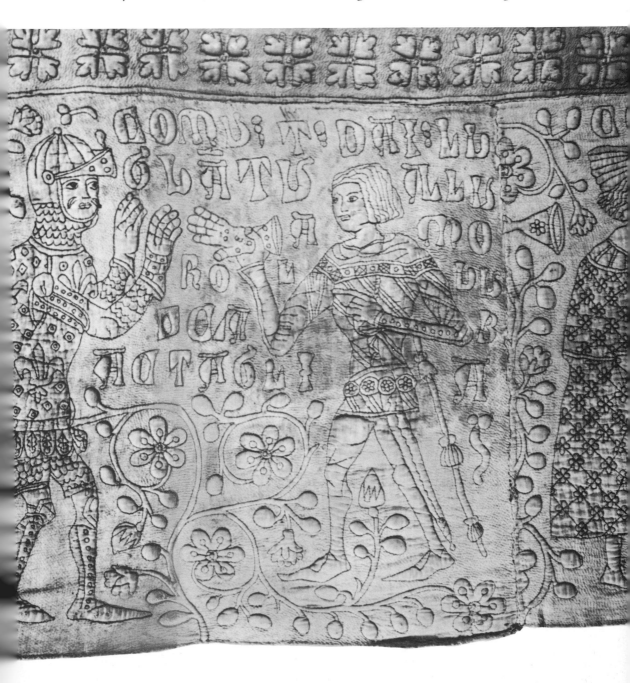

effect that Mark's suit was granted. Then, to ensure the happiness of the forth-coming marriage, the Queen prepared a love potion, which she passed to Brangain for safe keeping. Such was its power that 'with whomsoever any-one drank of it, that person, like it or no, must be loved by him above all else and in return must love him alone: they were to share one death and one life, one sorrow and one joy.'

With Ysolt and Brangain, Tristan embarked for Cornwall. On the way, their ship put into harbour for a while to give the ladies some respite from the waves. Sitting with Ysolt, who still nursed some hatred in her heart for her uncle's slayer, Tristan called for wine. A young maidservant went to the ship and fetched a flask, from which first the princess and then the knight drank.

55 The Cornishmen lament the fate of their sons, claimed as tribute by Morholt.

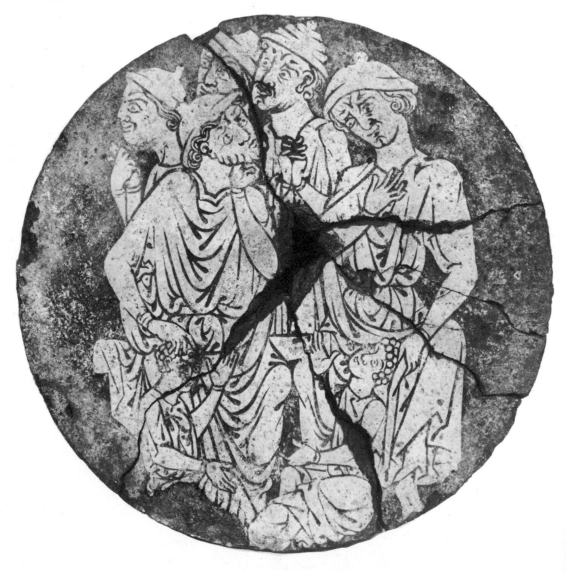

At that moment Brangain came to them. Horrified, she recognised the flask and, picking it up, hurled it into the sea with a cry of despair: 'Alas that I was ever born! Wretch that I am, I have betrayed my honour and the trust placed in me.... Alas, Tristan and Ysolt, this drink spells death for you both!' Love lost no time in driving enmity from their hearts, though both were loath to welcome it at first and concealed their growing passion as best they could. For it troubled each of them, setting at risk honour and loyalty, and particularly Tristan's sworn and cherished allegiance towards King Mark, his uncle. But very soon its power overcame their pretence, and by roundabout words their mutual confessions were made. Then they confided in Brangain, who put aside her misgivings and came to their aid in keeping secret their loving, which now broke through all restraint. Before the end of their voyage, Ysolt was a maid no longer.

(At this point Gottfried, ever free with his elegant commentary, pauses to reflect on the nobility of love, so often falsified in his day. This gives us an opportunity for a few thoughts of our own on what he, following Thomas, has so far offered us. The old Celtic magic has been largely banished from the story. The love potion, to be sure, is rather more than a common aphrodisiac; yet it functions mainly as a piece of narrative decoration, without which the story could have been much the same. From their first meeting in Ireland, Tristan and Ysolt showed how highly each valued the other [the tutor-pupil relationship conjures up memories of Abelard and Heloïse]; and in Cornwall Tristan was as ardent as any lover in his praise of the princess. Even her hatred was of the kind that serves to screen a guilty infatuation. So when they found themselves together on the ship, we were more than prepared to see their defences fall and a sensual relationship begin. Despite its magical origins, the potion now serves as much as a symbol as an agent, helping us to feel more acutely not simply the inevitability of their love but also its engulfing totality and hence, guilty as it is, its burden of joy and misery, of life more intensely lived and of ultimate doom.

Its very fatality, though, distinguishes it from the courtly love we have found elsewhere. In both cases, it is true, the act of falling in love is unpremeditated, although the essential natures of both knight and lady predispose them to it from the start. But in these Tristan romances they are reluctant to enter Love's garden; and the fact that they are forced into their passion against their will and better judgment is something quite new. Love, for all its infinite sweetness, is for Tristan and Ysolt a hostile force, more demon than god. The courtly trappings do not deceive us: we are in the presence of a passion more primitive because less spiritual, and so perhaps more human than was contemplated in the courtly code. Let us see its consequences.)

When the party arrived in Cornwall, the royal marriage was arranged with all speed. Ysolt, fearing the outcome should Mark find his wife no virgin, persuaded Brangain to be the first to lie with him in the dark of the wedding night. Thus the King suffered his first deception; and afterwards Ysolt, now Queen, found ample opportunity to resume her secret liaison with Tristan. But she began to think of what might follow if Brangain, who alone shared their secret, ever betrayed them to Mark. It would be better, she decided, to have her companion put out of the way, finally and at once; so she engaged

56 Tristan cleaves Morholt's helmet with his sword.

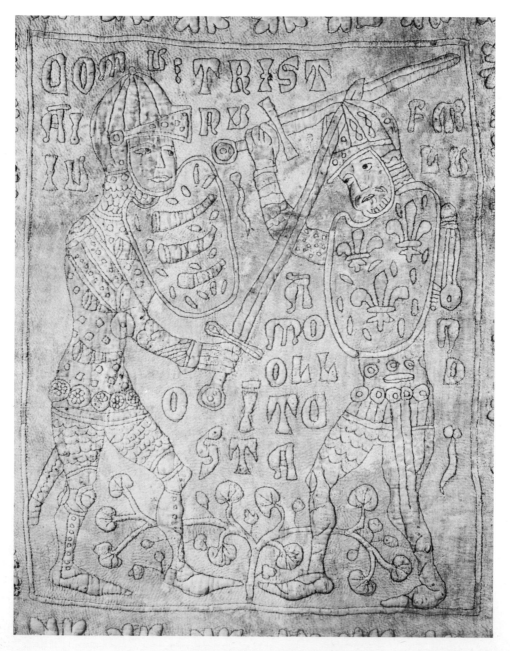

two squires to do the deed. Finding, however, that Brangain remained faithful even in the face of death, she was quick to relent, and redoubled her trust in her.

Once, while Tristan was out hunting, a knight from Ireland arrived carrying a rote (a harp-like instrument). Asked by Mark to play for them, he agreed, but demanded a gift in return. 'Anything you wish,' said Mark; but

57 'How Morholt treacherously shot Tristan.' In the version known to the embroiderer, the mortally wounded giant shot a poisoned arrow at Tristan from his boat.

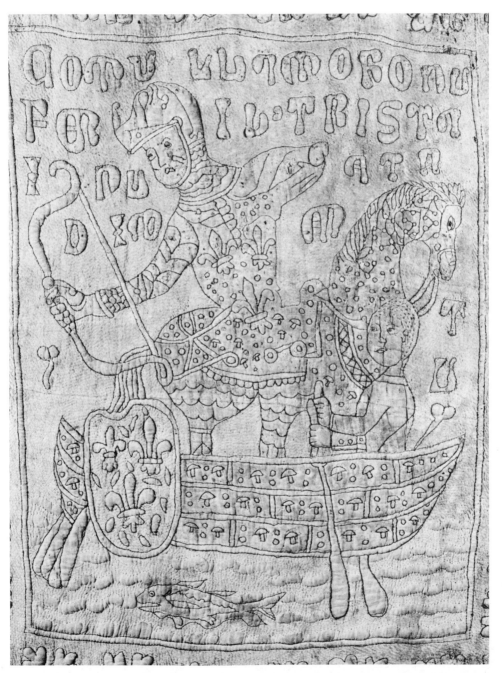

58, 59, 60 (*above, left and right*) Tristan slays the dragon molesting the land of Ysolt's father, and brings its head to the Court. Below are the various scenes which make up this 13th-century German embroidery.

to his consternation the reward claimed was Ysolt herself, with whom the knight had long been in love. As he led her away towards his ship, King and barons remained strangely impotent. At this moment of crisis Tristan returned from the hunt and, taking his harp, confronted the abductor. Challenged by him to dry the Queen's tears with his playing, he performed so well that he earned the knight's goodwill and his permission to conduct Ysolt to the ship on his horse. Needless to say, instead of seeing her safely aboard, he turned his horse and galloped back with her to the court.

Now fortune deserted the lovers. One night the King's seneschal surprised them together and, without disclosing the whole truth to Mark, made sure his suspicions were aroused. Tristan and Ysolt, however, were now also

61 As Tristan and Ysolt relax over a chess board the fatal potion is brought to them, and Tristan drinks.

on their guard, and the Queen skilfully parried Mark's attempts to trick her into betraying her guilt.

(The romance takes on the aspect of a game of cat and mouse, of ruse and counter-ruse. King Mark, goaded by others into devising more tests, suffers not merely the agonies of a betrayed husband but also violent shifts from doubt to certainty, to reassurance and to doubt again. Meanwhile the lovers' passion compels them continually to disloyalty, in full awareness of their guilt yet powerless to turn from its fatal course. Our sympathies are divided between the good but weak and vacillating King and the two who are deceiving him. Yet in his telling, Gottfried seems to wish us to forget the incidents and moral implications of the story and focus our minds on the purity of a love that in its absoluteness rises above common morality. Mark is not himself the real menace to this love, which is beyond his comprehension. Behind him stand the jealous barons, the slanderers, the informers, embodiments of all those malicious forces that traditionally beset courtly lovers. This is where part of the legend's appeal lies: it tells of the martyrdom of a transcendent love at the hands of baseness and ignorance. Much of its popular

attraction, though, came from the lovers' crafty attempts to outwit their enemies, in a series of episodes that found great favour with the artists of the time. The Middle Ages delighted in successful stratagems.)

King Mark was persuaded to ban his nephew from the company of the ladies. With Brangain's help, however, Tristan was able to make secret assignations with Ysolt by carving their initials on twigs and floating them down a stream that flowed by her quarters. One night a dwarf, who was in league with the royal seneschal, spied them embracing beside the stream; but in the darkness he could not be sure of their identity. This he reported to the King, who hid with him the next night in the branches of a tree that stood beside the stream. Tristan came first to the meeting place; but as he stood waiting he saw, cast by the moonlight on the grass before him, the shadows of the watchers in the tree. When Ysolt stole up, she was surprised to find her lover not running to embrace her. Then she too saw the shadows and, realising that a trap had been laid, called to Tristan reproaching him for summoning her to this secret rendezvous, especially in view of the unfounded gossip which, she said, was bringing suspicion on them. Taking his cue, Tristan declared his intention of leaving the court; and after Ysolt had promised to plead his innocence before Mark, they parted. The King was reassured by their words.

If his doubts were dispelled on this occasion, they were soon revived by his evil counsellors, and a new trap was devised. Together with Mark, the lovers had themselves bled one day, for their health. On the night of the following

62 Tristan harping to Ysolt.

day they retired, along with Brangain, the dwarf and a young maidservant, to bed in an ill-lit room. When the bell for matins sounded, Mark rose and, telling the dwarf to follow him, left for church. Before he joined his master, the dwarf spread a covering of flour on the floor between Tristan's bed and the Queen's. This Brangain had seen; but despite her warning, Tristan was determined to join Ysolt. Avoiding the flour with a tremendous leap, he gained her bed, but only to find that the vein where he had been bled had opened again, and the sheets were being stained with his blood. In alarm, he returned by the same aerial route. When Mark came back, he accepted Ysolt's explanation of the stained bed (her own vein, she said, had opened); but finding Tristan's in a similar state, he was seized by his old suspicion, even though no tracks were to be seen in the flour.

On the advice of high prelates in London, it was resolved that the Queen should submit to trial by ordeal. She had to travel to the place of her testing by boat, and, having secretly sent Tristan word of a scheme she had worked out, she found him waiting in pilgrim's disguise as the craft neared the land. In her present plight, she claimed, here was the man most fit to carry her to the shore. Tristan was only too glad to lift this precious burden and then, as previously arranged, to stumble and fall with her still in his arms. Mark saw all that happened; so he had no reason to question Ysolt's oath when she swore that never had she lain with any man save her husband and the poor pilgrim by the shore. That was the oath she took; and when she underwent

63 Tristan and Ysolt see in the water the reflection of the spying Mark. The scene on the right shows the slaying of a unicorn, a beast believed to surrender itself only to virgins.

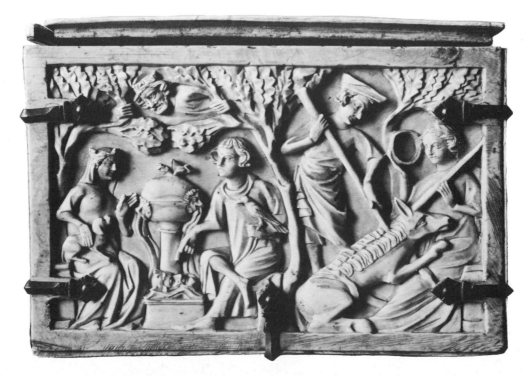

her ordeal by grasping a red-hot iron in God's name, her hand was not burnt. Gottfried's comment is surprising:

> Thus it was shown to public view and confirmed to the whole world that Christ in all his virtue blows in the wind like a sleeve: however one may try him on, he fits and clings closely and well, as it is right he should. He answers the call of every heart, for honest deeds and trickery alike. In earnest or in sport, he is just as one would have him.

Mark's mind was put at rest once more by this divine assurance.

His new-found trust was not to last for long. Fresh doubts and suspicions wormed their way into his thoughts and grew into certainty. Then, loving both wife and nephew as he did, he could find but one solution: to banish them together from his court. With sorrow more feigned than real, they journeyed to a place Tristan knew of. On a mountainside was a marvellous cave dedicated in heathen times to all lovers, exquisitely decorated within, and furnished with a crystal bed set on green marble and bearing an inscription to the Goddess of Love. There Tristan and Ysolt lived a life of rapture needing no other sustenance than their mutual devotion. It happened, however, that King Mark turned to hunting as an escape from his melancholy; and with his men he came to a nearby forest. In their cave the lovers heard the sounds of the hunt. Fearing discovery, Tristan thought it best for them to lie apart on the crystal bed; and between them he laid his sword. Sure enough, one of the huntsmen stumbled on the cave. Looking down through a high window, he saw a handsome knight and what he took to be a goddess sleeping upon the crystal. He went to tell Mark, who came to the spot alone. There he saw his wife and nephew, with the bright sword unsheathed between them and a shaft of sunlight from the window playing on Ysolt's enchanting features. The sight of the sword swayed him yet again to believe in their innocence. Fearing the sun might harm Ysolt's complexion, he blocked the window with grass, leaves and flowers, then went quietly away.

On his return to court, Mark sent word to the lovers that they were at liberty to come back and resume their former status and positions. They did so and, though it pained them, discreetly avoided all public sign of their love. Then one summer's day fate led the King to Ysolt's garden, where he found her enlaced in Tristan's arms. For Mark there was to be no more doubting, and for the lovers no more peace. Tristan bid his beloved a sad farewell. Ysolt gave him a ring as a remembrance, so that no other love should come between them, then spoke her parting words:

> 'We are one life and one flesh. Now always keep your thoughts on me, Ysolt, your flesh. Let me see my life again in you as soon as that may be, and so may you see yours in mine. You have the keeping of both our

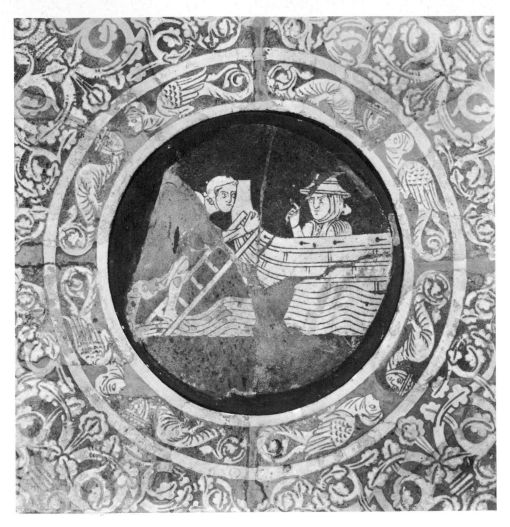

64 Ysolt has arrived for her trial; the disguised Tristan comes to convey her from the boat.

lives. Come here and kiss me now. You and I, Tristan and Ysolt, are for-
ever one and undivided. This kiss shall be a seal upon our pledge that
until death I shall remain yours and you mine, but one Tristan and one
Ysolt.'

Tristan took ship and for a long time adventured in lands beyond the sea,
then served a Duke of Brittany (Arundel in Gottfried's version) against his
enemies. The Duke had a lovely daughter, Ysolt of the White Hands; and
Tristan showed her much affection, while reserving his true love (though the
girl did not know it) for far-off Queen Ysolt the Fair. However, he began to
debate in his mind why the Queen had sent no messenger to seek him out.
Had she found happiness in her new life with Mark? Had thoughts of Tristan
passed from her mind? Gottfried was not to supply the answer, since this is
where his poem ends; but now a major fragment of Thomas' romance
begins.

Tristan found himself in mental torment. He was now loved by Ysolt of the White Hands, but it was her name not her beauty that evoked a response in him. Yet would he not do well to marry her, and so put himself in the position of the Queen, who was married to Mark? His experience would be as hers; and he would know for himself what complexion it put on love. If she had forgotten him, this would be his melancholy revenge. But if he did surrender to this girl's love, then it must be within marriage, for the Queen would have thought all else dishonourable. In the end, that was the course he took. But on the marriage night, the sight of the ring Ysolt the Fair had given him put him into an anguish of repentance. The maid was now his wife, but she kept her maidenhood that night.

In Cornwall, meanwhile, Queen Ysolt pined for news of her lover. One day she composed a sad lay of love telling how a count, whose wife had taken a paramour, served her the slain man's heart to eat. As she sang her lay, a knight who would dearly have won her affection brought to her the news of Tristan's marriage. Ysolt was plunged in deep distress.

(Here this fragment of Thomas' poem ends; but there are others which together bring the story to its conclusion, while the gaps between them can be bridged from the medieval adaptations of the Englishman's romance.)

For his consolation Tristan had constructed in Brittany a magnificent hall within a secret cavern; and there he had fashioned statues of Ysolt and Brangain so lifelike that he could embrace his beloved and pour out his thoughts to both as if they were flesh and blood. Although he was still torn between his love for the Queen and his fears that her own had grown cold, his marriage to Ysolt of the White Hands continued to exist in name only (and being unconsummated had not, in medieval eyes, achieved full legality). Thomas, like any setter of courtly riddles, asks his public which of the four has the greater torment: King Mark, who has Ysolt's person but not her love; his Queen, who possesses what she does not desire; Tristan, married to the Ysolt whose passion he does not share; or his maiden wife, committed in wedlock to a man withdrawn from her.

Ysolt of the White Hands disclosed her plight to nobody until one day, as she rode with her brother Caerdin, her horse stumbled in a muddy pool, splashing water up onto her leg. When Caerdin asked the reason for her bitter laugh, she explained that never had Tristan been as bold as this water. Caerdin, who had been Tristan's close companion, felt deeply this slight upon his family honour. He taxed his friend with it and, when Tristan confessed his love for the Queen whose beauty outshone even that of his wife, Caerdin demanded proof of this extravagant claim.

Together they travelled to England. At a certain city they learned of

Mark's imminent arrival, so went out to watch for him and his retinue, hiding in a tree beside the road he would take. Once the King had passed, there came the ladies of the court, singing and making love-talk with their escorts; and Caerdin's wonder grew as he watched the ever more dazzling cavalcade ride by. When at last he saw Ysolt and Brangain, he freely admitted that his sister was no match in beauty for either. As Caerdin was not known in England, he was able to approach the Queen at Tristan's prompting and learn from her of the castle in which they were to spend the night. There the two companions went in disguise, and there Tristan had a joyful if surreptitious reunion with his beloved, while Caerdin paid ardent court to Brangain. On the two following nights their meeting was repeated and, after a show of reluctance, Brangain accepted Caerdin as her lover.

Then word of the escapade leaked out, and the companions were forced to flee. The confusion was such that Brangain was persuaded, quite wrongly, that Caerdin had behaved in a cowardly fashion. Ysolt's defence of the knight's reputation served only to increase Brangain's bitterness, which she now turned against the Queen herself. In her chagrin she went so far as to blacken Ysolt's name before Mark with accusations that she was casting lustful eyes in new directions. Ignorant of how matters stood, Tristan after a

65 Tristan's marriage to Ysolt of the White Hands. Ysolt's father (King Hoel in this version) gives the couple his blessing in the presence of Tristan's companions Gouvernal and Caerdin.

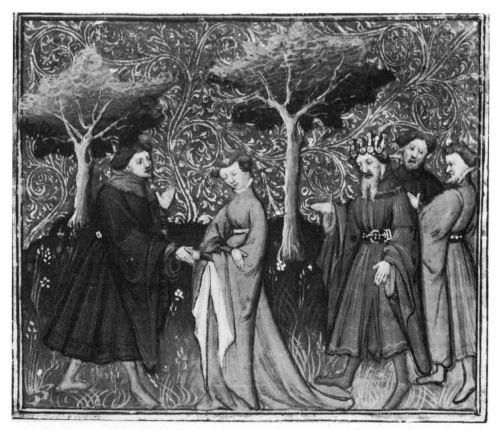

while ventured once more into the court, disguised this time as a leper. From an alms bowl he carried, given him by Ysolt in the first year of their love, the Queen knew who this was. So too did Brangain, and she, out of the malice she now bore, had him flung out of the court. But learning later that the leper was lying almost dead from grief in a nearby ruin, Ysolt stirred Brangain's pity and, through her, contrived another assignation that very night. At daybreak Tristan was forced to leave his beloved and make his way back to Brittany and his wife.

Once more Tristan and Caerdin ventured to King Mark's court, disguised now as penitents; and again they found brief solace with Ysolt and Brangain before returning to a life of adventuring in Brittany. There Tristan encountered a knight who implored his help to regain his abducted mistress. He fought and slew her captor, but in the duel was sorely wounded by a poisoned lance. Only one person, he knew, had the power to heal him. So he called Caerdin to his chamber, where he lay nearer death than life, and begged him to journey to Ysolt and, if he could, bring her back with him; for she was his only love, and she alone could restore him to health. When Caerdin returned he was to hoist on his ship a white sail if the Queen was with him, and a black one if she was not. All this his friend promised faithfully to carry out. But unknown to Tristan, Ysolt of the White Hands had overheard his instructions, which revealed to her where his true love lay. Her heart burned with jealousy.

The Queen needed no urging from Caerdin when he brought her the news. Soon they had slipped furtively from the Cornish court and were making good speed across the sea to Brittany. However, when they were in sight of land a great gale blew up. It raged for five days before they were able to hoist the white sail and make for the harbour. But that was the last day of the period Tristan had set for Caerdin's return; and now the wind dropped entirely, so that the ship could make no further progress. On shore, Tristan lay suffering and longing for its safe arrival. Then Ysolt of the White Hands came to him, saying she had spied Caerdin's ship far out to sea. At this, Tristan started: 'And what does it carry at the mast?' — 'For lack of wind they have run up a high sail, all black.'

> Then Tristan felt such grief as he had never known, nor would ever know again. Turning to the wall, he said: 'May God save Ysolt and me! Since you will not come to me, I must die for love of you. I can stay alive no longer: I die for you Ysolt, dear love. You feel no pity for my suffering, but for my death you shall grieve. It is a great comfort for me, my love, that you will feel pity for my death.' Three times he said: 'Ysolt, my love'; and at the fourth he yielded up his spirit.

Now the wind rose, and the ship came to port. Ysolt was greeted only by the mourning for Tristan's death. She ran through the streets to where his body lay, and all who saw her marvelled at her beauty.

'Tristan, my love, now that I find you dead, I have no right to stay alive. You have died for love of me, and I, love, die of pity that I could not come in time to heal you and your malady. My dear beloved, through your death I shall never feel any comfort, and no joy or gladness or pleasure will be mine. May that storm be accursed, my love, that kept me back on the sea so that I could not come here! Had I come in time, beloved, I would have restored your life and spoken sweet words of the love that has been between us, lamenting my own lot, telling our joy and delight, and the suffering and heavy grief our love has known: of all this I would have reminded you with kisses and embraces. Since I cannot heal you, then let us die together! As I could not come in time, not having heard how matters were, and have arrived to find you dead, then I shall drink my comfort from the same cup. You have lost your

66 Ysolt's voyage to Brittany to heal Tristan.

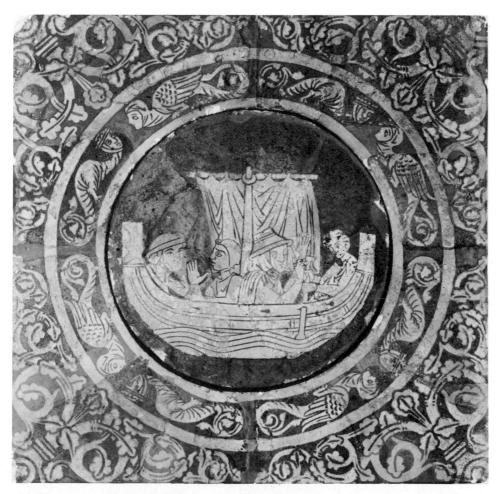

life for me, and I will do as a true lover should: my wish is to die in the same way for you.'

　　She lies and takes him in her arms, kissing his mouth and face; and, with their bodies in close embrace, mouth pressed to mouth, she at once yields up her spirit and her life beside him, out of grief for her beloved.

So ends the story of this movingly human and yet fated love. It is a story purely tragic in that villainy does not play the major role. The lovers' struggle, though in part against the hostility of man, is waged even more within themselves and, above all, against the tyranny of an inflexible destiny. If its humanity was largely the contribution of the French and German romancers, the working of fate is a legacy from the Celtic world. Appropriately, both have a hand in the final tragedy: fate in the delaying storms and capricious winds, humanity in the false report given by the embittered wife.

　　I have suggested that the Tristan legend is not shaped to the conventional pattern of courtly love. Equally it carries us far beyond the bounds of everyday morality; and it was probably as much this aspect as any rivalry with Thomas that persuaded Chrétien de Troyes to pastiche it a little, and very gently, in his romance *Cligés*. His young people there are not bound together by a potion accidentally administered: they fall in love, timidly and to their own perplexity, during a rather rough sea crossing. Chrétien reserves the potion as a device to prevent the consummation of the marriage of the hero's uncle to his own sweetheart, the heroine being determined, as she says, to avoid Ysolt's shameful situation. Indeed, Chrétien's own principle, stated in the romance, is that he who possesses the body should also have the heart.

　　But whatever moral scruples the legend may have aroused in medieval consciences, its popularity was immense. More often even than it was written on parchment, it was told in paint through miniatures and frescoes, in carving, on tiles and tablecloths and, less tactfully one might think, on bedspreads and marriage caskets. If the world loves lovers, it seems to keep its fondest affection for those who die for their love — and who more passionately, if not nobly, than Tristan and Ysolt?

Chapter VI

Two Tragic Loves

We have seen how the courtly code of love found admirable expression in the lyric verse of the troubadours and their imitators, and how it inspired at least one poet to a sensitive exploration, through allegory, of the psychology of its devotees. What we still have to discover is whether it was capable of generating from its own resources a sentimental story that satisfies and can be taken seriously. With his *Lancelot* Chrétien de Troyes quizzically posed the question, but evaded the straight answer; the *Tristan* poets clothed their legend in courtly finery without taming its primitive, uncourtly nature. Was courtly love just an elegant roundelay, or at best an artfully cut prism through which a poet might project his moods and yearnings? Or did it have any dynamic force of its own that could motivate a plausible story of sentimental relations?

Andreas Capellanus' Rules of Love might seem to discourage any hope for a tale that concludes happily in a permanent solution to the lovers' problems. Did he not assert that there can be no stability in love, which is forever either waxing or waning? that jealousy is one of its essential ingredients? that the true lover is always fearful? If, by any chance, all the obstacles to a couple's union disappeared, and particularly if they married, then according to these principles love would fly out of the window. So there would be nothing for it but to end the story either on a note of uncertainty (like *Lancelot*, though this was rare in medieval tales), or unhappily. Two French poets, who probably wrote at about the middle and the end of the thirteenth century, chose the latter solution when they tried to illustrate the courtly principles in their romances.

We do not know the name of the first man, who may have come from Picardy, though the scene of his story is set in Burgundy; so we cannot pay him the personal tribute he deserves for the fine taste and economy with which he composed *The Chatelaine of Vergy*. It could have been told to a courtly audience in well under the hour, but they would have remembered it long after. In fact it became one of the best loved tales of the Middle Ages, was re-told during the Renaissance by Queen Marguerite of Navarre in her *Heptameron*, and after her by the Italian Bandello. The Chatelaine and her knight were held up as a shining example of faithful lovers and, like Tristan and Ysolt, were freely depicted on such intimate objects as ivory caskets and counterpanes.

From the beginning of the romance we are left with little hope:

> There are some people who pretend to be loyal and to keep secrets so well that you cannot but trust them; then, when you happen to confide in them to the extent of letting them know of your love affair, they

spread it far and wide and make it a subject of joking and mirth. In this way the one who has confided his secret finds his joy gone; for the greater the love, the more grieved are true lovers when one of them thinks the other has told what he should conceal. And often such damage comes of it that their love has to end in deep sorrow and shame, as happened in Burgundy to a bold, worthy knight and the lady of Vergy. The knight loved her so dearly that she granted him her love on this condition: he could be sure that, if their love were disclosed by him, that very day and hour he would lose both her love and the favour of her person.

We have been warned: the plot will hinge on the courtly rule of secrecy within love; and at once the lady is presented as the conventional authoritarian mistress, quite prepared, it seems, to adopt a legalistic attitude towards any infringement of her terms. We are uneasy. Can this really be true love, or is it no more than a sentimental game whose rules are being rehearsed

67 Scenes from *The Chatelaine of Vergy* decorate this 14th-century French ivory casket.

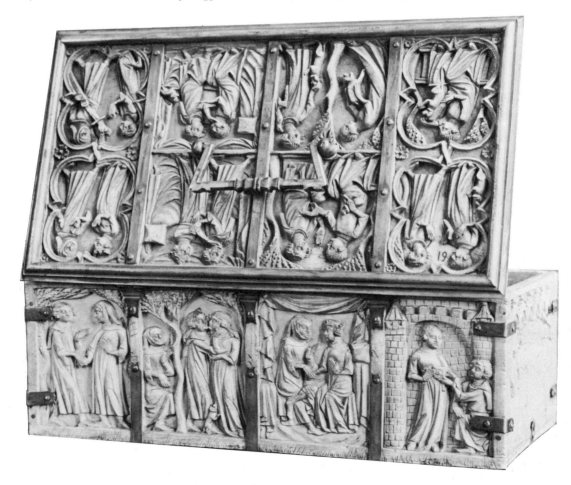

before the action begins? The knight, we must assume, has already per-
formed his amorous vassalage and has now acquired the status of recognised
lover, accepted on the lady's conditions. The stage is set.

The lovers found a way to meet in secret. At the appointed hour the
knight would go to the corner of his lady's garden and wait there until he
saw her little dog trotting about: that was the sign for him to proceed at once
to her chamber. In this way they enjoyed for a long time the fruits of their
affection. Meanwhile the Duke of Burgundy, recognising the merit of this
handsome knight, cultivated his friendship. But his wife the Duchess went
further; for seeing him so often at their court, she fell in love with him and
gave such signs of her tender feelings as he must surely have noticed, had his
heart not been in another place. Hurt by his lack of response, she tried a more
direct approach, telling him that a man of his valour and good looks deserved
to have a high-born mistress. Humbly the knight protested that the thought
had never entered his head. But the Duchess was not easily put off:

> 'I am a lady of honour and high rank: tell me if you know whether I
> have set my heart on you.' His reply is prompt: 'My lady, that I do not
> know; yet it would be my wish to have your love in an honest and
> honourable way. But may God protect me from such a love on my part
> or yours as would serve to bring shame on my lord; for nothing would
> impel me on any account to commit the criminal folly of so wicked and
> disloyal an act against my natural liege lord.' — 'Fie, Sir Ninny!' cried
> the lady in her vexation. 'And who is asking you to?' — 'Oh, my lady!
> I know, in heaven's name; but I am just telling you.'

That night, as she lay at her husband's side, the Duchess began to sigh and
weep. When the Duke asked what ailed her, she said she was grieved to think

68 A 14th-century Italian fresco showing scenes from *The Chatelaine of Vergy*.

that men in high places are so easily gulled by traitors. The Duke at once protested that he would never wittingly harbour one.

'Then hate that man,' she said (and named him), 'who has been imploring me all day to give him my love, saying it had been on his mind for a long while, but he had never dared tell me. My first thought, dear lord, was to tell you about it. And it may well be true that he has been thinking this way for some time, for I've never heard of him having any other love. So I ask you as a favour to look to your honour, as you know it is right you should.'

There was no more sleep for the Duke that night as he lay torn between suspicion and friendship. In the morning he sent for the young man, accused him of making improper approaches to his wife, and ordered him to leave his territory.

The knight was doubly distressed: not only was his feudal honour at stake, but he was to be driven from the lands where his lady the Chatelaine had her castle. He denied the charge, of course, and vowed he would do anything he could to prove it false. Would he then, asked the Duke, give a truthful

69 A wife tries to cajole her husband into revealing a secret.

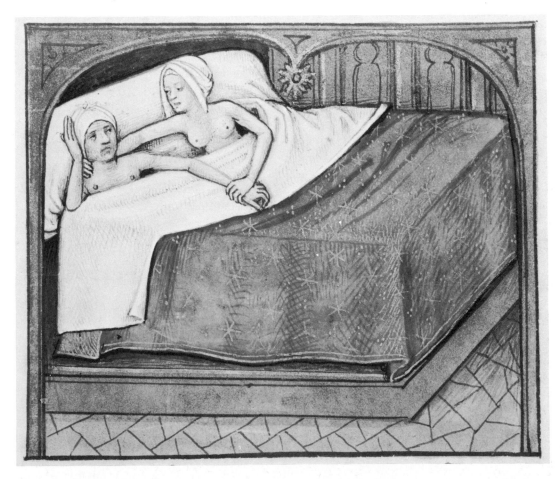

answer to one single question? Without hesitation the knight swore to do so. The Duke then admitted he would not have believed the story had there not been something about the knight's manner that suggested he was a man in love; yet no one knew of an attachment he might have to any girl or lady. Did he have a mistress? If so, let him prove it, and the matter would be taken no further.

Now the knight is in a cruel dilemma: he has solemnly sworn to answer the Duke's question with the truth; but he is equally pledged to the Chatelaine not to divulge their love. Whatever he does, his honour is compromised. Worse still, either way he will lose his lady; for if he lies to the Duke or refuses a reply, he will be banished, and if he discloses his secret liaison, the Chatelaine has vowed to withdraw her love. His quandary prompts the poet to quote some lines from a song by the Chatelain of Coucy, one of the northern *trouvères*, of whom we shall hear more:

> Love, in God's name, I find it hard to forgo that sweet delight and company and the fair favour shown me by the one who was both companion and mistress to me. And when I contemplate her simple courtly grace and the sweet words she used to speak to me, how can my heart remain within my body? Surely it is quite wrong of it not to depart.

The knight's distress was such that he could not hold back his tears; and seeing this, the Duke realised there was something he dared not tell. So with the best intentions, he promised never to let anything he might say go further, backing his word with a formal and solemn oath. Still weeping, the knight confessed his love for the Duke's own niece, the lady of Vergy, and explained how they had arranged their meetings in such a way that none could have an inkling of their relationship. So that no doubt could remain, it was agreed that the Duke should go with him to his next assignation; and this he did, hiding behind the spreading branches of a tree that grew close to his lady's chamber. Though it was night, he saw the young man joyfully greet the pet dog, then go towards the room just as the Chatelaine ran out to welcome him with countless kisses and embraces. He heard their joyful words:

> 'My dearest lady, my love and heart, my mistress, my hope and all my loving, how I have hungered to be with you like this every day since last I came!' And she, in turn: 'My sweet lord, sweet friend and sweet love, there was never a day nor an hour when the waiting did not grieve me; but now I have no cause for sorrow, for I have all I desire now you are here in health and happiness. So be most welcome!'

There was no more room for doubt, and the Duke was glad to have his wife's accusations disproved. Yet all night long, while the lady and her lover

found their joy together, he waited. Just before daybreak he watched them part with tender farewells; and then he joined the knight, assuring him of his eternal friendship now he had learned the truth. For this the knight thanked him, but begged again that no other person should ever be told, for that would bring the loss of his love and certain death. Once more the Duke gave his word.

That day, over dinner, he behaved in a more friendly way than ever towards the knight; and this so infuriated the Duchess that she left the table, pretending to have been taken ill, and retired to her bed. After the meal, the Duke went to see what was the matter. She told him plainly that she had come here rather than see him making such a fuss of the man whose banishment she had demanded. To this the Duke replied that he had sure proof that the story she had told him was groundless; and he left her without more ado. But the crafty woman knew how to bide her time until she could catch her husband in a more receptive mood. He had told her not to ask further about this matter, but in bed he might be more forthcoming.

That night, then, she drew away from him as if in anger; and when he went to kiss her, she broke into a bitter complaint. Until today, she said, she had always believed he loved her, but now the scales had fallen from her eyes. Why? Because he was trying to keep something from her. Not that she cared: it just served to show how she had wasted her love on a man who was not open with his thoughts. Never would she trust or love him again. The Duke was touched by her sighing and weeping, but insisted it would be wicked of him to disclose the secret. Then let him keep it. It was obvious now that he did not trust her, even though she had never betrayed any of his confidences. Still her tears flowed, and the Duke tried to comfort her, but to no avail. In the end his resolve weakened. His faith in her was so great, he said, that it would be wrong to hide anything from her. But never, on pain of death, was she to reveal what he was about to tell her. The Duchess gave her word, and the whole story was disclosed.

Having heard not merely that the knight had a mistress but also that she was of lower social rank than herself, the Duchess' grief and jealousy grew even blacker. But she hid her feelings and waited for a chance to speak with the Chatelaine. This did not come until Whitsuntide, when the Duke held full court. He invited ladies from all his lands to attend; and among them was the lady of Vergy. When the Duchess saw her, she trembled, but managed to hide her hatred under a mask of affability. After the feasting, when the tables were cleared, she took the ladies to her own room to help them dress becomingly for the dancing. There, seeing the opportunity she had been waiting for, she could no longer keep quiet:

'Chatelaine, you must look your best, since you have a worthy, hand-some friend.' And she answers simply: 'Indeed, my lady, I do not know what friendship you speak of, for I do not care to give my affection to anyone who would not bring complete honour both to myself and to my lord.' — 'That I grant,' said the Duchess, 'but you are a good mis-tress to have learnt how to train the little dog.' The ladies heard what they said, but without knowing what it was all about; so away they went with the Duchess to join in the dancing they have arranged. And the Chatelaine stays behind, her heart troubled and racked with anguish and in turmoil within her breast.

She went into a small chamber and flung herself onto a bed there, without noticing a young girl who was lying at its foot. In a long and bitter lament her pent-up feelings burst forth. How could the Duchess have learnt about the dog from anyone but her lover? And why should he have betrayed her had he not turned his heart to the lady to whom he had divulged their secret? She, the Chatelaine, had given him her love pure and undivided, believing him more loyal than Tristan to Ysolt. Betrayal would for her have been un-thinkable: she would more gladly have lost Paradise than him who was her sole treasure and joy. How could he be false, when she had never gone against his wishes and he had professed his own love so tenderly? She knew well that if he were to die first, she would not linger long behind him, for death itself would be more welcome than his loss.

'Ah, noble Love! is it then right that he should divulge our secret in this way and so lose me? For when I granted him my love, I told him and made the firm pact that he would lose me on the very instant he dis-closed our love. And now I have lost him first, I cannot, nor would I after such a blow, live without him, the object of my grief; for life holds no more pleasure for me. No, I pray God to let me die and, as truly as my love was loyal for him who has brought me to this pass, to have pity on my soul and bring honour, as I forgiveness, to him who has wrongfully betrayed me and sentenced me to death. This death of mine seems only sweet to me, since it comes from him; and when I recall his love, dying holds no pains for me.' With that the Chatelaine fell silent except for these words she uttered with a sigh: 'Sweet love, I commend you to God!' With this she clasped her arms across her breast, her heart ceased beating, and her face lost its colour: in great distress she swooned away to lie wan and pale upon the bed, lifeless, dead.

In the hall the dancing was in full swing. The knight, looking vainly for his beloved, quietly asked the Duke what had become of his niece. When they did not find her, that understanding man suggested looking in the small

chamber where, he thought, the couple might enjoy some welcome privacy. But when the knight discovered his lady there, it was a lifeless body he embraced and cold lips he kissed. At his despairing cry, the girl who had overheard the Chatelaine's lament told of her grief because of the Duchess' taunts about a lover and a little dog.

> And when he understood from these words that what he had told the Duke had brought about her death, his anguish was beyond measure: 'Alas,' he said, 'my sweet love, the best, most gracious and loyal who ever lived, like a faithless traitor I have caused your death! In justice, this affair should have turned against me and brought no hurt to you; but such was your loyalty that you have been the first to suffer from it. Yet I shall wreak justice on myself for the treason I have committed!' There was a sword there, hanging from a hook: he drew it from its scabbard and plunged it deep into his heart. He let himself fall upon the other body, and his life's blood drained away.

When the Duke found what had happened, he was filled with such rage and sorrow that he seized the sword and, rushing into the dance, brought it down upon the Duchess. He told the court the whole sad story, then had the lovers buried in a single coffin and his wife in a place apart. He never laughed again, but took the cross and journeyed overseas, where he died a Templar.

This is the gist of a short romance that has been justly called one of the jewels of medieval literature. Has its author, then, achieved the feat of turning a case of courtly love into a convincing story? I hardly think so. In fact he has failed to do so, and it is his very failure that has brought him such success. For, precisely in order to give his tale plausibility and, beyond mere plausibility, tragic depth, he found himself having to abandon the rules of the courtly game. Or rather, from the moment the Chatelaine stole the limelight from the knight, he rose above them. Made of less stern stuff than the lady of the troubadours or Lancelot's Queen Guenevere, his heroine could not find the heart to withdraw her love when she discovered the knight's breach of their pact, even when she imagined he had transferred his affections to the Duchess. It was too true and profound for that, burning all the more strongly when it seemed to have been spurned. According to the laws of the game, the courtly mistress should reject a faithless lover; the Chatelaine forgave him and, what is more, commended his honour to God. An innocent victim of circumstance, she has acquired by the end of the poem full status as a tragic heroine, well worthy of a place among our noble lovers.

Some time about 1300 a Picard poet called Jakemes (his name is known only

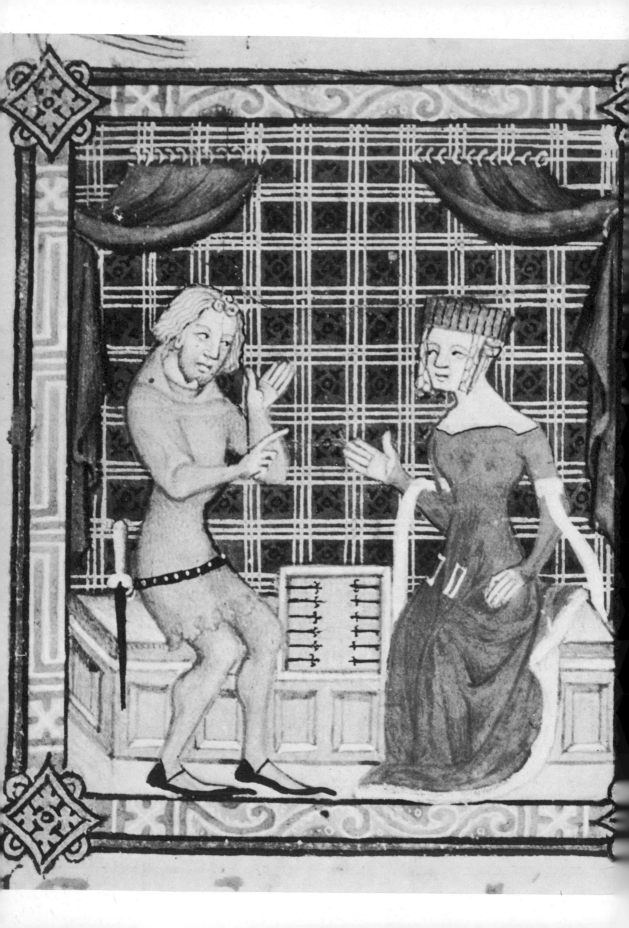

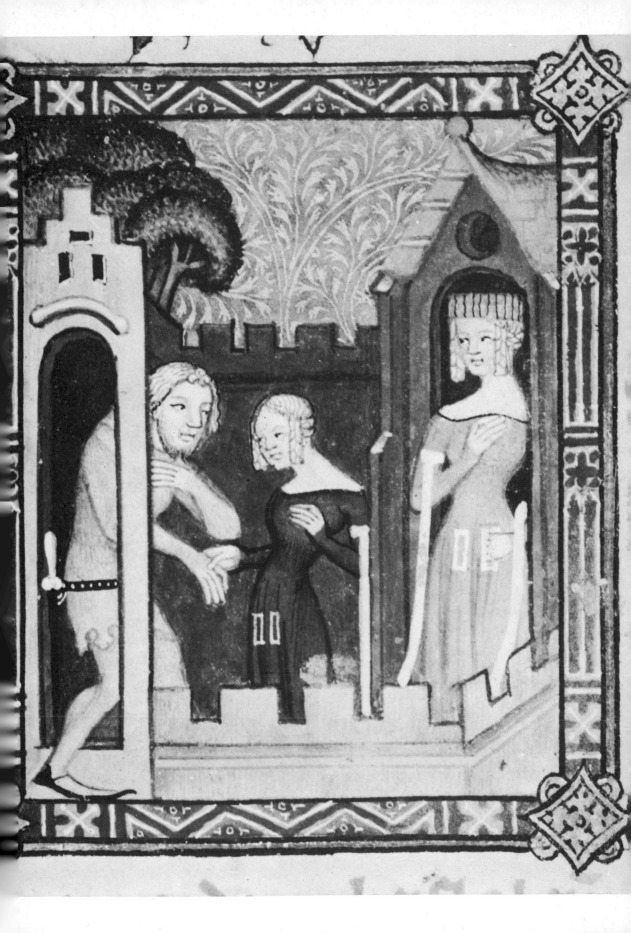

from an acrostic at the end of his romance) decided to tell the story of *The Chatelain of Coucy and the Lady of Fayel*. The Chatelain we have already met: he was that courtly poet, a snatch from one of whose songs was introduced into *The Chatelaine of Vergy*. According to most recent opinion, he lived about a century before Jakemes, died while on his way to Constantinople in the course of the Fourth Crusade, and was buried at sea. As a *trouvère*, he sang rather forlornly of his luckless passions, while claiming that even Tristan who drank the potion never loved more steadfastly than he. What Jakemes knew of him apart from his verses is a matter for conjecture. It was probably little or nothing; but that was no disadvantage, for Jakemes was a writer of romances, not a biographer; and having resolved to try his hand at a tale of courtly love, whom better could he choose as his hero than a genuine courtly lover? (A not entirely novel idea, as we shall see in our next chapter.) He therefore took up his pen and, after promising a story to uplift the hearts of all true lovers, pursued the Chatelain's fortunes and misfortunes through more than eight thousand lines of quite lively verse. My own account will be more brief.

The Chatelain, a fine knight and splendid poet, languished for the love of the fair lady of Fayel. One day when her husband was away, he went to lay his heart before her. Her reply was very straight:

'Oh, sir, you are ill advised to ask something that goes quite against my own honour and my husband's. But I believe you are trying me out: you know full well I am tied by the strong bond of marriage. I have a worthy, valiant, wise husband whom I would not deceive for anyone; nor would I love any man but him.'

Despite these honest words, however, she had not been untouched by love; and when later she heard a song the Chatelain had composed in her honour, she was secretly delighted to have him as a suitor. Even so, when he found the opportunity to renew his passionate declaration, she was scarcely more forthcoming: 'Indeed, sir, I know nothing about love: I never have loved, and am not going to try it yet.' But for all her coquetry, she did make one concession: although her love was not on offer, she would give the Chatelain any keepsake he cared to name. So he asked for a sleeve that he could wear for her sake in a forthcoming tournament.

Now the lady's defences began to crumble under love's assault, while the Chatelain went away to express his revived hopes in a new song, which began:

70 (*overleaf*) The Chatelain of Coucy speaks with the Lady of Fayel. He is admitted to her presence by Ysabel.

XII Knights joust to win the admiration of their ladies.

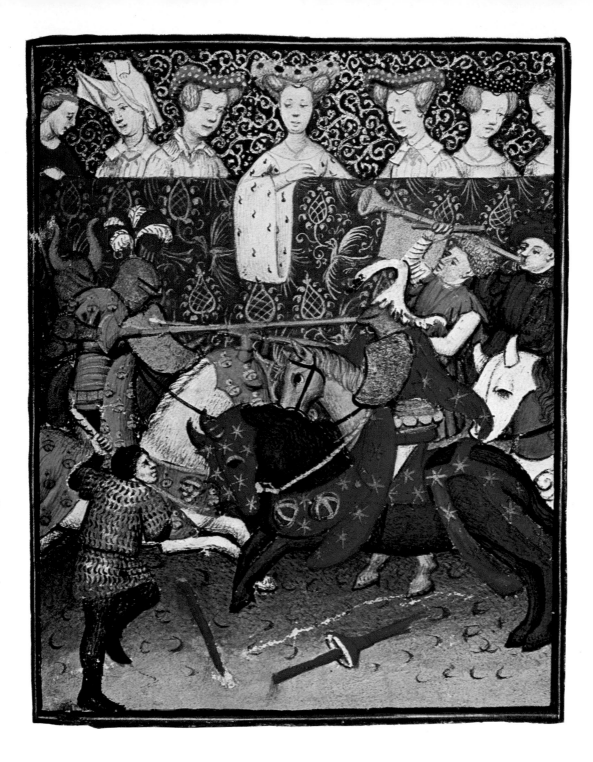

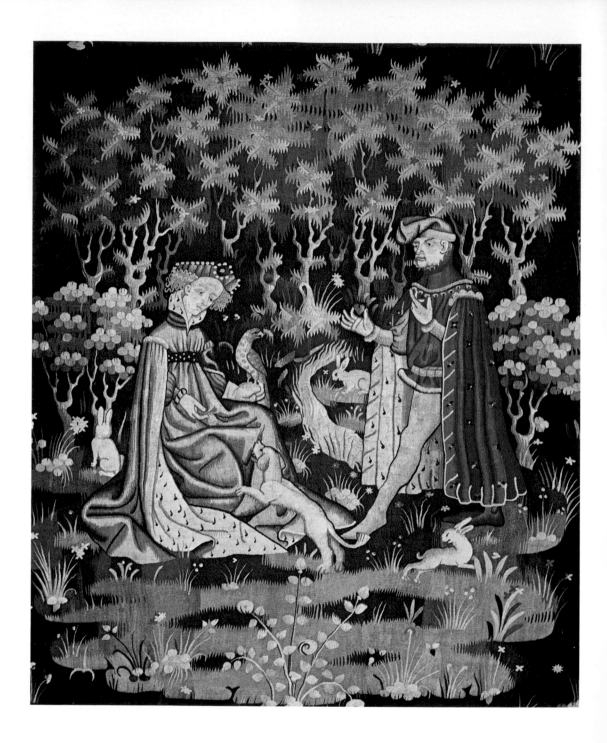

The sweet voice of the wild nightingale that I hear warbling and trilling by night and day brings sweet solace to my heart. Now I want to raise my spirits again with a song: for sing I should, since it pleases the lady to whom my heart has paid homage, that heart which must fill with great joy if she is willing to admit me to her service.

On the first day of the tournament, the Chatelain performed with honour. After supper he sat beside his lady, who asked if he had been wounded at all. 'Not by weapons, just by that malady only you can cure.' — 'Sir, I don't know what you are talking about or what cure you have in mind: you look sprightly enough, so don't expect any other cure from me that might arouse suspicion.' The second day, though, brought the Chatelain better luck in the shape of an invitation to Fayel the following Tuesday morning, when the lord would be away; then, said the lady, they would be able to discuss matters in private. We can be sure this gave the knight more satisfaction than the prize he was awarded for the jousting.

The promised interview went splendidly for the Chatelain. Though the conversation once more opened equivocally on the subject of wounds, the lady soon dropped her pretence, admitting that he had earned her love. But as she still feared the loss of her honour and reputation, they devised a plan for arranging secret trysts. She would confide in her cousin Ysabel; and the Chatelain must find a trustworthy young man, who was to be persuaded that he was in love with Ysabel and needed messages carried to her. The meetings would take place in a small garden, to which the Chatelain would be admitted by a disused gate when the coast was clear. Having pledged his love-service to his lady, the eager suitor demanded a rendezvous that very night.

The Chatelain's elation was to be short-lived. When the lady put the matter to her cousin, the worthy Ysabel was shocked; but she co-operated in a test the lady proposed. They would both go to the gate, not to open it but to see the frustrated knight's reaction. If, thinking he had been duped, he went away never to return, then his love would be proved false and worthless. That night the rain poured in torrents and the thunder rolled, but the Chatelain was undeterred. When he found the gate locked and no one to open it, his sighs and laments were so pitiful that even Ysabel thought he should be let in. The lady, though, was resolute; and only as dawn broke did the Chatelain give up his miserable vigil. Even then, he consoled himself with the thought that the lord must have returned unexpectedly from his journey; until, that is, he met him approaching the castle as he made his own wretched way home. There he composed a melancholy song, then took to his bed, suffering from both love and exposure.

XIII The courtly lover offers his heart to his lady.

When news reached the lady of Fayel that he lay at death's door, she had some qualms of conscience over her cruel behaviour. Soon Ysabel contrived to pass to the Chatelain a message, written on wax tablets, speaking of her lady's sorrow for his illness and her wish to speak with him again when he was able to come to Fayel. The promptness of the knight's recovery was remarkable, and he did not fail to keep a new assignation. Under cover of darkness he came to the garden gate and, full of joy and hope, waited to be admitted. The lady sent Ysabel to make sure, without being spotted, of her lover's arrival. Yes, he was there, said Ysabel, and should now surely be admitted. But no: the capricious lady this time decided that the Chatelain was to be kept waiting till midnight; and from inside the garden she listened with satisfaction to the lament that conveyed his mounting despair. At length, conceding that her favour had by now been fully earned, she told her cousin to open the gate. That night, the lady's surrender and the Chatelain's victory were complete.

(Although we are not yet half way through the romance, we have seen the affair progress and mature according to the courtly rules. The knight, having fallen in love with an initially unresponsive lady, has had to climb the steep ladder of amorous vassalage: first as aspirant, then as suppliant, then recognised suitor — but still very much on trial — and now at last enjoying the status of accepted lover. No wonder he celebrated his triumph in another song! But what more is there for the storyteller to say? His memories of *The Chatelaine of Vergy* and of *Tristan* come to his aid; and he also recalls a rather grisly folk motif, alluded to in *Tristan* and which, he decides, can be used to give a dramatic twist to the courtly conceit of the lover surrendering his heart to his lady's keeping wherever his body may be.)

The lovers had many further meetings, still under the cover of a pretended liaison between the Chatelain and Ysabel, who arranged their trysts when the Lord of Fayel was away from his castle. All would have been well had not another lady set her heart on the Chatelain and, noticing him at a feast exchanging surreptitious glances with his beloved, been struck by a jealous suspicion. So she had him spied upon day and night until he was seen making one of his protracted nocturnal visits to the garden at Fayel. At the first opportunity she told the lord of Fayel of these dubious activities and advised him to have a watch kept on the disused gate when he was away from home. The lord, in fact, went one better; for, having announced his departure from Fayel on some business, he himself lay in wait with his squire Gobert. The Chatelain arrived, knocked on the gate and, when it was opened, disappeared into the garden. The lord would have tried the same procedure for himself, but Gobert restrained him: the intruder might take flight by the

main gates; or, who knows? he might have come on some quite proper
errand, or else be paying court to Ysabel and not to the lady at all. The lord
was unconvinced, but did nothing more on that occasion. However, he
renewed his watch each night; and on the third, being warned of the Chate-
lain's approach, got to the door first. Imagine the lover's dismay when the
gate was opened, not by his lady or Ysabel, but by the lord of Fayel, fully
armed and in no gentle mood. It was lucky for him that his mistress was
unwell that night and had stayed in her room; so the excuse that Ysabel was
the object of his visit was grudgingly accepted. However, like King Mark,
the lord found it impossible to drive his suspicions from his mind; and he not
only had the offending gate walled up, but also ordered his wife to send
Ysabel away.

Now the Chatelain's adventures become even more involved and extrava-
gant. Gobert was persuaded to transfer his allegiance to him; and, being told
who the lord's informant had been, he took vengeance on that jealous lady
by enticing her into a secret assignation and then having her surprised by
Gobert and Ysabel at the most incriminating moment. Next we learn how
he was smuggled into his mistress' presence at Fayel disguised as a wounded
squire. In this and various other escapades Gobert's assistance was invaluable.
But the lord's suspicions led him to keep a closer watch on his wife; and on his
next expedition he took her with him. This gave the Chatelain the chance to
play a trick worthy of Tristan. He had warned his mistress that he would be
waiting for her in a mill beside the route; then, when the party arrived at a
nearby ford, the lady quietly slid from her horse into the water so that she had
to be taken into the mill to await dry clothes. She did not find the wait
tedious!

How could the lord rid himself of his untrustworthy neighbour? He had a
clever idea: he would spread the news of his intention to join the next cru-
sade, saying his wife would make the journey with him; then the Chatelain
too would take the cross and set out, but once the lord was sure he had left, he
himself would change his announced plans and remain at Fayel. At a secret
meeting the lady told her lover of the proposed expedition. On Gobert's
advice he sailed for England, where King Richard the Lion Heart was
reported to have arranged a tournament, after which the crusade would be
preached and the King himself lead the army. So well did the Chatelain per-
form in the jousting that the King asked him personally to join his company.
In his delight he composed a new song for his lady, praying God that he
might hold her once more in his arms before setting forth on his journey. His
prayer was granted: having learnt by letter of the lord of Fayel's deception,
he managed to pay a last visit to the castle, disguised this time as a blind man

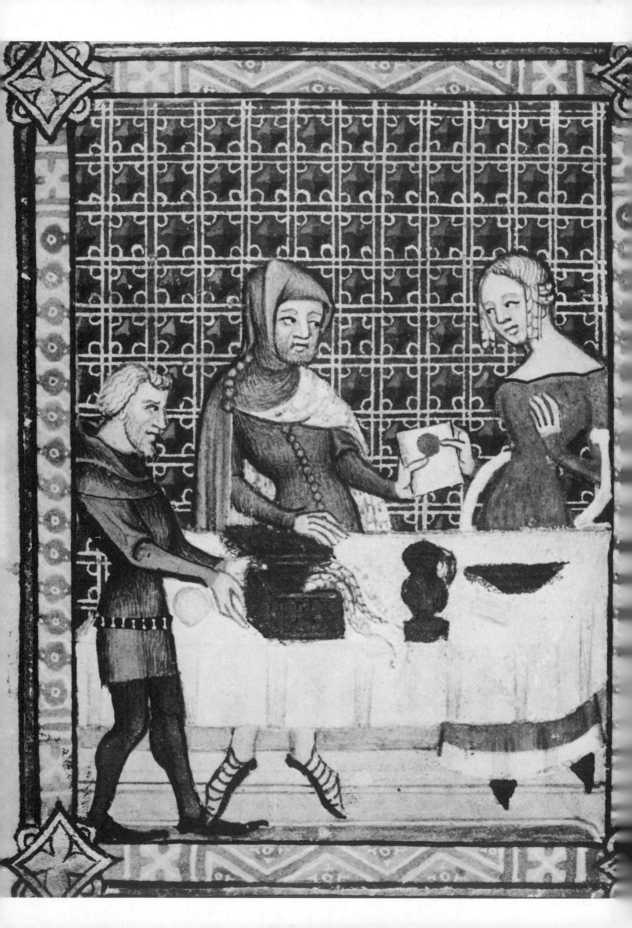

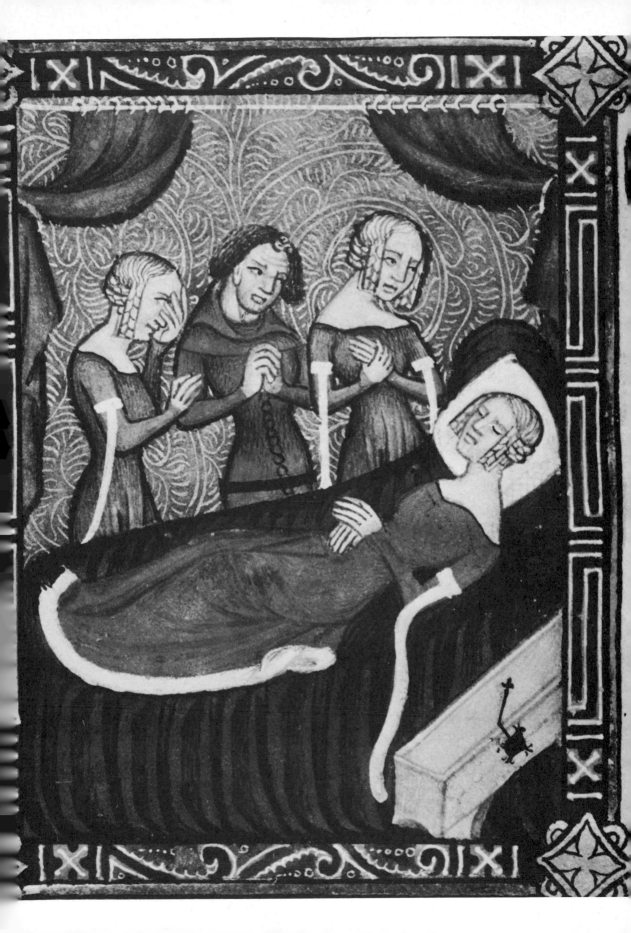

(the lord being on another of his excursions). After two days with his mistress, he took his sorrowful leave. Amid her tears and despite her lover's protestations, the lady seized some scissors and cut the tresses from her head, bidding him keep them always for her sake. As he took the long road for the East, the Chatelain composed a sad song of parting that ended with these words:

> Lady, I depart! To God the Creator I commend you, wherever I may be. I do not know if you will ever see my return, and perchance I shall not see you again; but I beg you, wherever my heart may wander, keep troth with me, whether I come or stay away; and pray God to bestow honour on me in the same measure as I have been true and loving towards you.

> There is no pity. Go, song, in the assurance that I leave to serve Our Lord; and have no doubt, most excellent lady, that, if I do return, it will be to serve you.

The crusaders arrived in the Holy Land. Outside the city of Acre they joined battle with the Saracens; and the Chatelain, conspicuous by the tresses he bore worked in gold wire on his helmet, won great honour for his prowess. For two years he fought valiantly with King Richard until, in one encounter, he received a great wound in his side from a poisoned shaft. Despairing of recovery unless he could see his lady again, he put to sea and in a song expressed his yearning for her. With death close at hand and his joy still far away, he called his faithful Gobert. When he died, his heart must be embalmed and placed in the silver casket where his lady's tresses were; and with them would be a letter, in which he spoke of his undying love for her and his hope that their souls might be united in the everlasting life of Paradise. Guillaume was to deliver this casket to his beloved. And when the Chatelain had received confession, he uttered his last words: 'Gobert, greet my lady for me!'

As Gobert approached Fayel, he met the lord, who seized the casket from him and, reading the letter, planned a grim vengeance: the heart was to be prepared by his cook and served at supper to his wife alone. His command was carried out. When the lady praised the exquisite flavour of the food, the lord revealed that it was indeed unique in quality, since 'in this dish you ate the heart of him who loved you most, the Chatelain of Coucy!' Producing the casket with its tresses, he convinced the lady of the terrible truth of what he said. In her anguish she called for death:

71 (*overleaf*) The lord of Fayel reveals to his wife the nature of the dish she has just eaten. She dies of grief.

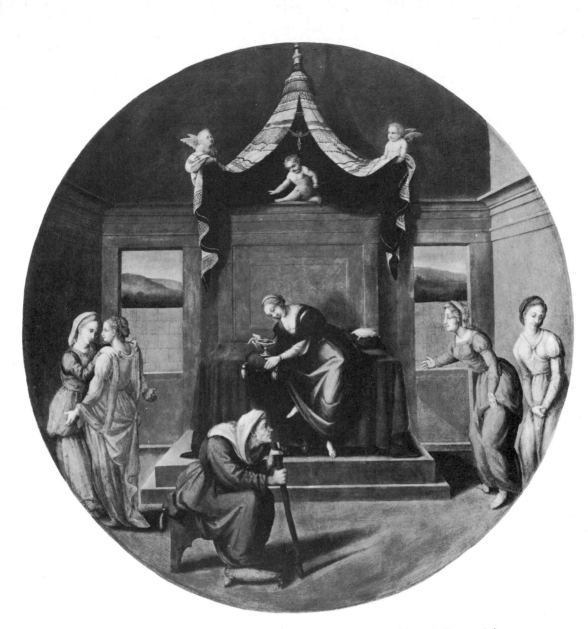

72 Like the Lady of Fayel, Ghismonda is given the heart of her murdered lover in Boccaccio's story (*Decameron* IV.1).

'Ah, how grievous is this thing he has sent me: the gift of his heart! He showed me it was truly mine, and mine should properly be his. And so it is! This I shall prove, since I shall perish for his love.'
Thus she died. Her lord had her buried with great honour, then crossed the sea in penance. He returned long after, but happiness eluded him to the end of his days.

In an epilogue on the noble qualities of love, the poet confesses that he too is in its thrall and has rhymed this story in honour of a fine lady to whom he has pledged his service and his heart. We can only hope she appreciated the offering: it is by no means badly composed. Yet as a narrative presentation of courtly love it is less than a triumph. Once Jakemes had allowed the lady of Fayel to submit to her lover, he was unable to raise his romance much above the level of a sordid account of adulterous subterfuge, at least until the closing episodes. The crusading theme and the sporadic utterance of devout sentiments by the lovers convince no-one of its spirituality; and in the telling, Jakemes never achieves the intensity of passion found in the Tristan story and the tragic purity of *The Chatelaine of Vergy*, from both of which he took some of his inspiration. For all its anecdotal fireworks, little enough of real feeling comes through. Far from gaining the impression that Jakemes was himself emotionally committed to the fate of his lovers, we now and then catch him indulging in a little ironic humour at their expense. This is a crucial fact: only emotional engagement on the part of the poet could persuade us, his public, to take the courtly fiction seriously. By failing himself to achieve this and, at the same time, letting slip hints of his own mildly cynical attitude, Jakemes has exposed the fragility of the amorous code. For all its affected rigour it is seen as founded on unreason, an impractical conceit, ripe for burlesque. Perhaps Jakemes did not fully realise this; but others before him had, as we shall soon discover.

Chapter VII

The Comedy of Love

Reason may be on the side of those who say that literature is powerless to capture so personal, so indefinable an emotion as love; but that has not prevented writers from making it the staple of literary creation down the centuries. Lyric poets try to set a sympathetic chord vibrating, story-tellers to create characters and situations that will make our emotions stir and mingle with theirs. In both cases we are asked willingly to suspend our disbelief and surrender wholeheartedly to the text. When we can, the serious writer has succeeded; when we cannot, he has failed, and we are apt to look coldly on his lovers, perhaps with not only scepticism but scorn or even mockery. Some writers, though, may themselves not be wholly dedicated to this purpose; for it is always possible for a man to have mixed feelings about his own fictions. He may, for one reason or another, offer us something he too finds implausible or, at the extreme, ludicrous. Then, as with Chrétien or Jakemes, an ironic touch may put us on our guard, entitling us to be more amused than moved. And sometimes, of course, we can be deluded into seeing sentiment where none was intended by the author, or mere foolery where he was sincere. Humour, after all, has much of the subtlety and uncertainty of love.

I offer these thoughts as a warning; for I am about to interpret as humorous and cynical a work that others have found largely serious and, in part, touchingly candid. If I am right, it is the most crafty refutation and mockery of courtly love I know. It is a romance, *Joufroi de Poitiers*, composed about the middle of the thirteenth century by an anonymous poet who may have hailed from the south-east of France. Its hero is very probably none other than our old friend Guillaume de Poitiers, the first troubadour, in rather thin disguise: at any rate, his lecherous habits are much the same. One unusual feature is the frequency with which the author intervenes in his story to make personal comments; and in doing so, I believe, he offers us the key to his romance. Let me then summarise the plot and, in italics, the poet's comments.

A new love has brought fresh joy to my heart; and I thank God for it, because all I need for my happiness is the thought that I love and am loved. Love makes the coward bold, the fool wise, the miser open-handed, it sweetens the bitter heart and makes the base man noble and courtly. Some say love is in decline; but it is truer today than ever, although, to be sure, there are both ladies and knights who are more adept at deceit, as I know to my recent cost. But now my own fortunes are restored by the one I love most of all — except that I am still hurt by her calling me 'sir' instead of 'my darling'. If only I can please her by my service! But now I will tell you a story I have rhymed for love's sake.

As a young man, Joufroi asked leave of his father, the Count of Poitiers, to go to England and seek knighthood at the hand of King Henry. Richly pro-

vided by the Count, Joufroi found the royal court at York; and, through his bearing and not least his liberality, he soon made a good impression on the English. Now it happened that the King's seneschal, having had his amorous approaches rebuffed by Queen Alice, spread it about that he had caught her in bed with a kitchen boy (a thing Alice would never have done, for fear of shame). When the gullible Henry uttered dire threats against his wife, Joufroi asked to be knighted so that he might defend her honour against the seneschal. His request was granted, the duel held, and the traitor despatched.

If only that were the fate of all those who sow discord in love! Were I the lord of France or Rome, I would make sure that love, the source of all good, was exalted at the expense of duplicity.

News was brought to Joufroi of the death of his father; so taking leave of the King and the grateful Queen, to whom he pledged his eternal service, he returned to Poitiers and was acclaimed as the new Count. There he devoted himself to tourneying, largesse and fine living, to his great honour.

Great honour too may be obtained from love, as I know very well since my lady's beauty and excellence have made me its prisoner. I would dearly wish her to return my affection.

One day Joufroi asked his minstrel to name the fairest lady this side of the sea. 'Agnes de Tonnerre,' came the reply: but her jealous husband kept her shut away in a high tower. 'He can't be blamed for that,' said Joufroi; 'but he would be a happy man who could get at her!' The challenge was on. Joufroi hastened to attend incognito a forthcoming tournament at Tonnerre; and, calling himself the lord of Cockaigne, he had his camp pitched by a magnificent pear tree that stood in a kind of recreation ground overlooked by Agnes' tower. After a triumphant day's tourneying, the 'lord of Cockaigne' had the pear tree decked out with candles and held a sumptuous feast there for all and sundry under the admiring gaze of the fair Agnes.

Knights and ladies are of all kinds and should be treated on their merits. A good lady ennobles a whole kingdom; and such a one is my beloved, who has rescued me from the despair into which a false mistress had cast me.

The next day Joufroi repeated his performance, then left for home, with Agnes so impressed that she contrived to discover the identity of this splendid knight, then fell to wondering how she could make his more intimate acquaintance.

Ladies are right to desire men who lead the gay life, and those who are honest will give their lovers proper reward. Such a one is my beloved; yet I am distressed that she treats me so harshly. Please God my trust in her goodness will be justified.

Joufroi hit on a plan. With a trusted servant he went to Tonnerre disguised as a hermit and, having obtained the lord's permission, built himself a

hermitage (of more than average comfort) within sight of the tower. By day he could be seen grubbing for roots and herbs; but by night his servant would procure tastier victuals, so that his rapidly acquired reputation in Tonnerre for ascetism and holiness was not altogether justified. However, it stood him in good stead when he went one day to see the lord with a proposition: he was wrong to keep his wife in such strict seclusion, for this might well put ideas of vengeance in her head; let her just come to see him in his cell, and he would confirm her in the ways of virtue. The lord, comparing her with Ysolt and confessing his fear of cuckoldry, was nevertheless persuaded, and even apologised humbly to his wife for his previous conduct (though jealousy, he asserted, is a necessary partner to love). In brief, it was the lord himself who led Agnes to the hermitage and, though he was not to know, to Joufroi's bed in a richly appointed secret room.

It is right for a lady to disclose her love promptly without keeping her suitor in such long suspense that he betrays his passion openly and gives the slanderers their chance. I am myself kept waiting too long, but must be patient in the hope of better things to come.

When Joufroi and Agnes had partaken of their illicit delights, the lady left the cell, declaring that Our Lord truly dwelt in the hermit, in whose words she gladly placed her faith. Then, said her husband, she must visit him more often. And so she did, until Joufroi left her for his own lands with protestations of undying love. On his return to Poitiers, he was holding court when a messenger arrived with an ivory casket full of jewels sent, he said, with the love of a lady whose name he could not reveal. Joufroi did not press the point, thinking the man would be more ready to disclose the donor's identity in private; so he looked for him later, but only to find he had already left the town.

My thoughts turn to my beloved; but liars and slanderers make contact with her difficult. However, I have put them off the scent by pretending to love someone else, and that is the rumour they are now spreading.

Joufroi hoped that in the course of his travels he might learn who the mysterious donor of the casket was. A dispute with a companion, Sir Robert, as to which of them was superior in chivalry led to their setting out together for England to put their prowess to the test. As Joufroi's appearance had changed greatly since he was last there, they were able to conceal their identity. Arriving in Lincoln, where the King was, they vied with each other in liberality and received from Henry a warm welcome.

Now I will give my tongue a rest by speaking of my sweet lady again, for to speak or think of her restores my vigour and spirits. How much greater my happiness would be if she would grant me a kiss! Ah, God, when will this be?

The Scots and the Irish launched an attack on Lincoln; but Joufroi and Robert fought victoriously for the King, then returned with him to London.

Tell me what I can do when I love and am not loved in return. I am like a candle that burns to give light to others. Ah, noble and lovely lady, I shall entreat your mercy all my life. It would be wrong of you not to return my feelings.

In London, the companions wasted not only their substance but also the King's generous gifts on high living, so that in the end they were driven to pawning even their horses and equipment. But still the money went. Joufroi had his quarters with a London bourgeois possessed of much wealth and a comely daughter. Claiming that he too was the son of a bourgeois, though his mother was of noble stock, the Count asked his host for his daughter's hand: then, he said, he would quit the life of a knight, return to banking, and look after his money in future. The host and his wife were delighted at the proposal; and by the next day Joufroi found himself the owner of a wife and a thousand silver marks to be going on with. The money he shared with Robert; but it was quickly spent, to the chagrin of his new father-in-law.

At home in Poitou there was consternation, because Count Alphonse of Toulouse had attacked Joufroi's possessions, and he was nowhere to be found. The troubadour Marcabrun (a historical character, whom we met in an earlier chapter) was among those sent to search for him; and by chance he was calling on King Henry when into the palace came Joufroi. With his incognito pierced, he prepared to leave for home, but first arranged with Henry that his low-born wife should be transferred to another husband of

73 Skirmishing before a castle.

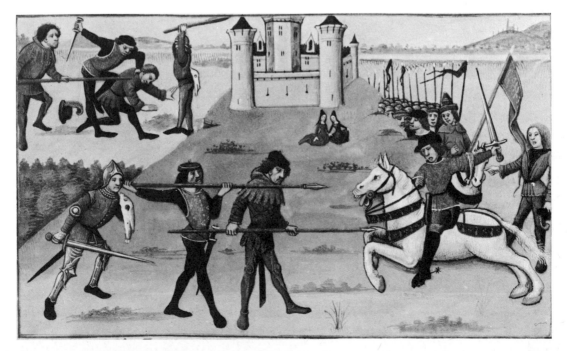

high estate; and this was quickly done. Before returning to Poitiers, however, he resolved to pay a visit to Queen Alice, who was staying at that time in Beverley.

Alice covered her joy with a reproof, asking why Joufroi had been over a year in England without coming to see her. Why had he sneaked into this country like an outlaw? The Count told her of the casket of jewels and how he had decided to travel the world until he found the lady who had sent it. — Would he know again the messenger who brought it to Poitiers? — Certainly. The Queen sent for her chamberlain, who was at once recognised by Joufroi. Yes, it was she, Alice, who had sent the jewels. Then, said Joufroi, let her bestow one further gift: her love. He in turn would serve and love her truly as her loyal liegeman. At this Alice confessed to having given him her heart when he wrought justice on the seneschal for her sake; and because she disapproved of keeping lovers waiting and pining, she would come to his bed that very night.

After the household had retired, Joufroi waited impatiently for his new mistress, tossing and turning in his anxiety. From this Robert, whose own bed was close by, guessed that his companion must be awaiting a nocturnal visit from the Queen. When he heard Joufroi tiptoe to the door to listen for some sign of his beloved, he slipped out of his bed and into his companion's, so that when Joufroi groped his way back, he found Robert snoring away as if sound asleep. Convinced he had made a mistake, he went to the place Robert had just vacated. The Queen meanwhile had been waiting for her maid to go to sleep; but at last she left her chamber and slipped through the dark into the bed she took to be Joufroi's. In fact it was Robert who received her with open arms, though she did not realise it. But now Robert was in a dilemma: should he carry through this deception of his rightful and honoured lord?

And you, good sirs, what would you do in his position? Give me your opinion, and I will tell you mine. Have you said what you think? Well, for my part I would have abandoned all the lords in the world before I left the Queen. But Robert had other ideas.

Loyally he confessed who he was, and led Alice to his lord. When she learned the trick he had played on Joufroi, she laughed the matter off. For the rest of that night the Count's joy was complete, 'and the Queen loved him with a true heart and love'.

Now hear, sirs, how the world has turned upside-down for me: I don't know whether I'm alive or dead, whether I'm singing or weeping, waking or sleeping, whether I'm a lowly or a courtly man. It's my love-service that has thrown me into this state; for when I began this romance I thought I had a loyal sweetheart who

*loved me truly, but now everything is changed, and my joy is gone. Still, to show
that my tongue is still under control, I'll finish off my work, though it will be my last.*

Joufroi was at Beverley for three days. Then he returned to Poitiers; and
after a hard fight in which, with Robert, he performed great deeds, the bel-
ligerent Count Alphonse was defeated and imprisoned. Eventually peace was
made between the two counts: do you know how? Alphonse had a beautiful
daughter, and Joufroi took her to wife. 'The Count had a wife, and you have
heard how he wed her. This wife he loved as his lady, for she was a most ex-
cellent woman, courtly and without any baseness.' — And that is where the
romance breaks off.

Let me, like the poet, turn at this point to my readers: And you, good sirs
and ladies, where do you think the poet's heart lay? Was he, as some have
believed, a courtly amateur, composing his first and only romance and at the
end abandoning his literary venture to nurse a broken heart in silence? Or
was he a cynical joker, as unprincipled as his hero, spinning an intricate web
of fiction? Well, I take the latter view. His interventions in the story are not
just chatty, casual comments: together they illustrate the classical stages of a
courtly love affair such as the troubadours would sing and indeed appear in
the verse of Guillaume de Poitiers himself. There is the explosion of joy at a
new love, the loyal and patient service, the doubts, fears, dangers, and the
final shock of disillusion and despair. The poet is the orthodox courtly lover,
playing the game by its rules, but only to lose everything in the end. Contrast
his hero, the opportunist philanderer, as successful as he is cynical in his con-
quests. And notice how cleverly the poet has set these two amorous quests in
counterpoint, with his own downfall coinciding precisely with the instant of
Joufroi's greatest triumph. He is showing us by example that to follow the
courtly code will get us nowhere, since patience, loyalty and idealism go un-
rewarded. Learn from Joufroi: lead the gay life and take your pleasures where
you can. The Count's relationship with Queen Alice does, I grant, have some
of the marks of the standard courtly love affair. But lest we should take it
seriously, our wily story-teller turns its climax, the lovers' attainment of un-
blest bliss, into pure farce worthy of those tales of comic bawdry that min-
strels hawked around the market-place. Courtly love, then, is at best a waste
of time, at worst a joke. And in the figure of Joufroi we see again that picture
of the predatory male for whom love was an amusing distraction, but whose
main concern was to burnish his knightly image.

Joufroi de Poitiers has confirmed us in the feeling that courtly love, as professed
by the troubadours and Andreas Capellanus, was a subject ripe for burlesque.
That very inwardness and artificiality which prevented it from generating a

convincing story-line removed it from everyday experience into a refined world of preciosity that could easily be made to look absurd. But let us turn now from courtly love in this its narrower sense to consider for a while the greatest of noble philanderers, that knight whose image needed no burnishing, Sir Gawain. No man he to languish for ever in fruitless love-service; yet there was never one who, for his gallantry in every sense, pleased the ladies more. We read of a queen who swooned in ecstasy at his name, and of a girl who, from a tender age and knowing him only by repute, swore to reserve the first-fruits of her love for King Arthur's nephew alone. One maiden wove his portrait in tapestry, another engraved his face on her ring, yet another had a life-sized wooden statue made in his likeness. And there was the damsel who used to greet strangers with the words: 'May He who made evening and morning save, keep and bless my lord Gawain, and you too.' So perfectly chivalrous was Gawain that he was at pains to satisfy such yearnings whenever he could.

It was, I think, Chrétien de Troyes who confirmed Gawain in the role of amorist, having taken his cue from an earlier writer who had put into his mouth praise of peace as a time for loving. His many adventures would fill, and indeed have filled, volumes; so we must be content with a few fleeting

74 Sir Gawain takes leave of King Arthur and Queen Guenevere before setting out on an adventure.

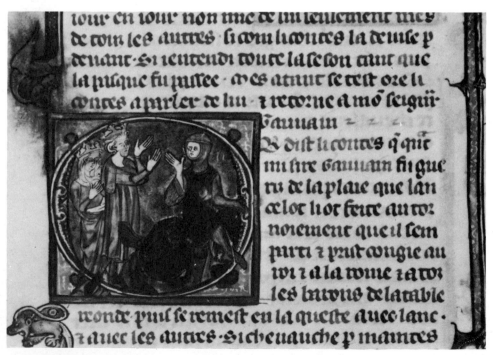

XIV A 'portrait' of Dante, some 170 years after his death.

glimpses of him pursuing his noble sport. In all Chrétien's romances he appears as the very pattern of chivalry; in the later ones we may detect a developing preoccupation with the fair sex; but it is only in the last, unfinished, Grail story that the spotlight is turned full on him, and then only in its second part. It is as though Chrétien has found a growing affection for this admirable man with his single endearing flaw, a compulsive bachelor flirtatiousness.

We see him prompt to undertake the rescue of a maiden in peril, then forced to turn aside to defend his reputation in a legal duel at Escavalon. But before he could keep that appointment he became embroiled in a tournament at Tintagel as champion of a sweet young thing, the Damsel of the Small Sleeves. 'Love', we are told, 'has such great dominion over those in its power that they would not dare to disobey any command it thinks fit to give.' Having assured this damsel of his perpetual service and remembrance of her, he headed for Escavalon and the embraces of another girl. However, she turned out to be the sister of his accuser; and a nasty brush with the townsfolk ensued before the duel was postponed on the condition that Gawain undertake a further quest. What next? A girl nursing a wounded knight who, instead of expiring and leaving Gawain the girl, suddenly recovered and made off on the hero's horse. Then he came across a maiden, bright-eyed as ever, but of a less attractive disposition. As he looked her over, she claimed to know his thoughts: he was aiming to carry her off. 'You are quite right', agreed Gawain. But though they did ride away together, he got no more than a lashing from her tongue. Then his luck seemed to turn; for across a river stood a castle with five hundred windows and girls and ladies gazing down from each. But when he entered this veritable harem and braved some initial dangers, he discovered firstly that, being now accepted as its lord, he might never leave it again, and secondly that the choicest of its potential concubines was none other than his long-lost sister. What solution, if any, he found to this predicament we shall never know; for Chrétien did not live to finish the work. He had, however, done enough to fix Gawain's character for posterity as that of an incurable amorist, whose love affairs were apt to interfere with the course of his knightly duty and turn out not always for the best.

This was further illustrated in a short romance, *The Knight of the Sword*, which was composed either by Chrétien himself or by a poet very familiar with his work. In it Gawain found himself being richly entertained by the sinister lord of a castle. When the man left him for a while in the company of his radiant daughter, the girl herself dropped hints of danger, though she seemed as susceptible to Gawain's charm as he was to hers. Night came, and with it the host's insistence that his daughter share the by now apprehensive

XV Love and Fortune, on the page of a heart-shaped book of Italian and French love-songs.

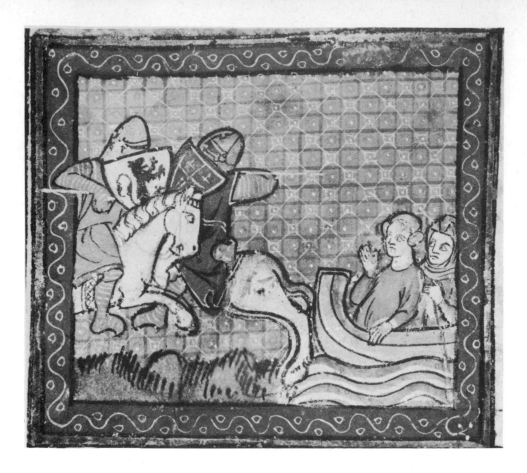

75, 76 Gawain's prowess earns him the admiration of the fair sex.

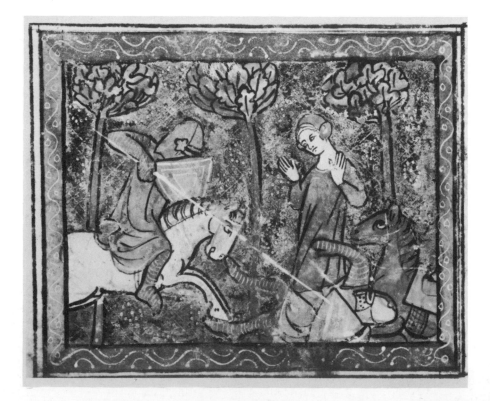

hero's bed. But Gawain did not let his fears quench his ardour; and only the untimely interventions of a flying sword deprived him of his full satisfaction, injuring his pride as a lover more deeply than his body. In the morning the castellan found him alive with a mere graze, and declared him proved to be the finest knight in the world. Declining an offer of the castle, Gawain accepted the girl; and the next night he spent with less frustration. Some time later he left with her for Arthur's court. However, a knight they met on the way caught this fickle lady's eye, so she promptly changed her allegiance. After a bitter outburst against women's infidelity (a nice irony!), Gawain despatched the knight and, leaving the girl to her own devices, moodily returned to court.

In later romances some of his adventures are even more extravagant; and the alternation of triumph and humiliation, of good and ill fortune is carried to ever greater lengths. Sometimes even his hold on his dignity becomes precarious, as in an episode from *The Marvels of Rigomer*. The scene is another castle, where Gawain is being attacked by the lord and his men. Hard pressed, he retreats with his back to a wall. But when he sets his foot on what he thinks is a firm plank, it gives way: in his preoccupation he had not noticed that it was the blade of a mill-wheel. It begins to turn, with him on it; and in a way this is fortunate, as it carries him out of range of his attackers. On the other hand, being a water-mill, the contraption pitches him through the air and straight for the rushing torrent below. This, however, is one of those occasions when his luck is in, for there is a boat on the river — really in, for on the boat's deck is a soft bed; and, more to his surprise than ours, in the

77 Gawain slays a lion and sleeps on a perilous bed in the 'castle of ladies'. The second, intrusive scene shows Lancelot on the sword bridge.

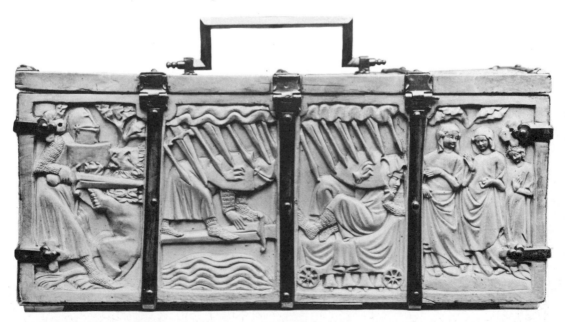

bed is a beautiful maiden, who receives with rapture this gift from Heaven!

Gawain's participation in the Grail quest, as told in a number of thirteenth-century romances, is an altogether more serious affair; and here, if we neglect one curious German poem, his luck runs very thin. In the First Continuation of Chrétien's unfinished work, he is on the point of learning the high secrets of the Grail when he falls asleep, and his chance is gone. The long prose *Lancelot* tells of a series of blunders and mishaps when he visits the Grail Castle. To begin with he tries three times to haul a girl out of a tub of scalding water, but without success, since only the best knight in the world may rescue the damsel from her painful ordeal. If this is a blow to his self-respect, worse is to come. As he is being entertained by the Grail King in the hall, a maiden appears bearing the Grail replete with succulent food. The others bow their heads; but Gawain, after a glance at the vessel, fixes his gaze on the radiant beauty of its bearer. Doubtless there is a moral in the fact that he is the only one present to get no food. By the end of the episode we are watching him being dragged from the castle bound to a cart, while bystanders pelt him with mud and dung.

The remarkable English poet who composed *Sir Gawain and the Green Knight* (with more than half an eye on *The Knight of the Sword*) did his best to reform him of his amorous ways. He is again given hospitality in a castle; and three times, while his lordly host is out hunting, the lovely and scantily clad lady of the place steals to his bed with flattery and endearments that contain more than a hint of pleasures ready for the harvesting. With all his famed courtesy but nothing of his usual ardour, Gawain plays her off with a kiss or two, no more, although he feels the temptation keenly. Yet the burden of his newly found virtue bears heavily upon him; and at the end of the romance we see him emptied of all his former ebullience, moody and dejected, while King Arthur and his knights do what they can to cheer him up.

78 In a tale related to *The Knight of the Sword* a stranger entices a maiden to ride off with him.

It was not the least of the English poet's achievements to have reversed two centuries of tradition by leading Gawain to an awareness of the merits of sexual continence. But his enlightenment was not permanent, and in later texts we often find him indulging his old fancies again. He is, surely, one of the most endearing of our noble lovers; so let us hope he has found his place in some happy Otherworld. Tennyson's Sir Bedevere may be right in a sense when he says:

> Light was Gawain in life, and light in death
> Is Gawain, for the ghost is as the man.

But for my part I cannot hear that same ghost forlornly complaining:

> . . . I am blown along a wandering wind,
> And hollow, hollow, hollow, all delight!

My Lord Gawain was no old roué; nor, however, is he depicted as being in the springtime of life. So his sentimental adventures burn with a summer heat, not the pure incandescence of calf love. In contrast, then, to his mature philanderings stand the passions of numerous young couples in a tradition running from Classical times to Romeo and Juliet and beyond. The story of Pyramus and Thisbe as told by Ovid in his *Metamorphoses* was well loved in the Middle Ages and, though far from comic in itself (except in the bumpkins' rendering in Shakespeare's *Midsummer Night's Dream*), inspired a few touches of parody in more than one medieval tale.

The parents of those young people, it will be remembered, lived in adjoining houses in Babylon; and when their parents looked unkindly on their love, they were forced to limit their communication to whispers through a crack in the party wall between the two dwellings. At length they resolved to escape by night and, evading the watchmen, meet beneath a mulberry tree at Ninus' tomb outside the city. Thisbe was the first to arrive at the spot; but

79 The hound shows itself more faithful than the maiden.

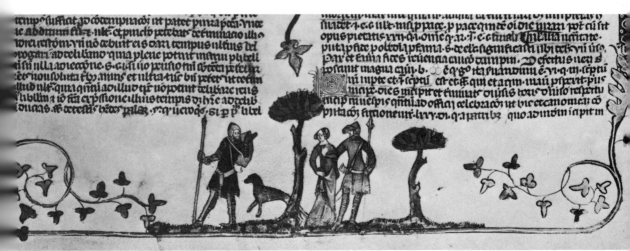

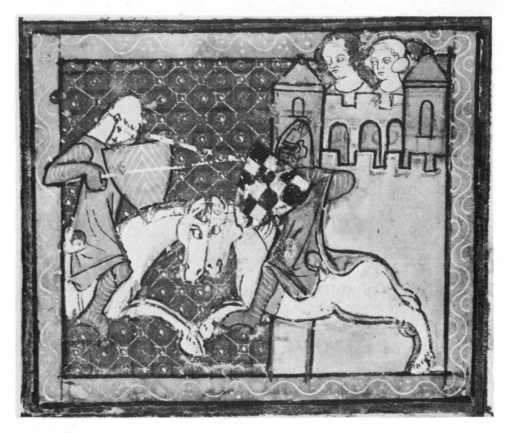

80 Sir Gawain despatches a hostile knight while two maidens look on.

81 In *Sir Gawain and the Green Knight* the lady comes to the sleeping hero's bed.

82 (*facing*) Pyramus and Thisbe converse through a chink in the wall, and below, the lovers' last embrace.

catching sight of a lioness come to drink at a nearby spring, she fled into a cave, shedding her veil as she ran. This the beast found and rent with its bloody jaws before making off. When Pyramus arrived soon after, all he saw in the moonlight was the lion's tracks and the bloodstained veil. Jumping too hastily to the conclusion that his sweetheart had been devoured, he took his sword and thrust it into his side, blaming himself for her death. Thisbe returned to find him breathing his last. Grief-stricken at the sight, she fell on the sword herself and expired with her lover beneath the tree whose berries are still stained with the purple of their blood.

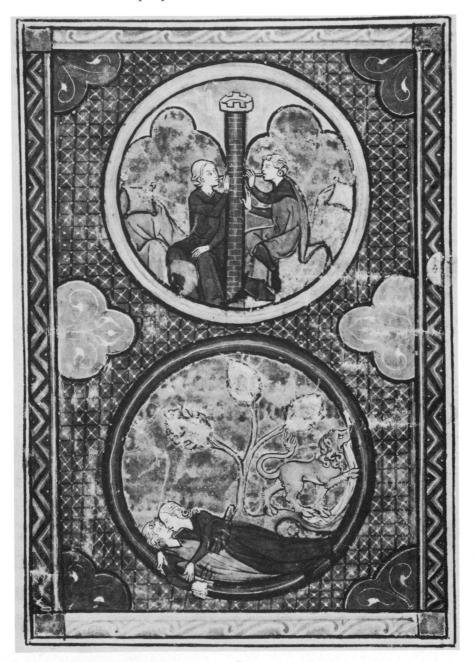

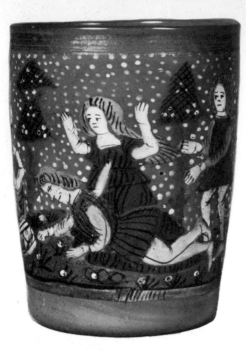

83 Thisbe finds the dying Pyramus, painted on a 15th-century Venetian glass.

84 (*facing*) As Pyramus dies beneath the mulberry tree, Thisbe plunges his sword into her own side.

In one of his romances Chrétien de Troyes gave the old theme a comic twist by showing a lion so distressed at finding, it thought, the corpse of the knight it had befriended that it propped his sword against a tree trunk and was about to fall upon it to end its days, when it happily discovered its mistake. In the enchanting tale of *Aucassin and Nicolette* a more extensive use is made of Ovid's story, as we shall shortly see.

Precocious love is very susceptible to gentle banter; and sometimes it is difficult to know when sympathetic sentimentality takes the short step into conscious humour. This is the case with *Floire and Blancheflor*, a twelfth-century romance whose author claims to have heard it told one evening by a girl to her younger sister. Here it is a Saracen prince and a captive Christian maiden who feel the pangs of adolescent love. The king sent the girl, Blancheflor, away, whereupon his son embarked on a quest for her that ended when he found her shut away in a harem or 'tower of maidens'. He contrived to have himself hidden, dressed in rose-pink clothes, in a basket of flowers and carried into the tower. By ill chance the porters deposited him in the wrong room, whose occupant cried out in alarm when he popped up from among the flowers. But the girl he had startled was a friend of Blancheflor's; so when her companions came in to see what was the matter, she explained with fine tact and presence of mind that a butterfly had flown from the basket and brushed her chin with its wing. All ended happily, of course, and the whole romance is a delightful illustration of the art of artless love. But how seriously is it to be taken?

The same question could be asked of *Aucassin and Nicolette*, a tale told part in

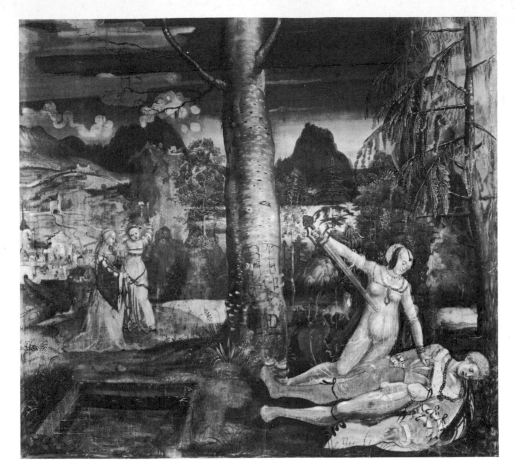

prose and part in verse by yet another anonymous Frenchman. Is it, for all its golden filigree of humour, a lyrical idyll meant to touch the heart? Or is it a friendly, but none the less telling, mockery of the well-worn style and themes of earlier literature, especially romance and epic, and of the courtly lover's total, unreasoning surrender to his passion? The author claims for it magical powers, calling us to come and hear

> of two handsome little children, Nicolette and Aucassin, of the great trials he endured and the doughty deeds he accomplished for his fresh-faced love. Sweet is the song and fair the telling, composed in fine courtly style. There is no man so vexed and laid low by suffering, ill of so great a malady, that, if he hears it, he is not quite cured and restored to happiness and joy, so sweet is it.

Already we suspect that the author's tongue is in his cheek. What 'handsome little child' is this, who will show such prowess in the service of love? Subtly set from the start, the tone will be maintained, with the grandiose and the trivial keeping startling company, so that our expectations are perpetually and deliciously deceived. So much of the charm lies in style and detail (including the music that accompanies the songs) that any summary, far from

stirring a sick man from his bed, can give little idea of the grace and wit of the original.

Count Bougar of Valence was warring against old Count Garin of Beaucaire, laying waste to his lands and slaying his men. Garin's only child was young Aucassin; but he had fallen so much in love that he had no mind to become a knight and help in the defence of his heritage — unless, that is, his father would give him Nicolette, the sweet object of his affections. But she was a Saracen girl, bought and baptised by the Viscount, and unworthy of so noble a marriage. Garin therefore, hoping to win Aucassin back to reality, ordered that the girl be sent away; and the Viscount, mindful of the fact that he had paid good money for her, obeyed only to the extent of shutting her away in a high room of his palace. From her window Nicolette saw the roses blossoming and heard the birdsong; and she determined not to be so easily parted from her beloved Aucassin.

The news of her disappearance reached the lad's ears and brought him little joy. When he asked the Viscount what had become of her and was told that their relationship would mark out his soul for Hell, his reply was more prompt than tactful:

'What would I do in Paradise? I don't wish to go there, unless I have my dear sweetheart Nicolette whom I love so much. For I'll tell you the only people who go to Paradise: old priests go there, the maimed, and aged cripples who grovel night and day in front of altars and in ancient crypts, people in old threadbare cloaks, their worn-out clothes hanging from them in tatters, half naked, without shoes or breeches, dying of hunger and thirst and cold and wretchedness. They're the ones who go to Paradise, and I want nothing to do with them. No, I want to go to Hell; for that's where the fine clerks go, and the handsome knights killed in tournaments and splendid wars, the good men-at-arms and people of quality. They're the ones I want to go with. And the lovely courtly ladies go there too, those with two or three lovers as well as their husbands. And that's where the gold and silver goes, the miniver and the sable; there too go the harpers and minstrels and the kings of this world. I want to go with them, so long as I have with me Nicolette my dear sweetheart.'

This outburst drew no sympathy from the Viscount; and Aucassin retreated to a palace room to weep and despair of life now Nicolette was gone.

Count Bougar, meanwhile, had not forgotten his war, but threw his forces against the castle. When Garin again called his son to help in the defence, Aucassin struck a bargain: yes, he would take up arms provided that, if God preserved him, he were allowed to have two or three words with

Nicolette and kiss her once. See him now arm for the battle! He saw with pride how well his feet were set in the stirrups. Then out into the fray! So overcome was he, however, by thoughts of his beloved that he failed to notice his steed carrying him among the enemy. Only when he heard them talking of finishing him off did he come to his wits and the realisation that, if he lost his head, he would never be able to speak those words with Nicolette. The thought inspired him to furious action; and before long he was leading Count Bougar by his nose-piece before his father. 'Now keep your bargain,' said Aucassin. But Garin refused, whereupon Aucassin released his prisoner on the sole condition that in future he must bring as much shame as possible on his deceitful father.

It is in the next episodes that clear reminiscences of the Pyramus and Thisbe legend appear. Count Garin, seeing his son's wilfulness, locked him up in a cellar; and there the lad sang disconsolately of his sweetheart's charms and his likely death for her sake. Nicolette, however, was made of sterner stuff. One night, by knotting together sheets and towels, she let herself down from her high window into the garden. In the moonlight the daisies looked black beside the whiteness of her feet as she ran to the gate, then out into the streets of Beaucaire. She came to the tower where Aucassin was languishing; and through a crack in its ancient wall she heard him weeping and lamenting her loss. Calling to him through the crevice, she declared her intention to escape across the sea and passed a lock of her hair, which Aucassin, like Lancelot, placed against his heart. But then the thought struck the lad that if she did go away, the first man to set eyes on her would be sure to take her to his bed. This would be too much for him: he would not wait to find a knife to drive into his heart, but would dash out his brains against the nearest wall.

'Ah,' she said, 'I don't believe you love me as much as you say. My love for you is greater than yours for me.' — 'Never!' said Aucassin. 'My lovely sweetheart, it would be impossible for you to love me as much as I do you; for a woman's love is in her eye, on the tip of her breast and in her toe, but the love of a man is planted within his heart and cannot leave it.'

Their debate was cut short by a kindly watchman on the tower. He had seen a band of armed men sent by Count Garin to take and kill Nicolette; so, having heard the lovers below, he gave them warning in a song. Nicolette hid until the party had gone by, then clambered over the crumbling walls of the castle, negotiated the dried-up moat, and fled into the nearby forest where, despite her fear of snakes and wild beasts, she fell asleep.

In the morning, she was wakened by the singing of the birds and the voices of some shepherd-boys, who were taking an early meal at a spring not far

away. They at first thought she was a fairy; but at the price of a few coins, they consented to give a message to Aucassin, should he pass that way. They were to tell him there was a precious beast in the forest; and if he could catch it within three days, it would cure him of his hurt, but if not, he would never be healed. She left the boys then, and came to a place where seven tracks met. There she built a fine bower of grass and leaves and lily flowers, intending it as a test for Aucassin: if he loved her as well as he said, he would recognise it as her work and rest there a little; if he did not, he would have her love no more.

 With Nicolette gone, Count Garin released Aucassin, and even arranged

85 Nicolette escapes from her imprisonment, climbing down the tower into the moonlit town.

a great feast to cheer him up. The lad was not so easily consoled; but as he leaned moping against a balustrade, a knight came to him with advice, saying he too had once suffered from the same malady. Let him ride to the forest: he would see the flowers, hear the birdsong, and even perhaps hear something to his advantage. 'Thank you, sir; I will,' said Aucassin. So to the forest he went; and there he was given the message by the shepherds and galloped off in quest of his beloved, paying no heed to the thorns and briars that tore his flesh. The coming of evening brought back his tearful despair; and it took a meeting with a hideous but optimistic ploughman to put new heart into him. Night had fallen when he came to the bower; but in the moonlight he could

86 Aucassin embraces Nicolette in her bower in the forest.

tell it was Nicolette's handiwork, and decided to rest there until morning. As he came to dismount, so full was his head of thoughts of his sweetheart and so tall was his horse that he fell and dislocated his shoulder against a stone. As he lay in agony, his eye fixed on a bright star: if only he were there with Nicolette, whatever the danger of falling! From her hiding place, Nicolette heard his musing and was quick to come and tenderly repair the damage to his shoulder, with the aid of God 'who loves lovers'. No more time must be lost, she said, for on the morrow Count Garin would search the forest and have her put to death. So without more ado, Aucassin caught her up onto his steed and galloped with her by valleys and mountains and towns to the sea.

Now the narrative gathers speed as it runs through a series of exotic episodes in the fashion of the adventure romance. The lovers take ship and come to the land of Torelore, where a war is being waged with crab-apples, eggs and fresh cheeses. The Queen of this strange realm is at the head of the troops, whilst the King lies at home in child-bed. Here at last Aucassin shows his mettle by belabouring the monarch with a stick and then, against all the local rules, slaying a number of his enemies. Next, Saracen marauders storm the castle of Torelore and make off, taking Aucassin in one ship and Nicolette in another. When the fleet is dispersed by a great storm, fortune decrees that Aucassin's vessel is blown ashore at Beaucaire, while Nicolette's makes harbour at Cartagena, where it is discovered that she is the Saracen King's daughter.

His parents by this time being dead, Aucassin miserably governs Beaucaire, thinking still of his lost sweetheart. In Cartagena Nicolette is much honoured; but under the threat of marriage to a great pagan potentate, she disguises herself as a minstrel, darkens her face, and finds a ship to take her to Beaucaire. There she plays her fiddle before the young Count and sings of a princess pining in Cartagena for her beloved Aucassin. Implored by Aucassin to go and persuade this princess to come and be his wife, she retires to strip herself of her disguise and dress in borrowed silks. When Aucassin sees her in all her former beauty,

> he holds out his arms and clasps her in a tender embrace, kissing her face and eyes. That was how matters stood that night; but early in the morning Aucassin wed her and made her Lady of Beaucaire. For many a day they lived in great happiness. Now Aucassin had found his joy, and Nicolette had hers. Our singing tale is at an end, for I have no more to say.

87 (*facing*) Aucassin and Nicolette sight the ship that will take them to Torelore.

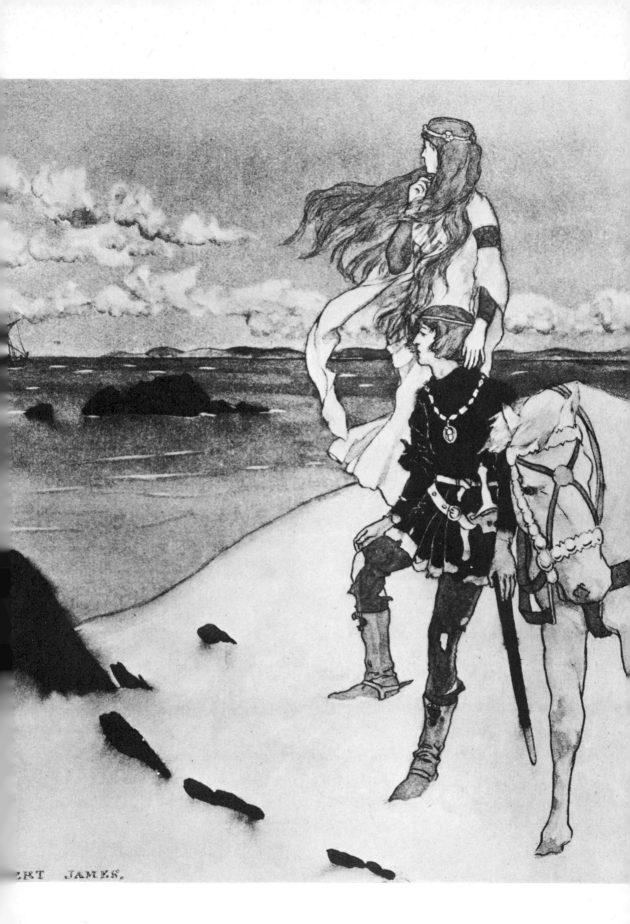

With this charming work it is as if noble love has come to the nursery and been viewed through the simplifying eyes of a child. From the beginning Aucassin appears as a petulant, pouting boy in a man's world. He must have his pretty Nicolette, and nothing else matters, least of all his parents' notions about chivalric behaviour and feudal duty. Only in the topsy-turvy land of Torelore does he seem to become a man, but then it is in a child's world of make-believe. To some degree he is a caricature of the true courtly lover: the passive, suffering aspirant to joys just beyond his grasp, his whole being concentrated on this single desire, ready to die for his love if need be, and prepared to debate its quality at the least appropriate of moments. Even Nicolette, who often reminds us of the practical, affectionate elder sister, has a touch of the troubadours' mistress-figure, dominating the relationship and vowing to withdraw her love should Aucassin not pass the test she has set him. Yet in the end it is she who seeks him out and makes possible the tying of the marriage knot. So this nursery game is over. The 'two handsome little children' have been mimicking the adult business of courtly love and romping through its imaginary perils. Now, breathlessly happy, they have been put to bed.

In this chapter we have seen something of the lighter side of courtly love. *Joufroi de Poitiers* showed its artificiality being exposed with ruthless cynicism. Turning to the romantic career of Sir Gawain, we watched him dancing to its tune with mixed success, but neglecting its more restrictive precepts as he went his philandering way. In *Aucassin and Nicolette* we found it tempered by the 'Ovidian' tradition of adolescent love and played out on an amusingly juvenile level. The troubadours may have made love a socially acceptable occupation; but they made of it an institution which, like the public apparatus of religion, was a tempting target for jocular attack. It is no accident that writers of romance were apt, in their light-hearted moments, to associate love and religion, mocking not the reality but the outward appearances. In contrast, we have already seen how other poets were able with grave reverence to merge their erotic and spiritual aspirations. Such a poet was Dante.

Chapter VIII

Dante
and
Petrarch

The young Dante was no stranger to the literature of courtly love. Born in 1265 in Florence, city of poets, artists and scholars, he quickly developed not only a taste for verse, but sufficient skill in its practice to gain the friendship, while still in his teens, of the rather older and already distinguished poet Guido Cavalcanti. At this time the Italians were very much under the cultural influence of their northern neighbours; and they drew on the legacy of the troubadours to produce their own autumn flowering of the songs of courtly love. Dante looked back with particular admiration to the verse of the Provençal Arnaut Daniel, 'the best craftsman of the mother tongue' as he is called in the *Divine Comedy*. So he too went early to school with the troubadours and learnt from them not merely technical aptitudes, but also how best to use them in the celebration of a noble love-relationship. They taught him how to play in his verse the role of courtly lover, a part which, if we are to believe his various writings, he was to sustain in real life. But should we believe him? Was that famed love of his for Beatrice just a continuation of the old courtly love game that converts perhaps trifling realities into impressive and resplendent fictions? How far have genuine feelings for a living girl been transmuted into a purer, more concentrated form in the courtly crucible? Where does fact end and fiction begin? It would be a bold biographer who tried to answer these questions; for even a fiction may be experienced by its creator quite as intensely and enduringly as any reality. And surely in Dante we see a man who was profoundly touched by the courtly experience that inspired him as a poet.

It is chiefly in the *Vita Nuova* (the 'New Life', or perhaps 'Early Life') that he tells the story of his love for Beatrice. Though he does not identify her further, it is generally supposed that she was Bice Portinari, the daughter of a prominent Florentine citizen, who married a banker, Simone dei Bardi, and died in 1290 at the age of twenty-four. Boccaccio was to introduce into his life of Dante a romantic account of their first meeting, as children, at a feast given one Mayday by the father of Bice, or Beatrice as Dante preferred to call her. But it is best to let the poet speak for himself through his *Vita Nuova*. To modern eyes this seems a hybrid work, part autobiography, part poetic treatise. In it Dante has put a selection of his early verse, with the prose account of his love for Beatrice forming a narrative linkage (it was composed a few years after her death). In addition he has provided the poems with technical notes that strike a curiously dispassionate chord in so lyrical a work. We are left with a strong impression of contrivance, yet of contrivance aimed at imposing an artificial but fashionable pattern on a profound emotional experience. The following is the story that emerges.

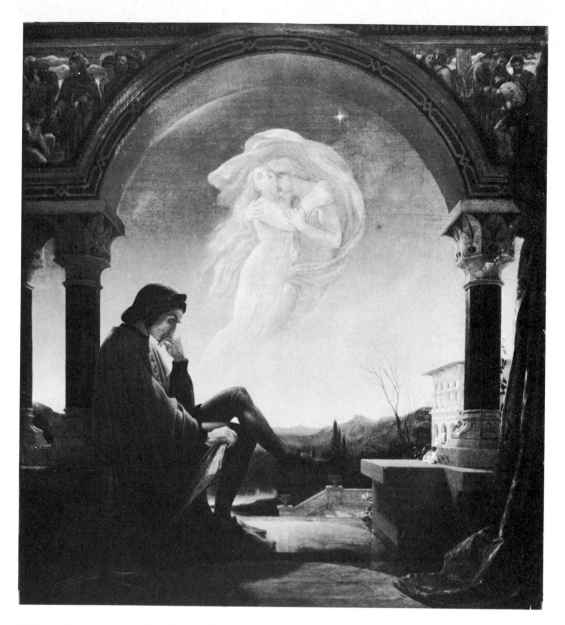

88 Dante's dream, painted by Sir Joseph Noel Paton in 1852.

It was at the end of his ninth year that Dante first saw Beatrice, who was almost a year younger, wearing a dress of delicate crimson. His pounding heart at once formed the words: 'Behold a god stronger than I who comes to rule over me.' And indeed from that moment he was Love's willing servant, forever seeking to catch a glimpse of this angel of tender years and seeing her inspiring image continually before him. It was nine years later that he met her in the street in the company of two older women. This time she was dressed in pure white and turned to give him a greeting, which filled him

with such joy that he fled to the privacy of his room; and there, with his thoughts fixed on her, he fell asleep.

In a dream he saw a cloud the colour of fire, and in that cloud a lordly figure, awe-inspiring yet seeming imbued with great joy. It spoke to him these words: 'I am your master.' In its arms lay the sleeping Beatrice, wrapped lightly in a crimson cloth; and in one hand it held a fiery object. 'See here your heart,' it said. Then, waking the sleeping girl, it made her, despite her misgivings, eat the burning object. Soon after, its joy turned to bitter grief; and taking the girl once more into its arms, it seemed to ascend into the heavens. At this Dante felt such anguish that he woke. For the benefit of his fellow-poets he recounted his vision in sonnet form and asked for an interpretation. One came from Guido Cavalcanti; and from that time the two men's friendship was formed.

After his vision Dante grew weak from love, and his friends remarked on his changed appearance. However, though he admitted the nature of his malady, he would not disclose his lady's name. In church one day he found himself placed so that he could look at his beloved. Between them sat another lady, and those who followed his gaze thought it was directed at her, not Beatrice. Dante encouraged this belief for several years, even composing some verses for this pretended love and, when she left Florence, a lament. Whom could he now use as a cover for his real passion? He seemed to see the the God of Love appear to him again, bringing back the heart he had taken to the other and about to carry it for lodging with a further lady, who was now to become his screen.

His new pretence was too successful. Beatrice's greeting, which was for him the source of purest joy, was on one occasion refused. It was for sorrow that Dante now withdrew to his room, where he could weep alone like a beaten child. Sleep came, and with it another dream in which the Lord of Love appeared, dressed all in white. Dante must dissemble no longer. Word had reached Beatrice that he had given some cause for annoyance to the lady who was now his screen; and fearing she might receive the same, Beatrice had withheld her greeting. So now Dante must compose for her a song in which the truth of his love would be told and be recognised by her. This song he soon wrote, and then a sonnet speaking of his vacillating thoughts about love. Here, as an example of his interjected commentaries, is what he says about the second poem:

> This sonnet can be divided into four parts: in the first I propose that all my thoughts are of Love; in the second I say they are of different kinds and speak of their diversity; in the third I say what they all seem to have in common; in the fourth I say that, wishing to speak of Love, I do not

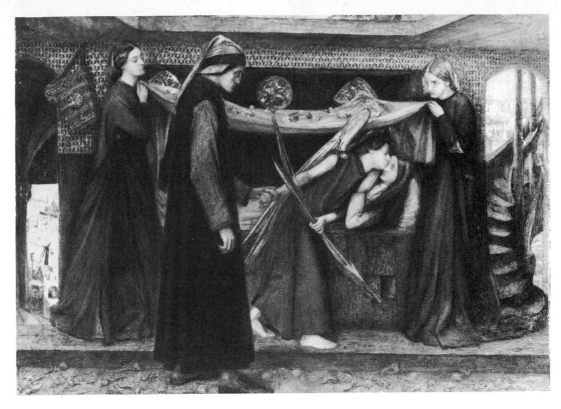

89 Dante's dream at the time of the death of Beatrice, painted by Dante Gabriel Rossetti in 1856.

know from which to choose my subject; and if I want to take it from them all, I have to call on my enemy, my Lady Pity. I say 'my Lady' in a derogatory way.

It happened that Dante was taken by a friend to visit one newly-wed who was entertaining a number of ladies. Having joined the company, he felt in the left side of his breast a sudden throbbing that quickly spread to his whole body. He leant against a wall to steady himself and, raising his eyes, he saw Beatrice among the guests. The sight routed all his senses, so that his friend was forced to lead him away, while some of the ladies mocked his behaviour in the hearing of Beatrice. Returning to his room of tears, he addressed a new sonnet to her, explaining the cause of his senses' disarray, then two further poems where he again told of his confusion as Love waged its battle within him. Now it became clear to some people who Dante's beloved was; and one day a group of ladies taxed him with loving her whose presence he could not endure. His reply was that formerly his highest desire was to be greeted by her; but now she has denied him this blessing, his whole joy lies in singing his lady's praises. So to this he turns, claiming that Heaven's only lack is the absence of so perfect a creature. A sonnet follows on the theme 'Love and the noble heart are one selfsame thing', and another speaks of the ennobling quality of his own lady, such a miracle of grace is she.

At that time, Beatrice's father died; and Dante, hearing from someone who had just left her of the piteous depths of her sorrow, was seized on the spot by such desperate grief that it was a wonder to the passers-by. Shortly afterwards he himself fell ill and had a delirious premonition of his beloved's own death. It seemed to him that the sun grew dark, the stars appeared to weep, birds fell dead, and the earth quaked violently. He had a vision of angels accompanying to Heaven a little cloud of purest whiteness and rejoicing as they went; and then he saw Beatrice's lifeless body and the look of serene repose on her face. At this he too called for death, and was invoking his lady's name when he wakened. On his recovery he told of his experience in a song. A happier vision followed: of Love joyfully heralding the approach of Giovanna, the mistress of his closest friend, preceding Beatrice just as Giovanni (John) had anticipated the coming of the True Light. After a digression justifying his personification of Love, with reference to the practice of the Classical and vernacular poets, Dante again extols, in prose and verse, the miraculous goodness and loveliness of his lady, and tells anew of Love's mastery of his very soul.

It was while he was still composing the last of this group of poems that he learned of the death of 'this blessed Beatrice'. No words of his would be adequate to relate the tragic event, so he would do no more than remark on its association with the number nine (Beatrice died at the ninth hour of the ninth day of the month according to the Syrian, at the start of the ninth decade by the Christian reckoning). That number is the square of three, which represents the miraculous Trinity. Beatrice is thus seen to have been herself a miracle, whose loss to the world is mourned by Dante in some further poems.

One day he saw a lady looking down from her window and seeming to be deeply touched by his obvious distress. To her he addressed two sonnets; and, drawing comfort from her compassion, he began to take pleasure in seeing her on other occasions. But was this right? He accused his eyes of inconstancy towards his dead Beatrice. Yet could it be that love wished to bring him peace after such pain? His doubts as to how he should behave towards this lady were at length dispelled by a vision of Beatrice in glory, dressed in that same crimson she had worn at their first meeting and seeming just as youthful as then. Now his former sighs and tears returned. More sonnets were written, telling of the city's loss when Beatrice departed and of his own thought's pilgrimage to the celestial realm where her soul was now being honoured. Then, in another vision, he saw things that decided him to write no more of her until his talent was more worthy.

In this way, if it please Him, the source of all life, that my own should last for some years yet, I hope to say of her what so far has never been spoken of any woman. And then may it please Him who is the Lord of courtesy that my soul may go to see the glory of its lady, that is of the blessed Beatrice who, herself in glory, beholds the face of Him who is blessed through all ages.

Thus Dante's account of his earthly love for Beatrice ends with a possible hint of her later appearance in the *Divine Comedy*, though this great work was written some twenty years afterwards. By then Dante had seen much of life, having devoted himself to philosophical studies, politics and diplomacy, and having been condemned to perpetual banishment from Florence. There are even grounds for suspecting a period of loose living and, perhaps, loving, despite the fact that he was married, and had been since long before Beatrice's death. Nevertheless, her image had not been dimmed by time; and in the *Divine Comedy* we learn from Virgil how it was she who had come to the Limbo, at the behest of St Lucy and the Virgin Mary, to urge him to act as Dante's guide through Hell and Purgatory. Beatrice herself awaited him in the Earthly Paradise and conducted him through the higher Heavens, abandoning him only to St Bernard and his ultimate vision of God. But by now she has shed all real humanity to become a kind of speaking symbol and agent of theological revelation. No longer is she that lady who, though scarcely less ethereal, was the inspiration of Dante the courtly lover.

Was she in fact ever a creature of flesh and blood? The reader will doubtless have identified many of the commonplaces of courtly love that go to the making of the *Vita Nuova*. There is the sudden, ecstatic shock of falling in love (a childhood experience here, as in some of the romances), and thereafter the total preoccupation with the beloved, her sweet greeting falling on the lover like a blessing. The lady is a source of both joy and moral improvement, with her eyes above all reflecting her essential, miraculous beauty. The lover is physically afflicted by his passion, growing pallid and weak, relapsing into sighs and fits of weeping; and the psychological effect is no less marked, for he is quite overwhelmed when he finds himself in his lady's presence, and is at other times subject to lurid dreams and a mental confusion that borders on derangement. He has a morbid fear of mockers and gossips, and conceals his beloved's name as long as he can, stooping when necessary to the deceitful pretence of loving another. As Dante himself points out, the personification of Love is a very ancient device; and there are other themes he has inherited— the lover gazing on his lady in church, the heart migrating from the body, its being given as food to the beloved, and, on a more mundane level, the lover comparing himself to a chastised child (as in one of Arnaut Daniel's poems).

We have seen that the mystical aspect of love was developed by some of the troubadours. This development Dante was to carry to its natural end in the beatification of Beatrice. Yet are we not already set on this spiritual pilrimage when we hear a troubadour like Peire Vidal exclaim: 'Good lady, when I gaze on your fair person, I think I see God'?

Unique as the particular form of the *Vita Nuova* may be, it too had evident antecedents in the manuscript collections of troubadour songs, where the individual poems were often preceded by prose commentaries on their themes. And if the troubadours could be provided with fictitious 'biographies', as we have found they were, why should not Dante have invented at least some part of his own? Did he, then, really love a girl called Beatrice (or Bice)? Or, steeped as he was in the lyric conventions of his age, was he most of all in love with love as an exalting experience and a subject worthy of his highest artistic endeavour? Our doubts about Beatrice's real existence are not allayed when we find him, in the *Convivio* ('Banquet'), revealing that the compassionate lady to whom he had turned after her death was, in fact, Philosophy. If he presented one abstraction in human form, why not two? I do not question his deep emotional commitment to Beatrice. But one is entitled to wonder whether she had more substance than a symbol of an erotico-mystical ideal transcending mere humanity. Does it really matter whether she walked the streets of Florence or moved only in Dante's mind and soul?

> Relations with women, without which I had at times supposed I could not live, I now dread more than death; and though I am often most sorely troubled by temptations, nevertheless when I recall what woman is, all temptation suddenly vanishes.

It will come as no particular shock to learn that this was written by a man who, having climbed an Alpine peak, with St Augustine's *Confessions* in his

90 Dante is cast out of Florence and is seen writing in exile in Verona.

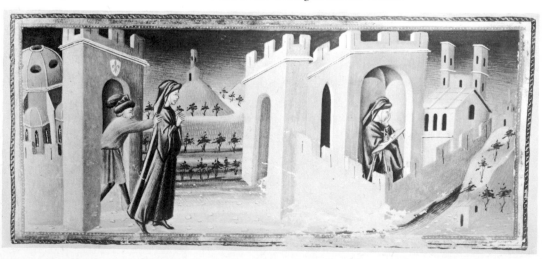

hand reflected that the ascent he had just made fittingly symbolised his aspiration to a better life. But what may perhaps astonish is the fact that this same man was Petrarch, one of the greatest singers of noble love, who declared so often in his verse an unfailing constancy to his lady, Laura. How can two such apparently contradictory attitudes be reconciled: on the one hand an anti-feminism typical of non-courtly medieval writing, and on the other the amorus devotion of the courtly lover? Perhaps we find a partial answer in some lines composed, it seems, in 1358, when Petrarch was fifty-four:

> Love's fires consumed me, joyful in its flames,
> Hopeful in pain, through one and twenty years.
> Ten more have passed in lamentation, since
> My Lady rose to Heaven with my heart.

91 (*above*) Before Beatrice leaves Dante, she shows him the white celestial rose where the angels minister to the souls of the blessed (*Paradiso* XXX–XXXI).

92 Dante reels under the look of divine love that shines from Beatrice's eyes (*Paradiso* IV).

Now, in my weariness, I blame my life
For faults so grave as almost to destroy
The seed of virtue: what remains I yield,
Almighty God, and consecrate to Thee

In sad repentance of my wasted years.

Florence might have had this second bright star in her firmament had not Petrarch's father fled the city in the same year as Dante's banishment. So it was in Arezzo that the poet was born, though he soon found himself in Avignon, where his father had obtained a post at the papal court; and it was there that he returned to a life of pleasure when, having pursued his studies at Montpellier and Bologna, he received the news of his father's death. At Avignon too he saw Laura, or so he tells us in a note written on the flyleaf of his copy of Virgil. It was, he says, on the sixth of April 1327, when he was at matins in the church of St Clare, that his eyes first lit on her; and on the same date, but in 1348, 'the light of her life was withdrawn from the light of day'.

Laura is a figure as mysterious as Dante's Beatrice, for we have no certain information about her. An old tradition has it that in 1315 she married into a venerable Provençal family, becoming the wife of Hugues de Sade, and dying the mother of ten or more children. If this is so, and there is nothing approaching proof, the infamous Marquis de Sade was justified in numbering her among his distant ancestors: she even, according to one of his letters, appeared to him when he was in prison — an encounter to set the imagination racing! The question must nevertheless arise, as with Beatrice, as to whether she ever existed outside Petrarch's mind. The general opinion is that she did. Yet even a close friend of the poet was able to express to him his own doubts on the subject, eliciting Petrarch's reply that his love for Laura caused him perpetual suffering, from which he could not escape. And in a confessional work that takes the form of a dialogue, in Latin, with St Augus-

93 Portrait of Petrarch, from a
manuscript of his writings.

tine, Petrarch defends himself against the charge of lust by claiming that Laura was for him a model of and inspiration to goodness, never yielding to his desires but remaining the only true object of his earthly love. If her existence was pure fiction, then it was a fiction staunchly maintained by its creator throughout his life.

Real person or not, as we look at Laura standing at the end of the long avenue of the courtly love tradition, we see little to distinguish her from the typical aloof, almost abstract, lady of the medieval troubadours. Yet Petrarch has been called 'the first modern scholar, the first modern literary man'; and his learning and interest in Classical Antiquity mark him as a figure more of the Renaissance than of the Middle Ages. He does not profess Dante's admiration for the troubadours, and their direct impact on his verse may have been slight. However, when we read his 366 lyrics devoted almost exclusively to Laura, in life and death, we find again and again, as in Dante, the old courtly clichés in graceful Italian dress. Nothing is more stereotyped than Laura's golden hair and radiant eyes. When the poet first saw them (in church, we remember), Love loosed an arrow through his eyes and into his heart. Since then he has been a prey to all the ailments of the courtly lover: loss of speech and confusion in his lady's presence, grief in her absence, though her merest smile or greeting fills him with unbounded joy. But she withdraws from him and shows little response to his passion. He craves her mercy, and will die unless she relents. Doubts enter his mind: should he abandon so fruitless a love? No, for she is the source of all goodness, and inspired by her he can make his pilgrimage to Heaven.

> When other ladies keep her company,
> And Love comes to repose in her fair face,
> The less their loveliness can vie with hers,
> The more intense my longing passion grows.
>
> I bless the place, the moment and the hour
> In which I raised my eyes to gaze so high;
> And to my soul I say: The gods be praised
> That you were blest with such a privilege!
>
> She is the source of that fond thought of love
> That leads you onward to the highest good,
> Despising all that other men desire.
>
> She is the source of that uplifting grace
> That guides you by the proper path to Heaven,
> So that I go already proud in hope.

The dreadful scourge of the Black Death struck Avignon in January 1348 and claimed, it is said, 150,000 souls in that city by August. Was Laura one of its victims? The news of her death reached Petrarch on the nineteenth of May, he tells us; and then began for him many years of mourning, expressed in some hundred poems, of which the following may have been the first:

Alas fair face, alas that gentle glance,
That manner full of dignity and charm!
Alas that speech which made all base hearts bold
And taught harsh, haughty minds humility!

Alas for that sweet smile which cast the dart
Whence now I hope for death, no other good!
That noble soul, worthy to reign supreme,
Had she but joined us in an earlier age!

For you I still must burn and in you breathe,
Since I was yours alone; and, with you gone,
Other misfortunes hold less grief for me.

With hope and with desire my heart was full
When last I left my greatest living joy:
But now the wind has swept her speech away.

Thus Petrarch laments his Laura as Dante had grieved for Beatrice.

94 The triumph of Love, on a 15th-century French tapestry once in the possession of the Hapsburg royal family.

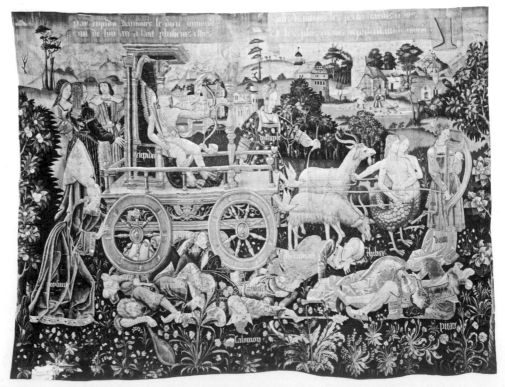

In the imaginary dialogue I have mentioned, another fault with which St Augustine confronted him was his thirst for fame. This had led him to covet the laurel crown for poetry, an ambition gratified by his coronation in Rome in 1341 as Roman poet, historian and citizen. Dante had refused a similar honour because he could not be crowned in Florence. So in this Petrarch had outdone his predecessor; but his work suggests a continuing urge to pit his poetic skills against those of the Florentine and to surpass him in glory. Dante had had his Beatrice so he must have his Laura: had she not existed, he would have had to invent her, and in a similar mould. He must celebrate her, living and dead, in a body of lyrics that would be his own *Vita Nuova*. He must carry her to Heaven in his song and show her enjoying a posthumous existence no less favoured, no less blessed than that of Beatrice. Laura too must have her *Divine Comedy*.

Petrarch's poetic zeal did not allow him the patience to wait until his lady departed this life; and as early, perhaps, as 1340 he started work on the first of his six *Triumphs*, long poems for which, significantly, he adopted the *terza rima*, a metrical form invented by Dante for the *Divine Comedy*. The generals of ancient Rome had been honoured on their return from a great victory with a lavish triumphal procession in which their captives were put on public display. Who better to honour with a parade of this kind than the all-conquering God of Love? Inspired by this thought, Petrarch composed *The Triumph of Love* (the Latin title he gave it was *Triumphus Cupidinis*).

95 The triumph of Chastity on a tapestry from the same series.

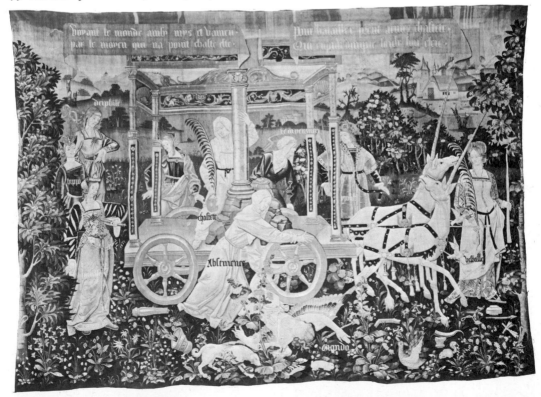

Weeping at the memory of an unhappy love, Petrarch fell asleep. He seemed to see a great light and, within that light, a cruel youth, winged and naked, on a fiery chariot drawn by four snow-white steeds. He had a bow in his hand and arrows at his side; and round him was a throng of people, some captive, others wounded or slain. One who had been Petrarch's friend greeted him with a warning that he too was destined to join this host held in thrall by the God of Love. Many of them he identified for the poet: mortals like Caesar and Cleopatra were found in company with figures of myth, Mars and Venus with biblical characters like David and Samson; and there too were Lancelot and Guenevere, Tristan and Ysolt, Paolo and Francesca da Rimini. Suddenly Petrarch began to tremble and turned pale; and beside him there appeared a pure young maiden. 'Now,' said his friend, 'you are free to speak with anyone you wish, for we are all stained with the same pitch.' Since that time, says the poet, he has known all the sorrows of an unrequited love. That maiden, disdainful and feared even by the God of Love, goes free, while he is in lifelong bondage.

> Harsh law of love! But unjust though it be,
> We must observe it; for its rule extends
> From Heaven to earth, throughout all time and space.

Then Petrarch saw the poets of love. They included Virgil and Ovid, and, among a group of Provençal troubadours, Arnaut Daniel and Jaufré Rudel; and there, with others from his own land, he saw Dante and his lady Beatrice. All these and countless more were compelled to follow the god on his triumphal way, until they came at last to Cyprus, Venus' isle, and were there led into dark imprisonment. Petrarch, his hair suddenly turned white, was left to languish with his fellow-captives and long for liberty.

His vision is continued in *The Triumph of Chastity*. Here we see Laura in combat with Love, whose fiery shafts are quenched by the coldness of her honour. Her many virtues come to her assistance; and in the end the god is vanquished, bound and beaten, his arrows broken and the feathers plucked from his wings. Now it is Laura who leads the triumph, with its procession of pure women, to the Temple of Chastity in Rome. These first two *Triumphs* appear to have been composed in Laura's lifetime; the others follow her death, with the last two being written quite late in Petrarch's life.

The Triumph of Death opens with Laura returning from her victory beneath her banner of ermine on a green field, when she is accosted by a black-garbed woman with a dark, dismal banner, and a multitude of the illustrious dead appear. So Death has come to claim Petrarch's lady, and he describes in moving terms her passing from this earth:

> Not like a brutally extinguished flame

96 Laura leads the unicorns who draw Chastity's triumphal car. Cupid, his hands bound behind his back, kneels at Chastity's feet.

But one that goes wasting itself away
Her soul departed, peaceful and content,
Just as a clear and gently burning light
Slowly consumes the oil on which it feeds,
Yet to the end keeps its pure radiance.
She was not pale, but whiter than the snow
Quietly drifting on a noble hill;
Weary she seemed, and come to take her rest.
A sleep-like sweetness touched her lovely eyes
Now that she had surrendered up her soul:

That is what foolish people call to die.

Death appeared beautiful in her fair face.

Then Laura appeared to her lover, crowned and holding out her hand. She brought him consolation and the assurance that only her sense of honour and fear of shame had kept her from betraying a passion almost as great as his own.

There follows *The Triumph of Fame*, with many examples to point the moral that glory can vanquish Death. Yet even Fame cannot stand before Time, to which the next *Triumph* is devoted. Is there anything, then, that can prevail over Time? The last section brings us the answer; for in *The Triumph of Eternity* Petrarch expresses his pious conviction that in Heaven all will be made new. There he will at last be reunited with his beloved:

Then all her loveliness will be restored:

If he was blest who saw her here below,

What, then, to see her once again in Heaven!

It was not in vain that Petrarch had aspired to rival the *Divine Comedy* with his *Triumphs*, since for a century or more they outstripped Dante's master-piece in public esteem and provided subjects for artists and craftsmen in many media. If nowadays we judge them less kindly, this is not to deny their nobility of purpose or the fact that they have some inspired passages, and none more moving than those that speak of Laura. With Dante, Petrarch had achieved the ultimate consecration of courtly love and its elevation above mere human passion. It is no longer the hope, however slender, of earthly gratification, but the assurance of spiritual salvation through the mediation of the beloved. What she was for the poet could hardly be better expressed than in the words of the familiar hymn:

Love divine, all loves excelling,

Joy of Heav'n, to earth come down . . .

From being a courtly game or a poetic exercise this love has become, at its most refined, a vehicle for spiritual contemplation.

We saw how earlier poets had accommodated the expression of a noble love to the feudal warrior mentality. Dante and Petrarch, harmonising it now with the Platonic ideal, have done much to reconcile it with religion, but only at the price of dehumanising the lady even more than most of the troubadours had done. For them she had been aloof, yet kept apart from the lover as much by her own caprices and the mundane hazards of jealous husband and gossips as by her essential unattainability. Now she is so chastely remote that questions of marriage are irrelevant, and even the protective veil of secrecy has been allowed to wear gossamer-thin. In life she is less mistress than goddess, in death an ornament of Heaven beside whom even the Virgin pales a little. The line between profane and sacred love has all but gone.

Chapter IX

The Legacy of Courtly Love.

Freeing itself gradually from the hold of heroic, epic attitudes, the medieval imagination surrendered to the gentler tyranny of love; and, having found the way to express it in socially acceptable terms, it made of it the dominant theme of literature. The coin of love had two faces; and though our concern has been with its nobler, idealised aspect, its reverse is not to be ignored. The so-called 'quarrel of women', incited by the conflict within the *Romance of the Rose*, was tacitly played out in literary terms all through the Middle Ages. Thus the ritualised courtship displays of the elegant poets stood in complete contrast to the crude, misogynistical realism of the fabliaux, comic verse tales in which the mating urge was depicted in the most basic terms, and re- fined manners appeared only as a subject for mirth. Both types of love are found in the works of Chaucer and Boccaccio; and although the latter re- vered Petrarch as his master and was no novice at the courtly game, his *Decameron* breathes more of the spirit of the fabliaux than of his mentor's piously Platonic yearnings.

The double standard in the European attitude to love, accentuated though certainly not invented by the medieval writers, persists to the present day. Does courtly love, then, still exist? There is no answer to the question; or rather there are as many as the term has meanings. It has even been claimed that the 'courtly experience' in love has existed in most times and places. But, taking a narrower view, it is quite possible to trace direct currents of influence flowing from the troubadours through eight centuries and more of literature and art, down to our own times. To the Provençal poets above all we owe that familiar vision of the beloved as the embodiment of ideal beauty and virtues to which the fearful, anguished lover must reach up as he lives in hope of some token of amorous charity. Because anguish grows as hope re- cedes, their cult was more of pain than of joy, of protracted suffering to win at best a fugitive happiness. However, the mystical element, present quite early in their verse, was developed by the Italians to offer the lover the promise of bright uplands awaiting him at the end of his vale of tears; and with them the course of his passion became almost an allegory of life itself.

When the French took the torch of Renaissance culture from the Italians, they inherited with it courtly love in the Petrarchan style, largely neglecting their own native poets who had carried the *trouvère* tradition through to the end of the Middle Ages. So for their early verse the leaders of the new poetic movement, Ronsard and his friend Du Bellay, chose their chaste 'goddess' figures and addressed to them verse that brimmed more with Petrarchan conceits than with passion: Ronsard's Cassandre was the daughter of a Florentine banker (is it only coincidence that Beatrice was the wife of one?); Du Bellay's Olive was his own cousin. A poet from Lyons, Maurice Scève,

acquired early fame as the discoverer, while a student at Avignon, of the tomb of Petrarch's Laura; so we are not surprised to find him composing in similar vein, but to an even less earth-bound mistress. He gave her the name Délie, 'object of the highest virtue'; and surely it is no accident that this is an anagram of *l'Idée*, 'the Idea', with all its Platonic implications — the abstraction of love and the lady can go no further.

Long before the waves of the Renaissance broke on the shores of England, this country was well acquainted with the ways of courtly love. It may be remembered that Bernard de Ventadour, one of the finest troubadours, probably paid a visit to the English court. It was the fate of Charles, Duke of Orleans, the last great courtly poet of the French Middle Ages, to spend a quarter of a century here; but his long stay was not of his choosing, for he had been taken prisoner at Agincourt, and it was to while away his captivity that he wrote much of his verse, in English as well as his native French. It would be tedious to list all the English poets of the sixteenth and seventeenth centuries who paid their homage to the courtly muse; but there is one name that cannot be left aside: William Shakespeare. And surely no book on noble lovers can properly be brought to an end without further mention of the immortal lovers of Verona, Romeo and Juliet.

The story was an old one, and Shakespeare had found it in an English translation of an Italian version by Bandello. It is in Dante's *Purgatory* that we come across the earliest mention of the feud between the Capulets and the Montagues, which frames the tragedy of the two young lovers. But other

97 Portraits of Ronsard and Cassandre from the 1552 folio edition of his *Amours*.

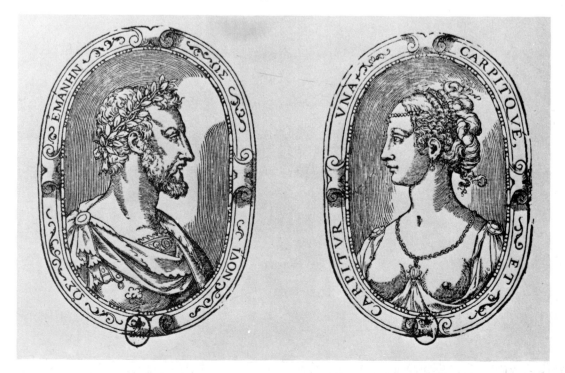

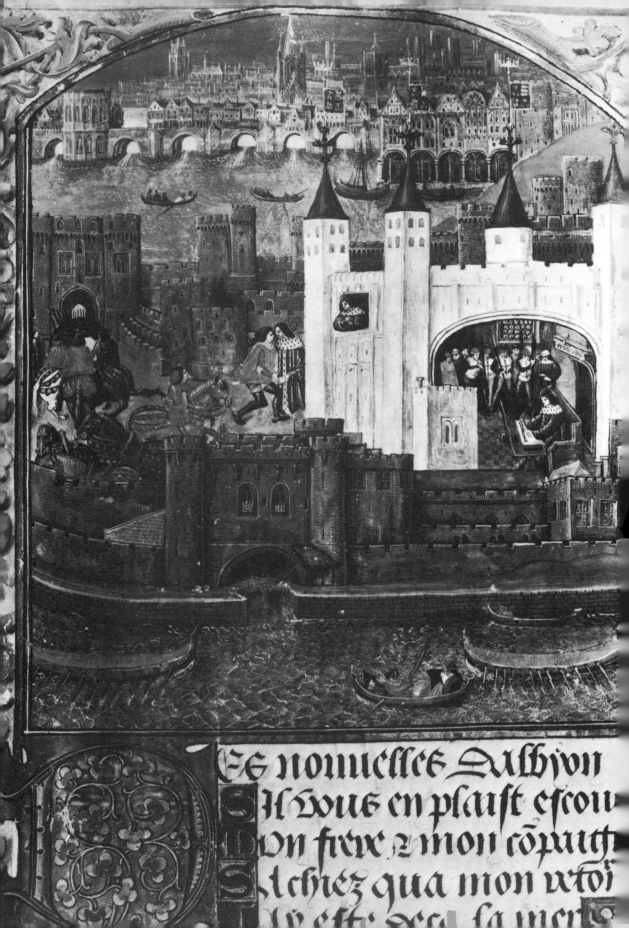

Es nouuelles Dalbion
il vous en plaist escou
mon frere z mon cõpaing
lchez qua mon retoi
ly est dela la mer

elements are much older still. The potion that produced in Juliet the semblance of death can be traced back to late Antiquity, and had already been used by the heroine of Chrétien de Troyes's *Cligés*. As for adolescent passion in the face of parental opposition, are we not reminded of the fate of Pyramus and Thisbe and, less directly, of the loves of Floire and Blancheflor, Aucassin

98 Charles d'Orléans composing his verse during his captivity in the Tower of London.

99 The balcony scene from Romeo and Juliet.

and Nicolette? Shakespeare's genius, of course, rose far above his sources; and though he was well versed in the courtly commonplace as found, for instance, in the *Romance of the Rose,* these too appear transfigured in his work. Mercutio made crude use of one of them when he told Benvolio what had befallen their friend:

'Alas, poor Romeo, he is already dead — stabbed with a white wench's black eye, run through the ear with a love-song, the very pin of his heart cleft with the blind bow-boy's butt-shaft.'

And Juliet, finding that Romeo beneath her balcony has overheard her admission of love, shows that she too knows the courtly role, and would have played it had her secret not been out:

'O gentle Romeo,
If thou dost love, pronounce it faithfully.
Or, if thou think'st I am too quickly won,
I'll frown and be perverse and say thee nay,
So thou wilt woo; but else, not for the world.
In truth, fair Montague, I am too fond,
And therefore thou mayst think my haviour light;
But trust me, gentleman, I'll prove more true
Than those that have more cunning to be strange.
I should have been more strange, I must confess,
But that thou overheardst, ere I was ware,
My true-love passion. Therefore pardon me,
And not impute this yielding to light love,
Which the dark night hath so discovered.'

Shakespeare, then, knew his conventions; but far from being a slave to them, he cracked the whip to make them turn somersaults for him, and nowhere to stranger effect than in the sonnets. When he comes nearest to traditional diction, he is addressing a man; and when he writes for his mysterious dark lady, what does he do but reverse the compliments we have come to know so well?

My mistress' eyes are nothing like the sun,
Coral is far more red, than her lips' red,
If snow be white, why then her breasts are dun:
If hairs be wires, black wires grow on her head:
I have seen roses damasked, red and white,
But no such roses see I in her cheeks,
And in some perfumes is there more delight,
Than in the breath that from my mistress reeks.
I love to hear her speak, yet well I know,

That music hath a far more pleasing sound:
I grant I never saw a goddess go,
My mistress when she walks treads on the ground.
 And yet by heaven I think my love as rare,
 As any she belied with false compare.

What mockery of the courtly tradition is this!

Although 'reason' and 'moderation' are terms that often recur in the literature of courtly love, the very frequency of their use suggests an uneasy awareness that the phenomenon is essentially both unreasonable and immoderate. Because it had so little to do with normal behaviour, it lent itself to over-refinement at one extreme and to public ridicule at the other. We have already noticed both tendencies operating in the Middle Ages, but matters did not rest there. The best known parody of the romances of chivalry was composed in Shakespeare's lifetime by a man who died in the same year as he: Cervantes. His mock-hero Don Quixote, with wits fuddled by too much reading, launched himself in his imagination on a quest of knightly adventure, inspired by the vision of an adored mistress, the lady Dulcinea. The comedy, of course, lay in the fact that the poor Don was alone in not recognising that the days of knight errantry were long past and that his fair lady was in reality a simple farm girl who had once caught his eye.

To mock the cult of noble love was not, however, to destroy it. In the middle of the seventeenth century, a group of intelligent and very sophisticated ladies fell under its still potent spell and adapted it to their own sentimental fancies. They were the Précieuses, who, with their admirers, pursued their intellectual pleasures in a number of Parisian *salons*. The preciosity they fostered revolved round a coquettish display of Platonic feelings, purged of deep emotion and conveyed in the most delicate of terms. They achieved that extreme of over-refinement I mentioned, and in the process laid themselves open to a great deal of mockery by their more level-headed contemporaries, including the great comedian Molière. In their attempt to avoid vulgarity they were apt to go to absurd lengths, preferring, for instance, to speak not of feet but of 'the dear sufferers', while a simple shirt became 'the perpetual companion of the dead and the living' and eyes 'the mirrors of the soul'. With verbal prudery taken as far as this it can be imagined how restricted was their expression in the erotic sphere. They were reluctant, in fact, to deal with passion at all, choosing rather to think in terms of that tenderness whose vagaries Mlle de Scudéry charted in her famous allegorical map, the Carte de Tendre. There we follow the river of Inclination as it passes from the town of New Friendship through Tenderness to the Dangerous Sea. The countryside around is dotted with hamlets bearing names like Pretty Verse,

Love Letter, Sincerity, Great Heart, Obedience, but also Forgetfulness, Slander, Perfidy. Beyond the Dangerous Sea lie the Unknown Lands; but if we venture there, it will be without a guide, for the good Mademoiselle was not prepared to stray so far herself.

For all their excesses, the Précieuses did help to promote a refinement of thought and psychological awareness that left its mark on later French literature, and their influence on social manners helped to reinforce the old ideals of courtliness and courtesy. These were very much the concern of a pioneer medievalist called La Curne de Sainte-Palaye, who in 1752 turned the story of Aucassin and Nicolette into modern French. It was well received; and in his preface to a subsequent edition, which he entitled *The Loves of the Good Old Days*, he tells us what moral he sees in the tale:

> Love, so much recommended by all our old authors, is here hardly ever presented except as a passion which, kept within proper bounds, can be the principle of the most shining virtues and the greatest deeds. But at the same time it can also be the source of an infinity of disorders and calamities, when one forgets all obligations to one's birth, family, station and country.

100 The love-sick courtier, a miniature by Nicholas Hillyarde.

101 Title page of La Curne de Sainte-Palaye's *Les Amours du bon vieux tems* (1756), a probable source of Voltaire's *Candide*.

These are sentiments that the Précieuses would certainly have approved; but with their overtones of social snobbery they were unlikely to have appealed to Voltaire, the great champion of the Enlightenment.

I mention Voltaire because he seems to have known Sainte-Palaye's version of *Aucassin and Nicolette* and indeed to have derived from it the basic plot of his satirical short novel *Candide*. There the main target for his wit is the fashionable doctrine of philosophic optimism; but the old-fashioned notions of noble love, disapproved or perhaps misunderstood by Sainte-Palaye, are also amply ridiculed. The young Candide's passionate devotion to his beloved Cunégonde and his separation from her do indeed lead him through 'an infinity of disorders and calamities', while she suffers on numerous occasions (though with seeming equanimity) the fate Aucassin had dreaded for Nicolette. When their final reunion does occur, Cunégonde's disfigurement is more permanent than was Nicolette's:

> Candide, the tender lover, seeing his beautiful Cunégonde turned swarthy, her eyes bloodshot, breasts shrivelled, cheeks lined, and arms red and scabbed, started back three paces in horror, then stepped forward out of good manners.

In fact he married her, though with all desire gone, and only to find her become more and more ugly and bad-tempered.

Early in the story we are confronted with Candide's former tutor, Dr Pangloss, cutting an even more hideous figure and all but dead of the pox. What was the cause of his desperate state? asked Candide.

> 'Alas! It is love; love, the consoler of the human race, the conserver of the universe, the soul of all sentient beings, tender love!' — 'Alas,' said Candide, 'I've known this love, this sovereign of hearts, this soul of our soul. To me it's never been worth more than one kiss and twenty kicks up the backside.'

Voltaire evidently had little faith in the redemptive powers of a noble passion.

In general it might be said that the eighteenth century tended to trivialise matters of the heart, at least until Rousseau came to stir souls and moisten eyes with his *New Heloïse*. (The story of Abelard's tragic love has never lost its emotional charge. At the beginning of the present century, for instance, André Gide appears to have had it in mind as he wrote his novel *Strait is the Gate*. In England, notable treatments of the subject have been by Pope and George Moore.) Then, heralded by Rousseau, the Romantic dawn broke, and passionate love was restored to its place as a leading literary theme; and it is only appropriate that the adherents of the new movement found in the Middle Ages a rich source of inspiration. An anthology could be filled with

102 Madeleine de Scudéry's allegorical Carte de Tendre from her novel *Clélie*.

103 A scene of 18th-century gallantry: Watteau's Pèlerinage à l'Île de Cythère.

poems, passages from novels, plays, *belles lettres* that show the ritualised attitudes of our noble lovers persisting, with hardly a finger or eyebrow out of place, in the writings of the Romantics. But that would be another book.

Let me, though, mention the treatise *On Love* by Stendhal, a Frenchman by birth but Italian by sentiment, who committed himself to the ardent search of ideal happiness. There are, he proposed, four principal categories of love: *amour-passion*, *amour-goût*, *amour-physique* and *amour de vanité*. As an example of the first he cites Heloïse's love for Abelard; the second is the type of love played out according to the rules of etiquette prevailing in eighteenth-century Parisian society and conducted with more delicacy than sincerity; the third is the point at which the sixteen-year-old begins his apprenticeship; and the fourth is a standard item of the fashionable young man's equipment, like a stylish horse. Stendhal describes the onset of love: one admires, hopes, and so love is born. Once assured of the lady's affections, the suitor proceeds to endow her in his mind with a thousand perfections, just as a bare branch left in the salt mines of Salzburg will become covered with tiny glittering crystals. There will then come a period of doubt, followed by reassurance and a further, more important, process of 'crystallisation'. So the affair progresses. The theory is neither profound nor, to our eyes, very new. Could it have been produced at all, had not the 'miracle' of courtly love happened all those centuries ago?

A marked feature of Stendhal's novels is his ironic wit. Now comic irony may not be the first quality one associates with the Romantics, unless, perhaps, one has just been reading Byron. But here is an example from Keats, a short poem, 'Modern Love', where we find him mocking the way in which the old amorous poses were struck in his day by people incapable of feeling those intense passions of the great lovers of the past:

> And what is love? It is a doll dress'd up
> For idleness to cosset, nurse, and dandle;
> A thing of soft misnomers, so divine
> That silly youth doth think to make itself
> Divine by loving, and so goes on
> Yawning and doting a whole summer long,
> Till Miss's comb is made a pearl tiara,
> And common Wellingtons turn Romeo boots;
> Till Cleopatra lives at number seven,
> And Antony resides in Brunswick Square.
> Fools! if some passions high have warm'd the world,
> If Queens and Soldiers have play'd deep for hearts,
> It is no reason why such agonies

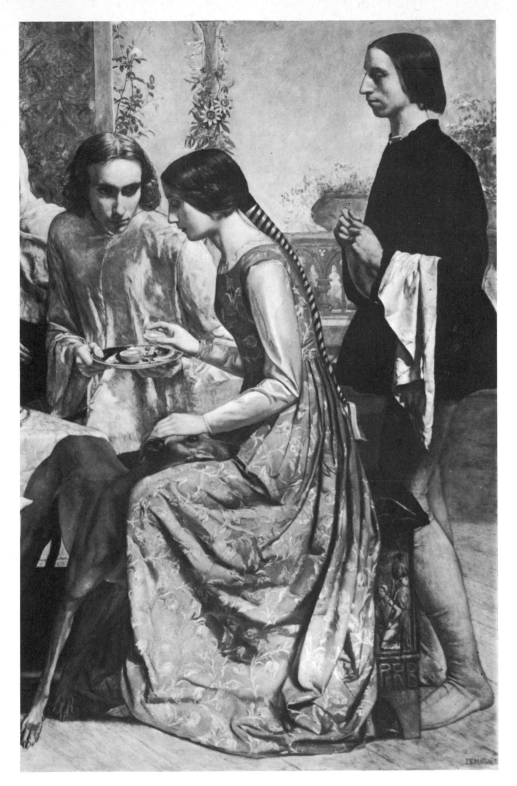

104 Lorenzo and Isabella—a pair of medieval lovers seen by the 19th-century eye of
Sir J. E. Millais.

Should be more common than the growth of weeds.
Fools! make me whole again that weighty pearl
The Queen of Egypt melted, and I'll say
That ye may love in spite of beaver hats.

A nice balance, here, of ridicule and reverence: reverence for the noble lovers of history and legend, ridicule of the shallow souls who try to ape them.

The Pre-Raphaelites came to try and recapture in words and paints something of the agony and ecstasy of the medieval lovers, Lancelot and Guenevere, Tristan and Ysolt, Dante and Beatrice among them. In music, Wagner paid the monumental tribute of his operas. Was all this the last wild fling of an archaic style of loving, or is it a response to a continuing need, at least on the literary and artistic level, for the ritualising of human courtship? The conventions have certainly made life easier for the authors of countless sentimental novelettes; and for a nine-year-old girl they came in handy when she arrived at the grand proposal scene in her tale of love and adventure. Here are a few sentences from Daisy Ashford's *The Young Visiters*, written in 1919:

She looked very beautifull with some red roses in her hat and the dainty red ruge in her cheeks looked quite the thing. Bernard heaved a sigh and his eyes flashed as he beheld her and Ethel thorght to herself what a fine type of manhood he reprisented . . .

Bernard sat beside her in profound silence gazing at her pink face and long wavy eye lashes. . . .

Ethel he murmured in a trembly voice.

Oh what is it said Ethel hastily sitting up.

Words fail me ejaculated Bernard horsly my passion for you is intense he added fervently. It has grown day and night since I first beheld you.

Oh said Ethel in supprise I am not prepared for this and she lent back against the trunk of the tree.

Bernard placed one arm tightly round her. When will you marry me Ethel he uttered you must be my wife it has come to that I love you so intensly that if you say no I shall perforce dash my body to the brink of yon muddy river he panted wildly.

Oh dont do that implored Ethel breathing rarther hard.

Then say you love me he cried.

Oh Bernard she sighed fervently I certainly love you madly you are to me like a Heathen god she cried looking at his manly form and handsome flashing face I will indeed marry you.

More like Aucassin and Nicolette, perhaps, than Lancelot and Guenevere; but coming from so young a head, it shows that courtly love, to use the term

105 'Crown of all ladies I have ever seen, fair, fairer still, fair above all the fairest is she'
(Heinrich von Morungen) — Miss World.

in its widest possible sense, had driven its roots very deep and still spread its branches wide.

Was it, though, purely a fiction, or was it, and is it still, practised in real life? Literature and life are close companions; and if we look back at Andreas Capellanus' rules, we may be surprised to find how many of them apply today — though whether they would have done a hundred years before he devised them is quite another matter. No doubt Victorian lovers did kneel

before their sweethearts like vassals offering their allegiance, heaving sighs as hot as Shakespeare's furnace, and, when rejected, pine away like latterday Dantes. It may be that some suitors still do. By tradition, the young lover in the courtly mode would quake with fear, blush and blench by turns, spend nights of sleepless anguish. Does he still? Surely the nervous suppliant is still to be found, even in these days of lightning conquest. Is there, then, in the human constitution some inbred cause of these fears and emotional turmoil? Or could this too be part of the legacy of courtly love, an ingrained condition nurtured by almost a millennium of romantic fictions: the conscious or sub-conscious dread of possible rejection by the beloved? The psychologists could perhaps tell us whether so insistent a celebration of the unpluckable rose has left the lover with an almost pathological lack of self-confidence.

We hear much today of the present sexual revolution and the new freedoms of the 'permissive society'; and we wonder if love is not remorselessly being stripped of its romantic associations, where 'romantic' implies the lingering presence of the mystique of noble love. There is much talk too of 'women's liberation', but that is something less novel: after all, courtly love itself was an astonishing leap towards female emancipation, whilst the feminist faction in the medieval 'quarrel of women' and, after them, the seventeenth-century Précieuses struck telling blows for the liberation of the weaker sex, even in some respects for female domination. Paradoxically, the present-day 'liberators' are trying to release women from one of the consequences of courtly love: their status as mere objects of desire. Woman must be an equal, no longer a goddess-figure to be worshipped. When protests are raised at the holding of contests to find that ideal terrestrial beauty, Miss World, the complaint is that the participants are presented as dehumanised sex-symbols, pandering only to men's baser appetites. But is this fair? Is not Miss World, robed, crowned, sceptred, and heavily chaperoned, the very image of the lady of the troubadours, chastely remote and inaccessible, a radiant tyrant promising joy but bringing only deception?

The cult of noble love still lingers on; and only in Petrarch's *Triumph* has its winged god been plucked, shackled and disarmed. For a social game, a gallant fiction, it has proved remarkably long-lived. Has the fiction now become reality, absorbed into the psychological make-up of western man?

Bibliography

General

Among the many general studies dealing with the historical, social and cultural background to our subject, the following may be consulted with profit: Luce Pietri, *Époques médiévales* (*Le Monde et son histoire*, Vols. III & IV), Paris, 1966; Friedrich Heer, *The Medieval World*, tr. Janet Sondheimer, Mentor Books, 1963; R. W. Southern, *The Making of the Middle Ages*, London, 1953; Christopher Brooke, *The Twelfth Century Renaissance*, London, 1969; J. Huizinga, *The Waning of the Middle Ages*, tr. F. Hopman, London, 1924; Sidney Painter, *French Chivalry*, Johns Hopkins Press, 1940; A. Fliche, V. Martin, etc., *Histoire de l'Église depuis les origines jusqu'à nos jours*, Paris, 1946–; Reto R. Bezzola, *Les Origines et la formation de la littérature courtoise en Occident* (*500-1200*), 3 vols. in 5, Paris, 1944-63.

General works on courtly love include: Denis de Rougemont, *L'Amour et l'Occident*, Paris, 1939 (tr. by Montgomery Belgion as *Passion and Society*, London, 1940); C. S. Lewis, *The Allegory of Love*, Oxford, 1936; and, for a collection of essays and full bibliography, see F. X. Newman, ed., *The Meaning of Courtly Love*, State Univ. of New York Press, 1968.

On Arthurian romance see: R. S. Loomis, ed., *Arthurian Literature in the Middle Ages*, Oxford, 1959; and R. S. Loomis & L. H. Loomis, *Arthurian Legends in Medieval Art*, London/New York, 1938.

Chapter I

The texts of Abelard's *Historia calamitatum* and his correspondence with Heloïse have been edited by J. T. Muckle & T. P. McLaughlin in *Mediaeval Studies* XII (1950), XV (1953), XVII (1955) and XVIII (1956). They are translated by Betty Radice in *The Letters of Abelard and Heloïse*, Penguin Books, 1974, and the *Historia* by J. T. Muckle, *The Story of Abelard's Adversities*, Toronto, 1964. Studies include: Ét. Gilson, *Héloïse et Abélard*, Paris, 1938 (English tr., London, 1953); Régine Pernoud, *Héloïse et Abélard*, Paris, 1970 (tr. Peter Wiles, London, 1973).

Chapter II

For a study of 'the courtly experience' in the medieval lyric, with a selection of Latin texts, see Peter Dronke, *Medieval Latin and the Rise of European Love-Lyric*, 2 vols., Oxford, 1965-6. Useful anthologies, which are provided with translations and may be consulted for editions of individual poets, are by

Alan R. Press (*Anthology of Troubadour Lyric Poetry*, Edinburgh, 1971), Frederick Goldin (*Lyrics of the Troubadours and Trouvères* and *German and Italian Lyrics of the Middle Ages*, both New York, 1973), and Brian Woledge (*The Penguin Book of French Verse* I, Penguin Books, 1961).

For the medieval lives of the troubadours (with modern French translations) see J. Boutière & A.-H. Schutz, *Biographies des troubadours*, Paris, 1964.

Studies on the troubadours include: Robert Briffault, *Les Troubadours et le sentiment romanesque*, Paris, 1945 (tr. L. F. Koons, Bloomington, 1965); Henri Davenson (= H.-I. Marrou), *Les Troubadours*, Paris, 1961, 2nd edn., 1971; René Nelli, *L'Érotique des troubadours,* Toulouse, 1963.

Andreas Capellanus' *De Amore* (= *De Arte honeste amandi*) was edited by A. Pagès, Castelló de la Plana, 1930, and translated by J. J. Parry, New York, 1941. See also Felix Schlösser, *Andreas Capellanus: seine Minnelehre und das christliche Weltbild des 12. Jahrunderts,* 2nd edn., Bonn, 1962.

Chapter III

Chrétien's *Lancelot* (*Le Chevalier de la Charrette*) is edited by Wendelin Foerster, *Christian von Troyes, Sämtliche Werke,* Vol. IV, Halle, 1899, and by Mario Roques, Paris, 1958. English translation by W. W. Comfort in *Chrétien de Troyes: Arthurian Romances*, Everyman's Library, new edn., 1975.

See Jean Frappier, *Chrétien de Troyes*, Paris, 1957; F. Douglas Kelly, *Sens and Conjointure in the Chevalier de la Charrette,* The Hague/Paris, 1966; *Arthurian Romance: Seven Essays*, ed. D. D. R. Owen, Edinburgh/London, 1970.

Chapter IV

Editions of *Le Roman de la Rose* by E. Langlois, 5 vols., Paris, 1914-24, and by F. Lecoy, 3 vols., Paris, 1965-70; also '*The Romaunt of the Rose' and 'Le Roman de la Rose'. A Parallel-Text Edition,* ed. R. Sutherland, Oxford, 1967.

Chapter V

For the origins of the Tristan legend see Gertrude Schoepperle, *Tristan and Isolt*, 2 vols., Frankfurt/London, 1913; and for the story of Diarmaid and Grainne see Myles Dillon, *Early Irish Literature*, U. of Chicago Press, 1948.

Texts: *Tristan et Yseut: les Tristan en vers*, ed. J. C. Payen, Paris, 1974 (Old French texts with modern French translation); Thomas, *Les Fragments du Roman de Tristan*, ed. Bartina H. Wind, Geneva/Paris, 1960; Gottfried von Strassburg *Tristan und Isold*, ed. Friedrich Ranke, Berlin, 1930. English translation of both by A. T. Hatto, Penguin Books, 1960. Reconstruction by Joseph Bédier, *Le Roman de Tristan et Iseut,* Paris, 1946.

Chapter VI

Texts: *La Chastelaine de Vergi*, ed., F. Whitehead, Manchester U.P., 1944; *Le Roman du Castelain de Couci et de la Dame de Fayel*, ed. M. Delbouille, Paris, 1936. Translation of *La Chastelaine de Vergi* by Pauline Matarasso in *Aucassin and Nicolette and Other Tales*, Penguin Books, 1971.

Chapter VII

Joufroi de Poitiers, ed. P. B. Fay & J. L. Grigsby, Geneva, 1972. On Sir Gawain see B. J. Whiting, 'Gawain: his Reputation, his Courtesy and his Appearance in Chaucer's *Squire's Tale*', *Mediaeval Studies* IX (1947), pp. 189-234.

Gawain texts include: Chrétien de Troyes, *Le Conte du Graal* (*Roman de Perceval*), ed. A. Hilka, Halle, 1932, and ed. W. Roach, Geneva/Lille, 1956; *Two Old French Gauvain Romances: 'Le Chevalier à l'épée' and 'La Mule sans frein'*, ed. R. C. Johnston & D. D. R. Owen, Edinburgh/London, 1972; *Les Merveilles de Rigomer*, ed. W. Foerster & H. Breuer, 2 vols., Dresden, 1908-15; *Sir Gawain and the Green Knight*, ed. J. R. R. Tolkien & E. V. Gordon, 2nd edn. revised by N. Davis, Oxford, 1967, and ed., with translation, by W. R. J. Barron, Manchester U.P., 1974.

Floire et Blancheflor, ed. Margaret Pelan, 2nd edn., Paris, 1956.

Aucassin et Nicolette, ed. F. W. Bourdillon, Manchester U.P., 1930, and by Mario Roques, 2nd ed., Paris, 1954; English translation by Pauline Matarasso, Penguin Books, 1971.

Chapter VIII

Le Opere di Dante, ed. Michele Barbi, 2nd edn., Florence, 1960. *La Vita Nuova* translated by Barbara Reynolds, Penguin Books, 1969. Among the many studies on Dante see Charles Williams, *The Figure of Beatrice*, London, 1943; Thomas G. Bergin, *An Approach to Dante*, London, 1965.

Francesco Petrarca, *Rime, Trionfi e Poesie latine*, ed. F. Neri, etc., Milan/Naples, 1951. *The Triumphs of Petrarch*, tr. Ernest Hatch Wilkins, U. of Chicago Press, 1962. See also E. H. Wilkins, *Life of Petrarch*, U. of Chicago Press, 1961.

Chapter IX

The Works of Shakespeare, ed. John Dover Wilson, Cambridge U.P. (*Romeo & Juliet*, 1955; *The Sonnets*, 1966). See John Vyvyan, *Shakespeare and the Rose of Love*, London, 1960.

On Cervantes, see Herman Iventosch, 'Cervantes and Courtly Love: The Grisóstomo-Marcela Episode of *Don Quixote*', *Publications of the Modern Language Association of America* 89 (1974), pp. 64-76.

La Curne de Sainte-Palaye, *Les Amours du bon vieux tems,* Vaucluse/Paris, 1756. Voltaire, *Candide ou l'optimisme,* ed. C. Thacker, Geneva, 1968, and by J. H. Brumfitt, Oxford U.P., 1968. For the connection between these two works see D. D. R. Owen, '*Aucassin et Nicolette* and the Genesis of *Candide*', *Studies on Voltaire and the Eighteenth Century* XLI (1966), pp. 203-17.

Stendhal, *De l'Amour,* ed. Michel Crouzet, Paris, 1965.

The Poetical Works of John Keats, ed. H. W. Garrod, Oxford, 1939.

Daisy Ashford, *The Young Visiters or, Mr. Salteenas Plan,* London, 1919.

Acknowledgements

In the preparation of this book I have received generous help and advice from many friends and colleagues, among whom I number the ever-patient staff of St Andrews University Library, from Susan Waterston, whose editorial zeal has been a constant encouragement, and above all from my wife. To all of them my warm thanks are due, as to the institutions and agencies mentioned elsewhere which have provided the illustrations to bring my narrative to life. For permission to quote extracts from Daisy Ashford's *The Young Visiters* I am indebted to Margaret Steel, Clare Rose and Messrs Chatto and Windus. All translations, other than the lines from H. F. Cary's version of Dante's *Divine Comedy*, are my own.

D.D.R.O.

List of Illustrations

89 Dante's dream. Watercolour by D. G. Rossetti, 1856. London, Tate Gallery.

90 Dante expelled from Florence. Miniature by Giovanni di Paolo, Sienese, mid-15th century. London, British Library, Ms Yates Thompson 36, fol. 159.

91 Beatrice shows Dante the celestial rose Miniature. Sienese, mid-15th century. London, British Library, Ms Yates Thompson 36, fol. 185.

92 Beatrice's look of divine love. Miniature. Paduan, early 15th century. Padua, Seminario, Ms 67, fol. 208. Photo courtesy Peter Brieger and Pontifical Institute of Medieval Studies, Toronto.

93 Petrarch. Miniature. North Italian, late 14th century. Paris, Bibl. Nationale, Ms lat. 6069F, fol. AV.

94, 95 Triumphs of Love and Chastity. Tapestry. French, 16th century. Vienna, Kunsthistorisches Museum.

96 Laura and the Triumph of Chastity. Painted wooden marriage salver by Apollonio di Giovanni. Florence, *c.* 1450. Raleigh, North Carolina, Museum of Art.

97 Ronsard and Cassandre. Woodcuts after Nicolas Denisot from Ronsard, *Les Amours*, 1552. Paris, Bibl. Nationale.

98 Charles d'Orléans in the Tower of London. Miniature, French, 15th century. London, British Library, Ms Royal 16F.II, fol. 73.

99 Romeo and Juliet. Engraving after T. Stothard, 1825. London, Victoria and Albert Museum. Photo Phaidon Archive.

100 Love-sick courtier. Tempera on vellum. Miniature by Nicholas Hillyarde, *c.* 1590. London, Victoria and Albert Museum.

101 Title page of La Curne de Sainte-Palaye, *Les Amours du Bon Vieux Tems*, 3rd edition, Paris, 1756. Newcastle University Library.

102 La Carte de Tendre. Engraving in Madeleine de Scudéry, *Clélie*, 1654. Paris, Bibl. Nationale. Photo Bulloz, Paris.

103 Pèlerinage à l'Île de Cythère. Oil on canvas. Jean-Antoine Watteau, 1717. Paris, Louvre. Photo Giraudon, Paris.

104 Lorenzo and Isabella. Detail of oil painting by Sir J. E. Millais, 1849. Liverpool, Walker Art Gallery.

105 Miss World 1967 (Madelaine Hartog Bel, Miss Peru). Photo Keystone, London.

List of Colour Illustrations

Index